WO**M**EN IN S

M
V
P
of
U
S
B
U
P
N
U
U
Su
P
Cl
W

Tl
ab
pa
pu
re
stu
br

As
pe
of
in
dis
law, physical education, art and social policy.

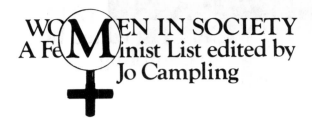

WOMEN IN SOCIETY
A Feminist List edited by
Jo Campling

Published

Sheila Allen and Carol Wolkowitz **Homeworking: myths and realities**
Niamh Baker **Happily Ever After? Women's fiction in postwar Britain, 1945–60**
Jenny Beale **Women in Ireland: voices of change**
Ruth Carter and Gill Kirkup **Women in Engineering: a good place to be?**
Angela Coyle and Jane Skinner (*editors*) **Women and Work: positive action for change**
Gillian Dalley **Ideologies of Caring: rethinking community and collectivism**
Leonore Davidoff and Belinda Westover (*editors*) **Our Work, Our Lives, Our Words: women's history and women's work**
Emily Driver and Audrey Droisen (*editors*) **Child Sexual Abuse: feminist perspectives**
Lesley Ferris **Acting Women: images of women in theatre**
Diana Gittins **The Family in Question: changing households and familiar ideologies**
Tuula Gordon **Feminist Mothers**
Frances Heidensohn **Women and Crime**
Ursula King **Women and Spirituality: voices of protest and promise**
Muthoni Likimani (*Introductory Essay by Jean O'Barr*) **Passbook Number F.47927: women and Mau Mau in Kenya**
Jo Little, Linda Peake and Pat Richardson (*editors*) **Women in Cities: gender and the urban environment**
Sharon Macdonald, Pat Holden and Shirley Ardener (*editors*) **Images of Women in Peace and War: cross-cultural and historical perspectives**
Shelley Pennington and Belinda Westover **A Hidden Workforce: homeworkers in England, 1850–1985**
Vicky Randall **Women and Politics: an international perspective** (2nd edn)
Rosemary Ridd and Helen Callaway (*editors*) **Caught Up in Conflict: women's responses to political strife**
Patricia Spallone **Beyond Conception: the new politics of reproduction**
Taking Liberties Collective **Learning the Hard Way: women's oppression in men's education**
Clare Ungerson (*editor*) **Women and Social Policy: a reader**
Annie Woodhouse **Fantastic Women: sex, gender and transvestism**

Forthcoming

Eileen Aird and Judy Lown **Education for Autonomy: processes of change in women's education**
Jennifer Breen **Women and Fiction**
Maria Brenton **Women and Old Age**
Joan Busfield **Women and Mental Health**
Frances Gray **Women and Laughter**
Eileen Green, Diana Woodward and Sandra Hebron **Women's Leisure, What Leisure?**
Jennifer Hargreaves **Women and Sport**
Annie Hudson **Troublesome Girls: adolescence, femininity and the state**
Susan Lonsdale **Women and Disability**
Mavis Maclean **Surviving Divorce: women's resources after separation**
Lesley Rimmer **Women's Family Lives: changes and choices**
Susan Sellers **Language and Sexual Difference: feminist writing in France**
Deborah Valenze **The Other Victorian Women**
Janet Wolff **The Art of Women**

Women in Engineering

A Good Place To Be?

Ruth Carter and Gill Kirkup

MACMILLAN

First published 1990

Published by
MACMILLAN EDUCATION LTD
Houndmills, Basingstoke, Hampshire RG21 2XS
and London
Companies and representatives
throughout the world

Photoset in Times by
Vine & Gorfin Ltd, Exmouth, Devon

Printed in the People's Republic of China

British Library Cataloguing in Publication Data
Carter, Ruth
Women in engineering: a good place to be?—(Women in
society).
1. Women engineers. Sociological perspectives
I. Title II. Kirkup, Gill III. Series
305.4'362
ISBN 0–333–45241–0 (hardcover)
ISBN 0–333–45242–9 (paperback)

Series Standing Order

If you would like to receive future titles in this series as they are published,
you can make use of our standing order facility. To place a standing order
please contact your bookseller or, in case of difficulty, write to us at the
address below with your name and address and the name of the series. Please
state with which title you wish to begin your standing order. (If you live
outside the United Kingdom we may not have the rights for your area, in
which case we will forward your order to the publisher concerned.)

Customer Services Department, Macmillan Distribution Ltd,
Houndmills, Basingstoke, Hampshire, RG21 2XS, England.

Contents

Acknowledgements vi

1. **Introduction** 1

2. **Setting the scene** 7

3. **The daily round** 21

4. **The critical step** 36

5. **Education** 50

6. **Public lives** 76

7. **Private lives** 100

8. **Commitment to a career** 122

9. **Engineering, technology and personal values** 140

10. **Working for change** 154

Appendix 1: Biographies 172

Appendix 2: Research method 176

Bibliography 180

Index of references to engineers 187

Index of authors and subjects 189

Acknowledgements

The idea for this book came out of the work that we do at the British Open University. We have been involved, for many years, in planning and supporting special initiatives for women in technology and engineering. We like to think that our work, combined with an increased interest among women in the UK in engineering courses at higher education level (Engineering Council, 1987), has been instrumental in raising the proportion of women registering for the University's first-year course in technology from 15 per cent to 26 per cent between 1980 and 1988. Part of our work has been to produce careers advice for adult students, and in doing this we have talked to many women engineers.

We feel it is important to understand the nature of new opportunities for women *and* their costs. Our aim is twofold:

— to provide a specialist study of women engineers for feminists and teachers of women's studies courses;
— to describe the experience of women engineers for engineering educators who are contributing to their development.

We have researched and written the book while continuing our day-to-day work at the Open University, and we would like to record our gratitude to the University and to our colleagues for providing us with such a supportive environment. We are especially grateful to the members of the University's Women into Science and Engineering (WISE) Group. We would also like to thank those friends and colleagues who read and commented on the first draft of this book. They are: David Boyd, Jo Campling, Cynthia Cockburn, Rita Daggett, Dave Elliott, Alison Kelly, Anne Overell, Hugo Radice, Helen Storey and Gordon Wilson. We found all of their

comments helpful, and their criticisms remarkably consistent; we have acted on them to the best of our ability.

Our five children, although not exactly offering support, at least refrained from excessive demands while we worked, and endured our distraction relatively uncomplainingly. We were able to re-compense three of them with a trip to Blackpool to celebrate the completion of the final draft.

<div align="right">RUTH CARTER
GILL KIRKUP</div>

The authors and publishers are grateful to the following for permission to reproduce copyright material:

Engineering Industry Training Board for the table entitled 'Occupation of women employed in the British Engineering Industry: 1986'.

Universities Statistical Record for the data used in the diagram entitled 'Full-time undergraduates studying engineering at UK Universities, 1986–7'.

Every effort has been made to trace all the copyright-holders, but if any have been inadvertently overlooked the publishers will be pleased to make the necessary arrangements at the first opportunity.

1

Introduction

This is a book about what life is like for practising women engineers in the United States of America (USA) and the United Kingdom (UK). Thirty-seven professional, qualified engineers who also happen to be women speak directly to the reader about their experience. They reveal details of their working lives and their private lives through personal histories. They talk about how being an engineer and being a woman affects them. We interviewed these women because we were struggling with our own difficulties in answering the question: *Should we be encouraging more women to become engineers?*

This is a question which, in the past, has been to do with whether women who have roles as wives should enter demanding careers where they compete with men. It assumed that women's primary sphere is necessarily domestic and feminine, that engineering is necessarily masculine and tough, and that women who enter engineering do damage to their feminine selves as well as to those – husbands, and children in particular – who depend on women fulfilling their feminine roles. As feminists we ask the question from a different set of assumptions. We see engineering as a socially constructed profession which is masculine, but we question whether it is inevitably or beneficially so. We believe that women benefit from being able to fulfil domestic and career roles, and that organisations benefit from the participation of all the groups in a society. However, we acknowledge the power of social structures over individuals. If the engineering profession and other social institutions are not practically supportive of women entrants, then the price that individual women pay is too high. Demands must be made on social institutions to change.

In this book we look at the lives and experiences of a group of *successful* engineers who are women. It can be argued that those who have succeeded in atypical occupations are by definition atypical. But we believe that in understanding what constitutes their success, we get some idea of the price of it; we learn about the engineers, and through them, about engineering.

It is easy to get caught up in an uncritical rhetoric of equal opportunities. Industrialised countries which have been restructuring their industries have developed programmes to retrain and update their workforce. These programmes have been based on a philosophy of individual opportunity which suggests that the obstacles of race, class or sex, which have always been strong determinants of career choice, now no longer apply. This philosophy has been supportive of special educational and training programmes to help women enter traditionally male areas of work.

We have always been rather cynical about statements like the following (made in Britain during Women into Science and Engineering Year, 1984):

> [The] marked under-representation of girls and women in engineering and science-related professions often stems from the outdated notion that such work should be carried out by men – a belief inappropriate in today's social and economic situation. Nevertheless, it has influenced actual practices associated with science and engineering and is still reflected in the advice offered to girls and women by their careers advisors, teachers and industry in general.

Such statements reflect a particular pragmatic position which has gained much official government support. They call for the increased participation of women in technology on the basis of arguments concerned with equality of opportunity for girls and women, and redressing the balance between the sexes. The proponents of these arguments offer increased goodwill and intervention programmes as ways of achieving their aims. Unfortunately such arguments frequently omit analysis which might explain how gendered occupational stereotyping has arisen. They tend to rely instead on a statistical description of the current position without attempting to explain its origins.

We intent to develop a more critical understanding of the gendering of a particular profession, and to examine whether and how that gendering is being perpetuated. At the same time, we

believe that more avenues *are* now open to women than there have been since the early years of the century. But what price do women pay for taking the avenues – or for not taking them?

Theories about women and technical work

During the 1980s there has been an increasingly sophisticated analysis among feminists about women's relationship to technology. Early research on women and engineering/technology in the 1950s and 1960s tended to be concerned with psychological investigations of the personality attributes of women entering and succeeding in non-traditional areas. A pre-feminist analysis struggled along without any useful concept of patriarchy, gender or women's oppression. It was then difficult to have a structural analysis of women's exclusion from areas of work which really took account of their gender. Most research papers of those decades which dealt with women engineers concentrated on examining sets of variables such as parental occupation and personality attributes to see how those of women engineers differed from those of women in more traditional occupations (for example, Ott and Reese, 1975; Robin, 1969).

Since the 1960s work on gender has blossomed, and particular aspects of it have touched on an analysis of women and technology. One particular strand has examined the process of gender stereotyping which divides girls and boys from the moment of birth. It traces this stereotyping through the different toys children are given to play with, noting that girls are expected to remain docile and dutiful while boys are encouraged to be adventurous, active and aggressive. It charts the transfer of these behaviour patterns to the classroom, where girls perform well in maths and science until puberty and then drop behind, where boys hog the access to hands-on computing facilities and teachers' attention. It notes that these features are eventually manifest in the low numbers of girls enrolling in courses in science and technology in further and higher education (Kelly, 1981; Byrne, 1973).

Another strand focuses on an analysis of technology as a product of national and international defence and economic policies. As voters and taxpayers, women are asked to support and contribute to nuclear weapons research which has the potential to destroy future

generations, but they are not expected to question its value or to understand it. Since both the armed forces and industry institutionalise stereotypically male traits, particularly aggression, competitiveness and hierarchical leadership, this strand argues that it is hardly surprising that women are not attracted into technological professions, preferring instead the ethos of the caring professions (Griffin, 1978; Cockburn, 1984).

Recent British work by Cockburn has been influential in developing a new strand to radical theories of technology. Cockburn's analysis of technology and masculinity takes account of an historical Marxist analysis of the development of the skilled and professional workforce, while seeing, with reference to jobs connected with technology, the primacy of gender in the very concepts of skill and professionalism. She argues, first in her analysis of the printing industry and later in her analysis of other new technology industries, that skilled technical work is synonymous with masculinity. We will argue that a similar connection exists between masculinity and being a professional engineer, although the more secure situation of the professional makes for more flexibility over the issue of gender.

A more optimistic position focuses on the need for women to take hold of technology. As the primary consumers of technology in their homes, in transportation networks, through health care and in the service sector, women need to be aware of its potential, of the choices that it presents. They need to be prepared to take a lead in determining a technological future. The masculine values currently synonymous with technology could then be ousted in favour of a new value system whose application would be controlled by women. Such arguments have been used to initiate woman-centred learning strategies (Rothschild, 1983; Zimmerman, 1983).

It is these controversial feminist analyses of science and technology which make an investigation of women engineers different from that of any other women professionals. There are many similarities between professions over issues such as level of qualification, social status, and terms and conditions of employment; even many administrative and managerial work tasks have much in common. It would be possible to study women professionals as a group, and see engineering as simply another profession. However, if scientific theory and method and the techniques of technology are masculine, then women need not only to have access and share

control in these fields, but to transform their basic theories and practices. We see how far our engineers share this analysis. Do they feel any need to transform their profession and its practices, and if they do, are they able to do so?

The structure of the book

In this book we are looking at issues which affect all women in the 1980s and 1990s in industrialised countries. How do women handle stress, both job-related and domestic? How do they handle professional competition? How are domestic roles handled in families where both partners are under great pressure from work? What decisions have to be made about relationships in and outside work? How is childcare managed, and how do women cope with the inevitable guilt over it? We are looking at these issues at a time when the state is withdrawing its commitment to welfare provision. Welfare of the elderly and the very young is located as the immediate concern of women, but women are also affected by legislation which removes employment protection or changes the nature of the relationship between employer and trades union. It is especially valuable to have a comparison between two countries in which changes are taking place in similar directions although from quite a different base.

In Chapter 2 we set the scene in both countries. We look at the differences between women in the engineering workforces of both countries. We also look at some of the historical factors that have led to the present situation and examine conditions of employment for women engineers. This provides the specific social and cultural context for the individual histories that unfold in the following chapters.

In Chapter 3 we try to give a feel for the texture of the daily lives of the engineers. We look at the variety of tasks that make up the job, and how the demands of the job fit in with other demands of life, for example children and partners.

In Chapter 4 we look at the influences in the lives of the women which contributed towards their choice of a non-traditional area of study or work. We examine whether their career choice was gradual, or had some critical choice point.

In Chapter 5 we are concerned to look at the educational

experiences of our engineers. How did they see themselves at school? How helpful was school in their career choices? What about single-sex schools? What does it feel like to be one of a small minority of women doing a subject at university and what effect does this have?

In Chapter 6 we hear the engineers describing their work, their working environment and their colleagues. They discuss whether they have ever experienced sexual discrimination, and how, if at all, being female has affected how they do their jobs and how others perceive them to be doing their jobs.

In Chapter 7 the women talk about their private lives. How do they balance being a mother or a wife with the sorts of demands a professional job makes? How far can they integrate their public and private lives, and how far do they want to? What support can they draw on from family and friends?

In Chapter 8 the engineers look to the future. How strongly are they committed to continuing in their profession, how ambitious are they, and where do they want to go? What do they see as the price of future success?

In Chapter 9 we examine some of the personal values that have been implicit in the earlier chapters; values to do with male and female friendship as well as values to do with technology and society.

In Chapter 10 we try to draw some lessons from the experience of our sample. We come back to our original question: should we be encouraging more women to become engineers? What has the price been for the women we talked to? If governments and employers do wish to open the technological professions to the most able members of society regardless of sex or race, what can be done by institutions as well as by women themselves to make equal participation a reality? Is engineering and technology changing, and is the entry of women at the professional level a way to initiate change?

2

Setting the scene

Although we interviewed each woman in our sample as an individual, listening, and later reading, with fascination about her life, we were always aware that her personal history should be viewed against a social and cultural backdrop. In order to appreciate the context in which these engineers live and work we need to understand how it is that in the 1980s, in two Western countries where advanced capitalism prevails, they are still part of a tiny minority: women engineers.

Here we need to set the scene. This involves a brief review of the position which women occupy in the workforce, followed by an introduction to the engineering profession. We then examine the participation of women in engineering at different levels and the terms on which women engineers are employed. The education of women in non-traditional fields, another important component of the picture, is reviewed separately in Chapter 5.

As we have chosen a two-country sample, some cross-cultural comparison is also necessary. We naively assumed that the USA was more progressive in discriminating in favour of women in non-traditional fields because we knew that equal opportunities legislation had been introduced there earlier, and special initiatives had been well publicised. We discovered, however, that the differences are fewer than we supposed; in many ways the situation of women engineers is similar in both countries, and as feminists, we would not describe either as particularly progressive.

We shall not, therefore, be doing a USA/UK comparison at every point in this chapter, since much of what we have to say applies equally to both countries, but we will highlight the differences

where we feel they are most relevant to our study. We look at differences in equal opportunities legislation and in the terms and conditions of employment of the women engineers in our sample. These struck us as areas of significant difference between the two countries.

Participation of women in the workforce

In both the USA and the UK women make up slightly less that 45 per cent of the workforce, and this figure has risen considerably in the last decade. It is now firmly established that women do not work for 'pin money', but to contribute to their household income. As the number of households headed by a female single parent rises, so does the need for women to support themselves and their children. In the USA, the number of single-parent households has more than doubled since 1970, and 90 per cent of them are maintained by women. Economic necessity clearly applies to women workers who are single, widowed, separated or divorced. There has also been a long-term trend towards the increased participation of married women in the workforce.

In recent years rising unemployment in both countries has hit men harder than women, so that married women are increasingly taking on the role of breadwinner in their households. Roughly 45 per cent of married British women and 50 per cent of married American women are in paid employment.

Women with dependent children who are also in paid employment work a double day: one working day at work and another, consisting of household chores and family responsibilities, which they fit as best they can around their hours of paid employment. It is not at all surprising, therefore, to find that over two-thirds of working women with dependent children work part-time, as do the majority of married women workers.

The engineering profession

Development

A glance at the backgrounds of the women in our sample reveals a

diversity of professional expertise, from aeronautical engineering to water engineering. It is really only in the twentieth century that the engineering profession has encompassed so many different specialisms.

The first British engineers to establish their professional status were civil engineers, who formed the Institution of Civil Engineers in 1828. Other specialised groups developed quickly, leading to the formation of new professional bodies such as the Institution of Mechanical Engineers (1847), the Institution of Electrical Engineers (1871) and the Institution of Mining Engineers (1889). Many more followed, so that just a hundred years later most engineers, whether they work with computers or in building services, have their status conferred by their own professional body.

Women's exclusion

As the engineering institutions and the engineering trades unions developed in nineteenth-century Britain, they adopted a deliberate policy of excluding women (Drake, 1984). This, combined with the protective legislation which such organisations also supported, drove women away from the more dangerous, but higher skilled and better paid, occupations involving technical processes.

The UK Amalgamated Society of Engineers (ASE), for example, seemed to see women engineers only in terms of unfair competition. The semi-skilled and unskilled work that women did in the engineering industries in wartime is widely acknowledged. What is less well known is that during the Great War of 1914–18, a small number of instructional factories were set up. These were designed to take better educated women and put them through a crash course in engineering to raise them to the level of training of professional engineers (Kozak, 1976). Only small numbers of women were trained at these factories, but their work was satisfactory and they worked successfully in munitions, tool-making, ship-building, aircraft and general engineering. However, the ASE was unhappy about them. At the end of the war all women were sacked, whether trained or not, under the terms of an ASE-negotiated government agreement; special training, too, ceased. It was almost immediately after this that British women engineers formed their own organisation.

Women's organisations

Women engineers have, of course, been acutely aware of their
rarity in all branches of engineering. For mutual support, they
formed their own professional societies in both countries. The
British Women's Engineering Society (WES) was established in
1919, and its American sister organisation, the Society of Women
Engineers (SWE), in 1949. Both have similar structures, a small
national office and executive committee and many local branches in
communities and in colleges and universities. Their aims, too, are
similar. They inform young women about the opportunities open to
them in engineering and the qualifications they will require. They
support women engineering students and promote special educa-
tional initiatives for women, such as schemes to assist engineers
returning to work after a career break. They encourage self-
education among women engineers and help them to achieve high
levels of educational and professional attainment.

The societies also act as pressure groups and centres of informa-
tion. They publicise the achievement of women as individuals and
as a group within the profession, and liaise with other pressure
groups concerned with women's issues such as the Fawcett Society
in Britain and the National Organisation of Women in America.
Since they cut across the specialism boundaries of other profes-
sional societies, they are the only organisations which women
engineers who are members have in common. The importance of
WES and SWE to engineers who are conscious of their gender or
who experience a sense of isolation is a theme which recurs
throughout the book.

Structure

There are three separate levels to which a British engineer can
aspire: craftsman/craftswoman engineer, technician engineer and
professional, or Chartered, engineer. The Engineering Council,
established in 1981, is the co-ordinating body charged with regulat-
ing the standards of education and experience appropriate for
admission to each level.

In the USA professional engineers are recognised on an in-
dependent, state-by-state basis, with each state operating its own

engineering registration board. Of approximately 1.4 million practising engineers in the USA, nearly 500,000 are registered. This reflects a steady growth in the registration of practising engineers, although in the USA as in Britain, registration is not a mandatory prerequisite of practice.

Like most other professions, engineering is hierarchically structured and conservative in admitting members to its ranks. The system of professional recognition functions on the one hand to license members as competent practitioners, and on the other to protect the privileges accorded to members. In the USA, for example, contracts for engineering services entered into by an engineer who is not professionally registered may be considered by the courts to be invalid and thus unenforceable. While the British profession may smile kindly on young entrants who take an accepted route to recognition as a chartered engineer via university and work experience, those who take a non-traditional route, such as mature students of the Open University, have experienced great difficulty and frustration in gaining admission. The impression they receive of the Engineering Council is of an impenetrable bastion of the establishment.

Women's employment in engineering

In the British engineering industry women form a steady 20 per cent of the workforce, a far lower proportion than that found in the economy as a whole. Table 2.1 shows their distribution by occupation.

Of the 388,400 women workers in the industry, 88 per cent are employed in clerical jobs or as semi-skilled operators performing routine tasks such as assembly work. Less that 1 per cent are skilled craftswomen; slightly more than 1 per cent are scientists and technologists, the professional engineers. Viewed in another way, only 4.6 per cent of professional engineers working in the engineering industry are women. However, this figure is growing. Since 1978 the proportion of the workforce who are engineers, scientists and technologists has increased one and a half times, but the proportion of women in this category has increased three and a half times, an encouraging and clearly identifiable upward trend.

The low numbers of professional women engineers are reflected

Table 2.1 *Occupations of women employed in the British engineering industry, 1986*

Occupational category	Number of women (000s)	% of all women	Women as a % of all employees
Managerial	4 700	1.2	3.8
Scientists & technologists	4 100	1.1	4.6
Technicians & draughtspersons	5 300	1.4	2.9
Administrative & professional staff	22 300	5.7	16.7
Clerical & office staff	146 900	37.8	74.7
Supervisors (incl. foremen/women)	7 600	2.0	8.1
Craftspersons	1 700	0.4	0.5
Operators & others	195 900	50.4	24.5
Totals	388 400	100.0	19.9

Source: Engineering Industries Training Board.

by the few women members of the professional engineering institutions. In the UK in 1985, women formed 5 per cent of the membership of the Institution of Chemical Engineers, 0.9 per cent of the Institution of Production Engineers, and 0.8 per cent of the Institution of Mechanical Engineers.

In the USA the National Science Foundation performs a legally required monitoring function in collecting statistics biennially about women and ethnic minorities in science and engineering. In 1984, less than 5 per cent of professional engineers were women. Table 2.2 shows their distribution by specialist field of employment.

Women are best represented in chemical and petroleum engineering and worst represented in mechanical and electrical engineering. However, among women engineers a greater proportion work as mechanical and electrical engineers than in any other field, and fewest work in nuclear or mining engineering. Unfortunately, no British legislation requires similar monitoring, so equivalent data are not available.

Table 2.2 *Fields of employment of American women engineers, 1984*

Engineering field	Number of women	% of all women engineers	Women as a % of the field
Aeronautical/ astronautical	2 200	2.9	2.7
Chemical	8 800	11.8	6.3
Civil	9 300	12.5	3.0
Electrical/ electronics	12 200	16.4	2.4
Industrial	5 300	7.1	4.0
Materials	2 200	2.9	4.3
Mechanical	10 900	14.6	2.4
Mining	600	0.8	3.6
Nuclear	800	1.1	3.6
Petroleum	2 000	2.7	6.0
Other engineers	20 100	27.0	4.5
Totals	74 500	100.0	3.7

Note: detail does not add to totals because of rounding.
Source: US National Science Foundation.

Equal opportunities legislation

Equal pay

The fact that a woman has the same occupation as a man does not necessarily mean that she receives the same pay for it. Women systematically earn less than their male counterparts in the same occupation in both Britain and America, though the extent of the difference varies from job to job. In Britain in 1985, women's gross hourly earnings averaged only 74 per cent of men's; in America the comparable average ratio of female to male earnings was 65 per cent.

Despite equal pay legislation, operating from 1963 in the USA and 1975 in the UK, which is designed to prevent differential earnings between women and men, neither country has been able to ensure equal access to jobs. In both countries the ratio of female to

male earnings improved considerably in the few years following the introduction of the Equal Pay Act, but then stabilised at its current level. Since the legislation prohibits sex discrimination in pay where women and men are employed in broadly similar, but not identical, work, there unfortunately remains great scope for disagreement in the interpretation and assessment of equality of qualification, skill, effort, responsibility, and working conditions.

Anti-discrimination

The 1964 Civil Rights Act (Title VII) was the first piece of American legislation to prohibit sex discrimination across all facets of employment: apprenticeship, training and retraining, terms and conditions of service, hiring, promotion, and firing. Its enforcement is monitored by the Equal Employment Opportunity Commission (EEOC), set up in the late 1960s. The equivalent British legislation is the Sex Discrimination Act of 1975, which prohibits both direct and indirect discrimination in employment and applies equally to women and to men. (Indirect discrimination is the situation where a requirement or condition of employment applies equally to women and men, but is such that a considerably smaller proportion of one sex than of the other is able to comply.) The monitoring body is the Equal Opportunities Commission (EOC), which has a remit to monitor and improve the relative position of women.

There are some key differences between the legislation in the two countries. First, in the USA, following a complaint of unlawful employment practice and the failure of subsequent reconciliation procedures, the EEOC may support an employee in bringing legal action against an employer. Class action suits, which relate to a number of employees instead of one individual, have sometimes resulted in well publicised settlements, forcing many large companies to reform their employment practices. The influence of class action suits can therefore be wide ranging.

Second, while the spirit of the UK legislation is confined to anti-discrimination, the spirit of the US legislation is directed more broadly towards equality of opportunity. Its power has been reinforced by Executive Orders that require corporations which seek or have negotiated federal contracts (essentially all large employers) to set goals for the improvement of their employment of

women and ethnic minority workers. The progress of their plans is monitored by the Office of Federal Contract Compliance. Despite these good intentions, however, monitoring can be turned into a simple statistical exercise based on the proportions of workers with certain skills or characteristics in the population. Thus, if it can be shown that there are only, say, 2 per cent of women electronics engineers in the local population, it is incumbent upon a computer manufacturing company, for example, to ensure only that 2 per cent of its electronics engineer employees are female. Interpreting the law in this way obviously does very little to improve equality of opportunity.

On balance, the USA may appear to be more progressive in its support for anti-discrimination policies; certainly they have been incorporated into the legislation for longer. However, their effectiveness in the USA, as in the UK, is very much subject to the vagaries of local interpretation.

Terms and conditions of employment

Salary

Making rough comparisons at different stages of career and allowing for the international difference in cost of living, the American engineers in our sample were consistently higher paid than the British engineers by 25–40 per cent. However, because women are frequently coping with daily family responsibilities outside their paid employment, the clauses of their contracts which deal with items other than pay can be especially important to them. We have been surprised to find that, among our sample, the terms and conditions of employment for women engineers seem significantly less favourable in the USA than in the UK.

Hours of work

More of the American engineers than the British ones were contractually obliged to work an eight-hour day, excluding their lunch break. The norm seems to be for a forty-hour week in the USA and a thirty-seven-and-a-half-hour week in the UK, although

we found that most of the engineers in both countries frequently worked longer hours. Overtime was rarely paid, since engineers are regarded as professionals who will put in as much time as is required to complete a job. This is a mode of working with which many women find it hard to comply – those with children to collect from a nursery, for example.

Some of the British women benefit from a flexitime system. Instead of having fixed hours for being at work, they are able to choose to work their hours at any time between 7.00 or 8.00 a.m. and 6.00 p.m. They are required to be at work during the core times of 10.00 a.m. to 12.00 a.m. and 2.00 to 4.00 p.m., but they can come and go as they wish outside those times. The main requirement is to work a certain contracted number of hours per month. This system has the advantages of day-to-day flexibility and the opportunity to gain up to two days' extra paid holiday a month by working consistently longer hours on other days. We did not come across such a comprehensive scheme in America. There flextime simply allows an employee to choose her daily fixed hours of work from quite a narrow range. For example, Pearl, a highway engineer, chooses to work from 8.00 a.m. to 4.30 p.m. instead of her office's standard hours of 7.45 a.m. to 4.15 p.m.

Paid vacation

Noreen's job as an electrical engineer requires her to work from 8.00 a.m. to 5.00 p.m. with a half-hour lunch break. She more often starts her working day at 7.15 a.m. or 7.30 a.m. and is not paid for the overtime; she also works in her office an average of two Saturdays a month just to keep up with her workload. She gets two weeks paid vacation a year in addition to the usual paid public holidays.

Noreen, of course, is American. It is very unlikely that a British professional employee would be content to enter into a contract of employment that included so little paid vacation. Yet the American engineers frequently reported paid vacation which started at 10 or 15 days a year and rose by 5 days for every 5 years of service with the same employer. So Pauline, after working 25 years in one organisation, finally had 5 weeks' paid vacation and 11 days of paid public holidays. By contrast, most of the British engineers expected to be

paid for between 4 and 6 weeks' vacation in addition to approximately 10 public holidays a year.

This difference in vacation pay is not, in fact, a quirk among women engineers, but has been more generally recognised as a systematic and significant difference in employment practice between the USA and European countries (Green and Potepan, 1987).

Health care and sickness benefits

Everyone in Britain is entitled to free medical treatment and health care under the National Health Service (NHS); all workers make a statutory weekly National Insurance contribution towards its cost. This same payment also contributes towards sickness and maternity benefits, a proportion of the cost of dental care, unemployment benefits and various state allowances and pensions. The private health-care sector is growing, but since it is not yet possible for employees to opt out of paying their National Insurance contributions and basic NHS care is always available, the attraction of private health insurance schemes is limited. Some employers now offer company schemes in which they contribute to premiums paid on behalf of their employees to private health insurance companies such as the British United Provident Association (BUPA). However, this is still regarded very much as an extra benefit or perk which is attractive only to some employees.

In the USA, employers who offer schemes which reduce the cost of private health are offering a basic service to their staff. All health care is privatised, and being able to afford it is a fundamental advantage which those in work have over the unemployed.

We therefore found that very few British women in our sample were offered private health insurance cover through their employment, but that all of the American women were. Many companies offer a complex range of plans where, essentially, the more you contribute, the more benefits you are entitled to. Clearly, the best employers in this context are those who expect their employees to contribute least, bearing the bulk of their premiums themselves. Flexibility to suit a wide range of personal circumstances is also considered an advantage. In some companies vacation time, health care and other benefits may be packaged together. Lois, who works

for a satellite corporation described the menu system operated by her employer:

> you have so many credits to start with and I can choose, for instance, as little as two weeks' holiday or as much as six weeks. I happen to have chosen four, but that means I have fewer credits left if I want to, for instance, provide dental care for all my family, so it's simply a way of selecting overall from a variety of benefits. (*Lois*)

Whereas most British firms operate a statutory scheme of benefits in case of sickness (so many days paid without a medical certificate, so many certificated days on full pay less state benefits, so many days on half-pay less state benefits, and so on), American firms offer variable benefits. Most seem to make provision for so many paid sick days per 'paycheck', typically one or one-and-a-half per month, which can be accumulated but not exceeded without loss of pay. They also state very clearly how many paid 'personal' days an employee may have each year, to be used for doctor's appointments, coping with a family death or other approved purposes. In Britain such days may be available to be claimed formally, but their existence is rarely specified in a contract of employment; they are discretionary. More often employees are able to negotiate the time off individually or by custom and practice in each company or department. This leaves a degree of flexibility in the arrangements which, particularly in the case of family emergencies, can often be to the employee's advantage.

Maternity benefits

Here the differences between the USA and the UK are very striking. The 1975 Employment Protection Act provides British women with special employment protection for pregnancy and childbirth, with paid maternity leave and the right to job reinstatement. The usual provision, once a woman has fulfilled length-of-service eligibility conditions (slightly under two years), is for eleven weeks' leave before the birth and a minimum of seven weeks afterwards, during which a state benefit is paid. The minimum provision for paid leave is six weeks at 90 per cent of normal earnings, but many employers, particularly in the public sector,

operate more generous schemes. A woman may opt not to return to work until twenty-nine weeks after the birth and to have her job protected until then. Only very small employers and employees working a very small number of hours per week are excluded from this legislation.

In the USA there is no nationwide scheme to cover maternity rights. Pregnancy and childbirth are treated in the same way as sickness, rather than as a special condition of wellness. If a woman is healthy, she will typically work right up to the birth and will return as little as four weeks later, after the payment of sickness benefits through her insurance plan. Some states have employment protection legislation which relates to maternity rights, but others do not. For most of the women in our sample who had had children during their employment, the amount of leave that they took and the extent to which it was paid was established on the basis of personal negotiation between their immediate superiors and themselves. This made them particularly vulnerable to poor working relationships at a time when they were likely to be under extra pressure at work and at home. Since they do such specialised work, no one reported difficulties over reinstatement to the same post, but this situation would be quite different for women in lower grades. The USA is exceptional among industrialised countries in treating the maternity rights of its women workers so lightly.

None of the women engineers in either country mentioned paternity leave arrangements that had benefited their partners.

All in all, the view we formed very early in our programme of interviews was that women engineers (and probably all women workers) in permanent full-time employment in the UK experience far better contractual terms and conditions of service than their American counterparts. But perhaps this is a uniquely British viewpoint; it may be that American women, who are in general more highly paid, prefer the prevailing conditions of work and value their incomes over other benefits.

Conclusion

In this chapter we have given thumbnail sketches of the professional and economic contexts in which our study is set. We see our engineers as workers of high status with concomitant high earnings

and associated benefits. The British women have better employ-
ment conditions than the women in the USA, but both groups are
considerably better off than women in non-professional occupa-
tions. They are members of a profession which has been con-
solidating its status for the last 150 years. The profession is still
expanding, seeking to incorporate new specialisms and to increase
individual membership.

As we proceed we shall be referring frequently to factors such as
terms and conditions of employment and the position of women as a
minority sex within engineering. Our interest is in how they affect
the engineers' real-life experience inside and outside employment
which we, and they, describe in the next five chapters.

3

The daily round

In a recent book written as a guide to engineering for secondary school students, the author suggests that engineering consists of controlling nature, asking questions, designing, making things work, and communicating. As we shall see, each of these broad activities conceals a multitude of tasks in which engineers are involved every day. He also describes the process of engineering:

> Engineers are involved in providing material answers to real problems. Engineering does not start by knowing the answers but by attempting to fill the need. Identifying the problem comes first and is often the most difficult part; sorting out the constraints follows, and the art of engineering is in proposing and executing a solution which most closely fits those constraints. (Walton, 1987, p 6)

Although this is a neutral statement of a value-laden professional method, it does provide a framework for understanding what our interviewees do in their professional lives.

One of our concerns in writing about women engineers is to emphasise that engineering can be done, and done well, by women who also lead full lives outside their professional spheres. In dealing with our own mature students taking technology courses at the Open University, we often came across stereotypes of engineering as being for strong men only, or involving a close relationship with heavy, oily machinery. As our interviews show, in the 1980s very little engineering work is about dirty machines or even nuts and bolts. With the advent of new technologies, the work is increasingly desk-based or visual-display-unit-based. So neither distaste for

machines, nor lack of experience with hand tools, nor slight stature should deter someone from choosing engineering as a profession.

Within an engineering company, bland, concise job titles are often misleading. They conceal complex tasks and awesome responsibility. Pauline, for example, has the seemingly simple title of Program Manager, but when asked for a brief job description, it turned out to be as follows:

> We're looking at geoponics problems involved with siting a geological waste repository. . . . We're interested in what happens at a waste site if you put the waste in and, for whatever reason, the groundwater influx comes into the repository and, for some reason, dissolves the radio-nuclides and gets carried out into the media – making sure the repository will meet the regulations to retain the harmful effects of radiation. (*Pauline*)

Similarly, Tanya, with the plain job title of Civil Engineer in a large petrochemical company, described her job as folows:

> I'm responsible for the initial conception of a project, estimating length, getting a figure for the capital expenditure programme, and the detailed design of the project; then financial control. That includes, of course, going out to tender on various contracts. It is pretty complicated. (*Tanya*)

What the job descriptions still do not tell is what it is like to do the work in question. It is this experience that the interviews address. The women speaking here are in work-places, mainly offices, from which professional women have been notably absent, doing work normally reserved for men. They do it well and enjoy it, as their accounts clearly reveal.

The texture of work

Our interviews began, inevitably, with short questions to gather information about each woman's personal details: her age, qualifications and family or other responsibilities. A similar set of questions enquired into the specific conditions of her employment: job title, industry, brief job description, salary, hours worked, entitlement to paid leave and other benefits. Usually, all this took only five to ten minutes, during which the intrusive tape recorder

was partially forgotten, but the relationship between interviewer and interviewee remained a formal one. To relax the atmosphere and to lead away from the quantitative aspects of working life into the qualitative, we then asked each woman to describe the typical working day from the time she gets up in the morning to the time she goes to bed at night. We wanted to know how she sees the structure and content of her day, and to get a feel for the range of tasks she undertakes both at home and at work.

The initial response from almost everyone was vigorous denial that they had a 'typical' day, followed by an absorbing description of the pattern which most of their days take.

I get up on time and I sort of do my chores around here, watering the garden, feeding the animals, taking the dogs for a walk, have breakfast, cup of coffee with the paper, get in the car and go to work. And then it's . . . the day is usually filled with working on, say, two or three projects and I guess there's usually a starting point with each one. Like I usually develop questions to answer by the end of that day. And then depending probably on whether I get stymied – you know, if things don't go the way I'd expected – I'd end up spending more or less time on each one. Probably answering a few phone calls which, you know, would be off in another direction. Yes, that really takes me through my day.

Wednesdays there's our weekly staff meeting, which takes up a good part of the morning. One of my other tasks is picking up data from the National Weather Service, so I'll have to go to their locations straight from home twice a month to pick up their data on precipitation. And then the other thing that I do is go to M–city quite a bit because I'm still working on transferring the models that I did for my dissertation which have applications here to the computers at work. Actually, what I'm doing at the moment is running them there. Since they're up and running and we want answers to particular problems, it seems a better idea to do that instead of getting involved in the debugging problems that will arise when we try to move them. Well, I spend a day a week actually in M–city and probably another half-day a week out of the office for something else.

[When I'm in the office] discussion with others is pretty important. I'd say maybe two or three hours a day spent in discussions. You know, just sort of really quick comments, first the question and then the answer, and then you'd do work on your own and then something else would crop up.

I spend a bit of time actually at my desk working out what it is I'm gonna be putting into the terminal. There is one in the office to be shared between two people, so, often, one of us is getting up and running into the spare terminal in the computer room because, you know, we both need to be dealing with the computer quite a bit.

I drive home; that takes about twenty minutes. And then there's

walking the dog and go running and eat dinner and sometimes go to the movies. A lot of my social activity is still in M–city, so often I'll go up there in the evenings or the weekends. Reading, knitting, watching a little television, but not much. [My day usually ends] about 11.30 p.m., something like that. (*Frances*)

As a water resources systems engineer, Frances spends her day at work mainly in technical activity, developing and running computer simulations of mathematical models used to forecast water availability and demand in and around a vast river basin. Since she lives alone she can determine how to use her time at home to suit herself; some of it is filled with leisure activities. Veronica, a civil and structural engineer, also has a technical day at work. She spends long hours in the office, but her time at home is structured by the requirements of childcare. Amazingly, she finds herself refreshed by playing with her son in the evenings, and she can continue by tackling work left undone earlier in the day!

This will have to relate to when there was only one child. I get up at about quarter to seven and get washed, dressed, have breakfast with my husband. If our eldest son is awake then he may come down and have breakfast with us. We have a live-in nanny and she is technically on duty from the time we leave the house. It doesn't mean that she has to be up, but she is responsible, so if our son isn't up, she may not be either. She knows that she has to get up and deal with him when he does wake. If he is up then we will give him to her as we leave, and we try to leave the house by about twenty to eight. My husband takes the car into the city and he drops me off on the way. I'm normally in the office, I suppose, between about half past eight and quarter to nine.

I'll probably spend the first bit of the day tidying up odds and ends, going through notes I've left from the previous day reminding me of what I have to do. And then I'll get on with whatever project work is required. Maybe a project meeting, which will perhaps be with a full team of consultants, perhaps just with the architects at an early stage of a project, to discuss various details of the building. There would probably be correspondence to deal with, there will be other people to talk to within the group to make sure that they have work to do, [to look at] what they're doing. There would probably be a discussion at some stage, depending on the point in the project, with the draughting team, making sure that the drawings are being progressed. The post normally comes into the office at about eleven/eleven-thirty and at that stage there may be more letters to respond to, minutes of meetings to read and check, and particularly more drawings to attend to, drawings from the architects and drawings from the other engineering consultants. And this may require telephone calls, perhaps a brief meeting to discuss what's come in and

perhaps some further work on our own drawings in consequence. There might be some calculations, work on the computer, possibly putting something into the computer with the results expected back later in the day.

Lunch is officially from 12.30 till 1.30; that tends to be a slightly moveable feast. I might go a bit late. I might have only about ten minutes – you know, I might just pop out to buy a sandwich and take it back to my desk and press on.

And that pattern really will continue during the day. If there's a project that's on site, at some point there may be a visit to site; there might be a meeting actually on site to discuss the progress of the job, problems that are coming up. Discussions with our own resident engineer on the site make sure that he or she is happy with what's going on and resolve any particular problem which he or she may have . . . We don't tend to travel terribly far because [the firm has] a large network of regional offices . . .

I normally leave by about six or six-fifteen or later. Particularly since I've had children, I do try to get home by about seven o'clock. I come back on the train. [My husband's] always much later than I am. Then I'll probably have a word with the nanny and see what's been going on during the day, if there are any particular problems. We might sit down and have a bit of a natter and a cup of tea. Then I'll look after the child (I suppose now it'll be children) until he goes to bed, which is around eight or eight-thirty. In the early days when I went back to the office I was still feeding him, so in particular then I would try to get home in reasonable time so I could feed him and get him settled down in bed. But now he's older obviously, running around, I just play with him for an hour or two and it's very relaxing. I find that I can leave the office absolutely drained, play with James for an hour or two, put him to bed and then, feeling in much better spirits, I can get on with some more work. I mean, if needs be, I will bring work home and reckon to do it much later in the evening rather than staying in the office for hours and hours.

[My husband gets home] anywhere between about eight and midnight, but hopefully somewhere around nine o'clock. [I sit down and eat with him] unless he's going to be ridiculously late, in which case he rings me and says that I should get on and eat on my own . . . At the moment [we go to bed] quite late because we're trying to spin out the late-night feeds, probably around eleven, eleven-thirty. (*Veronica*)

From both these accounts it is clear that being an engineer requires good verbal and written communications skills. They talk with colleagues in person and on the telephone, write and evaluate reports, and attend meetings both inside and outside their organisations. They also require the technical expertise relevant to a particular branch of engineering. Frances uses a computer system and her knowledge of simulation programming to construct, run and interpret her models of the river basin. She must first define the

problem implicit in her client's questions and decide which para-
meters are relevant. Veronica uses her knowledge of structures and
project control to liaise with architects and other engineering
consultants. Her skills in reading technical drawings and making
structural calculations enable her to assess the accuracy and
applicability of the plans they are submitting to her. She must also
be prepared to make rapid assessments of work in progress on site in
order to be able to offer practical solutions to immediate problems.

Both engineers plan their own work. Its execution involves
social, managerial and, in Veronica's case, supervisory roles which
integrate the skills they use on a daily basis.

The working day is not composed of a single, sustained activity,
but of a variety of tasks which overlap and jostle for priority. Zena,
a process engineer, characterises her day:

> It's like a hurricane! It's hard to say. A lot of times the day goes because
> of emergencies that have come up and you have to deal with them right
> away. (*Zena*)

Frances, Veronica and Zena are all very close to the technical detail
of their engineering work. We found that the women who had
moved towards engineering management positions had an even
wider variety of tasks to fit in during the day. Victoria, a
measurement and control technologist, is Control Section Head at a
pharmaceutical plant. She describes the responsibilities of her job:

> Well, I have a section here which consists, at the moment, of four
> engineers, graduate and chartered, and at present we have three trainees
> as well. I have a workshop with a supervisor and three technicians and my
> own secretary. My job funciton is obviously controlling their work and
> delegating work to them, scheduling their day and maintaining a watch
> over what they do to make sure it reaches [company] standard. At the
> moment I'm also handling project work as well, which is not what I
> should be doing, but we're not staffed up to cope with that work as well,
> so I also handle project work on the control and instrumentation side.
> (*Victoria*)

Victoria has a managerial role in project development and control
and in the direct supervision of the work of five other people. Jane, in
a management job which she had only just begun, compared the
work with the research work in her last post:

The job description is to assist [a director] in managing, planning and formulating the long-term strategy for all the programmes he is responsible for, and basically, at [the institute], that is the programmes that fall within the nuclear power research area. There are a number of areas at [the institute] with directors; there are five directors and they take different areas. His area, the nuclear power research, is the biggest one. I directly assist him in that and then I will liaise with other directors and their assistants as appropriate. Where their work interfaces I also have a role to play in formulating what we call our medium-term corporate plan, which is the five to ten year corporate plan . . .

At the moment, it is primarily seeing people. I'd envisage in the long run with this job dividing up sort of – say, a fair balance between actually going to see people, primarily the programme managers who deal with the individual area and directors, and then I would also have a certain amount of desk work. That contrasts very strongly with what I have been doing whilst I was doing research, where I would essentially have an actual experimental objective for the day and a certain number of hours to put in under the microscope or with a piece of equipment. If I wasn't doing experimental work then I would have been sitting either mulling over results, dealing with results, or writing reports. (*Jane*)

Jane seems to be describing her role as that of an extremely high-powered personal assistant who acts as a gate-keeper and channel of communication for her boss. However, she could not carry this out successfully without the experience she had already gained in her three previous technical posts in the same organisation.

Lois gave a precise account of her very varied day as a senior executive in broadcasting communications. She spends the early part of the day listening to a radio station for which she used to work and reading the business section of the leading daily newspapers to keep herself up to date with financial affairs, an essential requirement of her job.

The first thing I do is bring my calendar up to date, look at what appointments I have, perhaps get some correspondence out of the way, dictate or give drafts to my secretary. There are quite often meetings in here in the mornings, staff meetings or personal meetings of one sort or another. Or if I have people coming in I usually schedule them in the morning, which is a little better time of the day to meet people I've discovered; it leads one to keep the appointments.

Usually I have at least one long-range research project going. That might be an investigation of a new video opportunity or it might be a review of some other research. Right now we're working on a project that involves a proposal from an outside company, and I'm evaluating

whether the numbers in that are real . . ., because this is a question of our having to decide if we want to invest in this other company or get ourselves into the business. I might work with corporate development staff on that or do some work on my own, and then share that work with them and have a meeting.

Probably four days out of five I would have lunch with a client or someone from another company with whom we're co-operating, or someone from a government agency with whom we might be doing work. The fifth day I would have lunch by myself or just skip lunch altogether and do errands, that kind of thing. The business being located in a downtown area, that's a convenient time to get things done, but probably four days out of five I'm actually with someone else.

In the afternoon, if I have any writing to do that's usually when I try to get my thoughts in order, then I'd be writing a research report or a more lengthy letter. I'm on several outside boards and organisations, and those, if they're here locally, generally tend to have afternoon meetings, so I might be away for two or three hours to meet with a board or a committee of that board. Or I might go and see a company here that we're planning to do business with. If I leave on a trip it would usually be in the afternoon. And then again see the staff here, internally; it's a company that operates a lot on personal meetings, so there's a good deal of activity within the building.

Generally at the end of the day I would catch up on any urgent correspondence, finish phone calls, especially to the West coast where there's a time difference, which is one reason that I'm often here till after closing time. And then I decide if I want to take work home, which is usually if I want to read. I very seldom read professional journals in the office here because there simply isn't time, so I take some newsletters, magazines, whatever's come in that I'd like to get read, home with me. (*Lois*)

Here Lois is describing her role as policy-maker for her company. She is responsible for making financial decisions on their investment in new technology and for liaising with executives with a similar level of responsibility in client organisations. She is the most senior of all women in our sample, and her post carried the highest salary. The rest of her life is also pervaded by her work:

And when I get home, I fix dinner, watch probably an hour of news on television, do whatever reading I have, make personal phone calls. Because I have some outside board service there's a certain amount of time that I have to devote to reading reports, evaluating things that I have to do for outside boards. I do play several instruments and I've been active in the theatre . . . Weekends in summer are generally devoted to sailing. I have a friend and we have a boat together, so I'm generally with him on the boat. Winter weekends are a little bit more flexible. I might go

to a museum or concert or take a short trip out of town. A lot of reading sandwiched in between, just to keep up with the field, that't the one thing I never have enough time for. I consider it part of the job. I mean I would certainly have the interest . . ., but I select what I do because of the job. (*Lois*)

It is worth noting that although Lois is in a senior position in her company and has a management role, there are usually some other alternatives to management for senior employees in an engineering environment. We shall explore the question of career progression more fully in Chapter 8.

Circumscribing the options

The enthusiasm with which the women described their work, and the accounts of the almost superhuman efforts they make to fit even more work into the day, show us how much satisfaction and enjoyment they derive from their work. Claire, a control engineer, expresses her pleasure in variety:

the beauty of it is that no two days are the same. There's always things happening. I can get a phone call first thing in the morning to, say, put together a price for this piece of engineering, so I leave what I was going to do, go off at a tangent and do something totally different. So, you know, it never settles down and gets dull, which is good. It keeps you on your toes. (*Claire*)

She, like all these engineers, finds the variety stimulating. But most of them also have to find ways of preventing such varied, exciting work from taking them over completely. They need to create space among the activity for reflective work and to find time to maintain their relationships and responsibilities outside work. This leads them to look for strategies which allow them to prioritise some activities over others, to select some options and reject others.

Reflection

We were told many times about the difficulty of fitting in reflective work, a common problem for people working in a busy environment. Zena's day begins unusually early, as she chooses to do any

work she takes home with her in the morning rather than the evening.

> About half the time I get up early. That means sometime between 4.00 a.m. and 6.00 a.m. And I try to get some work done before I go to work. You know, some quiet writing or planning or whatever. And I might do that for an hour. I don't do it every day, but I try to, so let's say on average I would do an hour a·day. I usually leave for work around seven-thirty, so I arrive around eight, eight-fifteen, somewhere in there. (*Zena*)

The early morning period of reflection provides, for Zena, a much needed antidote to the hectic nature of her day at the plant. She has developed a coping strategy, albeit one which involves working extra hours. Meg, an aeronautical engineer with a similarly overpacked day, finds that, as she gets older, it becomes increasingly difficult to tolerate the busy office environment for longer than she needs to. She has developed a slightly different coping strategy which involves returning to work at night when it is quieter.

> This never would have happened to me when I was younger, but occasionally now I feel that I just have to get out of the building. And while it would be more practical, perhaps, to try to stay another hour and finish something off, I just can't do it, so I throw it into my briefcase and bring it home. But I find that when I try to do that I sometimes don't get the briefcase open. I guess by the time I've made dinner, I'm so tired I don't bother. The most practical way is for me to return – go home and have dinner and go back to work, even though it's at least a 20-minute drive . . . But sometimes that works, because being in an office atmosphere I think I can put my mind to getting back to work. (*Meg*)

Travel

Women who were feeling pressured by their dual commitment to work and to family life looked for aspects of their work which they could cut. Abigail, for example, opted out of business travel.

> I do not travel. There was a time when I travelled an awful lot. And loved it. I do love to travel, but I don't do it now unless it's extremely crucial or it's a desirable location which I haven't visited. I choose my assignments to suit myself; I obviate the need to travel. It takes a lot of planning. It took a lot of finagling to be able to do it. (*Abigail*)

Ella, on the other hand, was much less successful in reducing this part of her work:

> Just last week I was travelling all week and I had an option, I thought I had an option, to cut out one day of travelling. And I ventured to bring that up in a phone conversation and [my boss] was pretty sure to say that it would certainly be best for the company if I didn't come home, if I went on the extra day. I guess that was predictable. I shouldn't even have brought it up, I should have just come home, but . . . something in me was looking for some approval or support that said: 'That's OK, you can come home.' But I didn't get it, so I stayed. (*Ella*)

She lacked the confidence to assert her own personal priorities over those of her company. However, although it may appear from what they say here that Abigail, a 38 year old environmental engineer, is more experienced and self-assured in running her life than Ella, a geotechnical engineer aged 28, increased maturity may not be the only explanation for their differences in handling the problem of travel.

Abigail works in the public sector, while Ella works for a small, but rapidly expanding private firm. In examining our data, we discerned increasingly a tendency for the engineers employed by private companies to experience more pressure generated by their employers in their work. They worked longer hours, were required to handle more projects, travelled more and were more likely to take work home and feel obliged to do it, than were the engineers employed in the public sector. So the different approaches which Abigail and Ella take to their business travel may simply typify the responses of engineers in the two sectors to the different demands placed upon them by their employers.

Working at home

The women also had to limit the demands of their work by taking it home as rarely as possible. Victoria avoids weekend work 'like the plague'. Claire used to take work home but didn't do it unless the alternative was working in the office on Saturdays. Anne, a senior academic engineer, is emphatic about her preference:

> I try not to [take work home with me]. That unfortunately doesn't work. Very often we have special reports to get out, and I find that, much as I

would like to do it in the office, it's just too interrupted here, so I will take home some work then. I really try not to. I find that I really want to be able to spend time with my husband and the evening is really all we have. I feel imposed upon when I have to take work home. I will do it on occasion, but I really try not to. (*Anne*)

In Chapters 6 and 7 we explore in detail the interesting issue of women engineers erecting and attempting to maintain clear boundaries between their working and family lives.

Family responsibilities

Despite the stimulating atmosphere of work, the cares of family responsibility rather than the enjoyment of work were sometimes foremost when we asked for a description of the day. Although Abigail later fleshed out the detail of her paid work, her initial response was to describe her unpaid work:

I have no typical day, but let me tell you about the things I must do each day. My husband is a banker with a very demanding schedule. My days begin with getting the kids off to school, then I take off down here. I get here at about ten past nine; I stay until five. Then I go home and see about the dinner and homework, baseball in summer and basketball in winter, that continues cyclically, and that's about it. (*Abigail*)

Childcare arrangements force working women to limit their work commitments, even where a live-in nanny is on hand, a situation which Veronica has already described. When Dora's children were small and her nanny was ill, she occasionally took them to work with her.

I never said anything, I just did it. I never asked permission. (*Dora*)

Julia takes her son to a childminder. Their schedule works well most of the time, but poses problems when he is ill enough to need to stay at home:

Mainly because we live closer to my work than my husband's work it's more convenient for me to take Wilson to the doctor and to stay home and go back in the evenings and work. But I guess we sometimes need to work a fifty or sixty-hour week and that might be a problem. Fortunately,

with the type of work I've done lately it's possible to duplicate the hardware at home with the personal computer . . . and I can work at home and watch out for the baby and have time to be with my husband. (*Julia*)

Luckily, Julia's company permits this flexible working practice, but many other employers would not sanction it. Working mothers are faced with such difficulties even when the children are old enough to go to school. If the parent leaves home earlier than the child leaves for school and gets home later, bridging arrangements with childminders, friends or neighbours are needed. Illness on either side calls for special fall-back care which may have to be done by a working woman, taking the time off work from her holiday entitlement.

Even apparently straightforward school–parent communications can be problematic:

And, of course, when they were in school the problem I had was you had to take annual leave just to go down there for discussion with the principal. He'd just act like you had all the time in the world and you might spend an hour or two waiting. (*Dora*)

Many readers who are parents will recognise the situations we are describing. We are not suggesting they are unique to women engineers. We know that they are common to all women who do paid work outside the home and also shoulder the burden of childcare. Even among dual-career couples it is more often the woman who takes the larger share of this responsibility. However, for the women engineers we interviewed we felt that, though taken on willingly, the burden could make the pressures of working long hours almost intolerable. We very much admired their energy and power of survival.

Relating to partners

Yet another problem arises for couples with or without children, whose lives are so busy at work and outside it that they only pass on the stairs. They rarely have time to talk or relax together and can become strangers living in the same house. It can take a while for a

couple to recognise that this situation exists and even longer to learn how to improve it. Some of the women we interviewed talked rather vaguely about needing time to be with their husbands; we assumed that, for them, the need had not yet become problematic. Others had developed strategies to earmark the time and to ensure that it was not encroached upon.

> I'm usually out two nights a week and I have a rule not to be out more than that. If my husband is going to be out two nights himself, then we try to cut it down a bit, otherwise we'd never see each other.
>
> Sundays [are] the only day we usually get together because we work Saturdays. Most Sundays, actually, we come into town and we go and see a film, go and see an exhibition, both of these things, and probably have a meal out. (*Lucy*)

> Friday evening is our evening off together and we try and preserve that absolutely – sort of sanctified. Otherwise in this sort of situation where Philip is out every evening during the week and at the weekends, Saturday night and all day Sunday, you know, you'd just end up never spending any time together. So we really decided when we got married that we would stick to Friday nights, always having that either with our friends or going out together on our own. (*Jane*)

Summary

We have used the words of our interviewees to demonstrate that their work, engineering, is a complex mix of technical and managerial tasks. They include office, laboratory and site work, designing, draughting, report writing, computing, supervising, attending meetings, internal liaison, client presentations, modelling, planning, testing, experimenting, forecasting and budgeting and decision-making. These combine into demanding professional roles. Knowing how to balance the tasks and how to order them in itself requires skill and experience and could be called an art.

We have also seen how each woman's day could be extended indefinitely and filled with even more of these tasks, how she needs to limit her options at work to allow herself time at home, how time for family commitments vies with time for work. The skills she requires to maintain her own sanity and her professional and personal relationships make considerable psychological demands

on her. She needs to develop strategies to cope with apparently limitless and competing responsibilitiess.

In this chapter we have focused on personal solutions to these problems. Chapters 6 to 9 look in more detail at how other people affect, and are in turn affected by, the working lives of women engineers. Later, in Chapter 10, we shall deal with existing and potential strategies which develop social solutions for coping with the relentlessness of their daily round.

4

The critical step

After hearing about the personal satisfaction the women in our sample gained from their work, we might have been forgiven for accepting one person's view of their choice:

> All the girls that I've met haven't drifted into engineering; they are there because they believe in it. (*Jennifer*)

In fact, we were surprised by the haphazard nature of the decision-making process and its generally serendipitous outcome.

In our interviews we probed the way in which the women had taken the critical step to opt for engineering. We asked them about their adolescent ambitions and the process leading up to the point where they were following a definite path into the profession. Because we knew that girls who make non-traditional choices of any kind lay themselves open to criticism and are quickly forced to defend themselves, we had expected to find among our sample a very high level of commitment to engineering from an early age. It turned out that reality displayed a wider range of behaviour than we had hypothesised.

Influences at home

Family culture, upbringing and expectations all played a part in the critical step, sometimes complementing what took place at school, sometimes opposing it, sometimes offering the young women encouragement in the face of school hostility towards a non-traditional decision

Angela's practical background and her leanings to maths and science led her to consider engineering. Her school 'looked a bit askance' but was helpful, and she says of her family:

> Oh yes, they were encouraging. My father was a farmer and I think that probably helped because I worked on the farm quite a lot. But there was never any 'girls don't do this' attitude. I don't think they were very surprised when I said I was going to do engineering. (*Angela*)

Whereas Angela's family was accepting and comfortable with her decision, Abigail's thrust her into the outside world in a competitive, combative spirit which limited her options another way:

> I'm from a very large family, we're eight kids in my family of whom I'm the youngest. My siblings are all professional people, it was natural. My mother was the kind of person who pushed you beyond your own bounds. In our house there was no room for second best. There were no choices about how you did at school. Find someplace else to live if you want to be mediocre, not in our house. Second best was unacceptable. (*Abigail*)

Abigail's mother was central to her success, and her older siblings provided role models. Other women also spoke of the role played by mother, father, sister, grandparent, boyfriend or family friend in their decision to become an engineer.

Fathers

Some studies of women engineers have seen the influence of an engineer father as crucial, but they also show that female friends and male engineers are equally likely to have an engineer father too. As Peggy Newton (1987) discusses, it seems that their influence is indirect, but that professional families are more likely to support a daughter's non-traditional career choice. Our sample confirms this suggestion.

One in three of the American engineers, but only one in seven of the British ones, had a father who was an engineer. Although we perceived these fathers as providing strong positive role models, their daughters tended to see their father's profession as just one factor among the many that they considered. Frances, for example,

mentioned almost in passing that her father is a mechanical engineer, explaining:

> So I think it was just sort of a gradual decision; you know it's hard to put a point on when that decision was made. I was just sort of leaning toward the areas that I'd done well in at school and they were relevant, you know, and the fact that I'd enjoyed studying those areas. (*Frances*)

But her understanding of the relevance of her good high school subjects to engineering and her knowledge about the profession both came, of course, from her father.

Elaine was introduced to mechanics as a child while helping her mechanical engineer father with his hobby:

> He was a clock collector . . . To see what was inside these old clocks, all these little gears and everything, and why did it work, who invented that, you know, what else is there [fascinated me]. Just the whole bit. I enjoyed working with him and I think he really wanted someone else, other than the two boys, to go into professional fields – one of the girls, and none of them had yet, so that really spurred me into it. If I saw him doing something around the house I'd get involved, learning what all the tools were and everything, but we had a good time of it too (*Elaine*)

Later, the process of immersing herself further in a familiar world took a more theoretical turn:

> My father taught at the university. I used to attend his classes when I was in high school and that was very, very beneficial. I'd read the literature that came into the house for him and just a lot of reading on my own too. (*Elaine*)

Zena's father, an electrical engineer, had gone to a prestigious technical university and it was her wish to follow him that drew her, eventually, into engineering:

> I had known about [the university] my whole life. My father went there. And I don't even remember when I decided I was going to go there; it was from very early I wanted to do that. It was just a matter of getting in . . . I liked chemistry a lot in high school; I had a really good chemistry teacher and he was . . . he had worked for the FBI in forensic chemistry and he had a lot of exciting stories. And I've always like problem-solving, puzzles of that sort. I'm not really sure why I wanted to be a doctor; that kind of popped up in the last year of school. Oh, I know! I took advanced

biology and I liked chemistry a lot so I was kind of thinking in terms of, you know, maybe biochemistry or artificial organs. I don't know, there was just a bunch of things like that. When I actually got to [the university], a lot of the artificial organ work was going on in the chemical engineering department. And that also seemed to be a good place to train if I were going to go to medical school. So that's kind of how I ended up in chemical engineering. (*Zena*)

Two or three of the women had actually had engineering specifically suggested to them by an engineer father, but the way that they relate their stories indicates that the fathers had exercised discretion, and had not mentioned their own professions until their daughters presented skills and inclinations which might lead them in that direction anyway. Their tacit influence is, of course, immeasurable, and their interests may have provided an environment where these skills and inclinations could flourish in childhood, while others withered and died.

I wanted to be a civil engineer from when I was fourteen because I liked the sound of it (*laughter*) . . . When I was in primary school I wanted to be a domestic science teacher because I liked cooking. And the other girls didn't seem to be any good at cooking. I always had an eye for the main chance and what other people couldn't do, I thought, 'Ah, I'll do that' . . . Then I realised that in fact cooking wasn't that difficult and other people could do it. And I found quite a lot of people did have problems with maths, so I thought, 'I'll use my maths.'
 . . . we did some plans and elevations, I mean it isn't even technical drawing, it's just, you know, given a matchbox you had to draw a plan and an elevation . . . I thought it was wonderful, I really enjoyed it. And it made me think of sort of technical drawing and of architecture, but then I thought architects have to be quite good at art and I'm not . . . So I was talking about this to my parents and my father's an engineer and he said, you know rather jokingly, he admits it was a bit of a joke, he said, 'Oh, it sounds as though what you want to be is a civil engineer'. So I pricked up my ears and said, 'What's a civil engineer?' and he told me. I said: 'Well, how do I go about finding out about civil engineering?', so he said, 'Write to the Institution', and he arranged for me to go an visit this professor . . . and chat about what civil engineering was like.
 . . . this all took a while and I was about in the fifth form by then, so I was actually beginning to think about university and that sort of thing. But you know as soon as he said it I thought, 'Gosh, that sounds really interesting, it's building bridges.' I've always loved building. I mean I had building sets when I was little, so it was just right. (*Eileen*)

Mothers

Before the present generation there were almost no women engineers, so it was to be expected that none of our sample had mothers who were engineers. Suzanne, however, identified her mother as an engineer *manquée*:

> My father is an engineer and my mother is not – she's a housewife – and of course I was exposed to engineering projects when I was a child. Always on vacation he found one to take us to, much against our will at that point. But it was actually my mother who suggested that I consider engineering, and I think maybe if she'd been born thirty years later she might have been an engineer, because she's very practically minded and she likes things like that. So I decided that it probably made sense to choose a programme like that and that's why I'm into engineering. (*Suzanne*)

Several of the young women were faced with fathers who felt that engineering was not quite what they wished for their daughters. Two more were spurred into it through outright rebellion against their mothers' ideas, with more than a touch of stubbornness.

> Well, I was a little unsure during high school what I wanted to do. I decided I would major in math or be a commercial artist or be a veterinarian or try engineering. And I never really got along that well with my mother during my teenage years. Anything that displeased her I did. And she just couldn't imagine a woman being an engineer. She told my father: 'If we don't say anything, she's gonna change her mind.' I shouldn't have heard it! And I was very nervous about it because there weren't a lot of women who had done it. And I started [college] in June of '64 and I decided, 'Well, I can't let her say "I told you so".' So I started freshman engineering for the summer; that summer I said, 'I'll do it for the summer, just to prove it to her, then I'll change my major to math.' And I got in it, I really liked it . . . I stuck with it after the summer. (*Pearl*)

> At the time I was deciding on my career my mother was pushing very, very hard to talk me into becoming a high school teacher. At the time, careers for women were really very limited . . . I mean the object of college was you became educated, preferably in the liberal arts, to become the sort of woman that some doctor wants to marry. And that's generally the way it worked. My mother, because she came from really a refugee background, with enormous upheaval of her own life during World War II – you know, transition years – felt very strongly that it's

important for women to be able to support themselves. And that's something at which I would be able to support myself no matter what happened in life. She pushed the teaching very hard. I was good at math and science, I was also good in things like English literature and history and that kind of thing. But I always found math and science a little more difficult and I like a challenge . . . so it was obvious to her that I should be a math or science teacher.

And I think really as a form of rebellion, I didn't want to do it. The boys who were in school with me at the time who were interested in math and science talked in terms of engineering. I didn't even know what engineering was or what engineers did. So I said: 'Fine, why not?' The first time I said it everyone went crazy. 'Oh my God, you're out of your mind. People are going to think you're queer. What's wrong with you?' As soon as I heard that – 'I'm gonna be an engineer, I'll show them.' And from such a ridiculous kind of reasoning – you know, from rebelllion really – I decided to become an engineer. It's a rotten way to make a career choice. (*Anne*)

It was as though these women were flexing the muscle of their independence. They used the critical step of opting for engineering as a different turning point which enabled them to break away from their mothers' influence and to establish themselves as independent adults.

Brothers

Older brothers were cited several times as sources of inspiration and support. The positive role models which they provided were identified more clearly and acknowledged more openly than that offered by fathers.

He taught me algebra. I had chicken pox when I was in fifth grade and by then we had word problems, and Mother said to [him], 'I don't care what you do, just get her off my hands.' Because I wasn't very ill but I couldn't go out because of the quarantine. So he sat down and said, 'Hey, Dora, you know those word problems that you got last week. I'll show you how to write in symbols. You know, they're really all the same problems.' And he showed me how to write x and how to write equations and then he went on, he taught me to factor them in two weeks . . .

And he was very much interested in physics. He went to [the local prestigious university] and the fellows used to come over to our house to study and then Mother would feed them cinnamon buns and coffee, and I used to sit around under the dining room table and they would discuss

problems and they didn't pay any attention to me because I was invisible, I was the kid sister, but I was listening . . . He was the sort of role model. He went to [the local prestigious university] and I wanted to go [there] too, but they wouldn't admit women so I had to go to [another high-ranking university] which was 700 miles away. (*Dora*)

Dora studied physics and maths and followed her brother's interest in astronomy and astrophysics as far as one of her early jobs in an observatory. It was only then that she discovered that the work did not suit her and she moved towards applied physics and acoustic engineering.

Rebecca's brother was a pilot. She enjoyed sharing his interests and he encouraged her in her selection of an aeronautical engineering course, supporting her alongside their mother in the face of opposition from their father, who thought that education was wasted on a woman, whom she was determined to prove wrong. Veronica's brother was just one of many family influences:

I was reading some university prospectuses that my brother had. I read about engineering courses and I thought they seemed like a reasonable blend of the things I was interested in.
 . . . although my father was a chemical engineer, he in fact moved into management on the technical side when I was very young, so there wasn't a sort of strong engineering flavour in the household. But I had a godfather who was a director of [a large civil engineering firm] and various friends of my parents were involved in engineering, either on the contracting or on the consultancy side. (*Veronica*)

Significant others

A few of the British women in our sample talked about the influence of their boyfriends. Victoria applied to go to the same university as her boyfriend, which also allowed her to stay near home and offered her the kind of sandwich course she wanted in electrical and electronic engineering,

because I was, believe it or not, an extremely shy and immature young girl. About a year into my degree I regretted it all and wanted to be miles away from home and on a campus having lots of fun. (*Victoria*)

As none of the American engineers spoke of the influence of their

boyfriends, we wonder whether male friends and relations played a particularly significant role in providing information about engineering for women who went to single-sex schools, as this subset of the British engineers had.

Claire and Eileen both mentioned being encouraged to be independent by their families. Claire's grandmother, with whom she spent her early childhood, 'knew where she was going and what she wanted out of life'. Eileen's older sisters had careers and her mother was a maths teacher, providing for her strong, independent female role models in addition to her father's influence as an engineer.

Influences at school

Most of the women had not thought about engineering until some time in the two years before they left school and went on to university. For the Americans, this period was marked by their selection of a combination of high school classes to form a college preparatory programme. The British women had spent that period in a more specialised study of three, or at most four, A level subjects. The majority of both groups knew by this time that they were academically successful and destined for higher education, but they had not necessarily decided on a future in engineering.

> I had a very strong background in physics, chemistry, trigonometry and geometry. That was the college preparatory class. I wasn't really sure about being an engineer right away. But I graduated with honors from high school; I was in the top 20 per cent of my class. I knew I was going to college, but I just wasn't quite sure what. And it took me quite a long time, well a whole summer, to decide. There was a local college near where my parents lived. They had a really good engineering curriculum and I decided that I would go and try it and see how I did. (*Noreen*)

Sometimes informal advice or encouragement was proffered by enthusiastic teachers operating purely in their individual capacity rather than as part of any advisory structure.

> I'd always been mathematically very gifted, right from very early at junior school. And in the first year at secondary school I started to have a definite sort of feeling of finding science very attractive and interesting.

> The really crucial period came in the third year when I had a very
> enthusiastic physics teacher who teased me because I asked a lot of
> questions; it was a very friendly sort of teasing. The more he did that, the
> more I actually enjoyed asking questions and also the feeling of being
> different, because there were few girls who found science interesting . . .
> And he encouraged me, this teacher, very much to read and to think,
> although I don't think he was a brilliant physicist by any means, he was
> actually a biologist. But he had this capacity to take a question and say:
> 'Well, yes, you're right. That is a good question', and either he'd find out
> a bit more for me or tell me where to go. (*Jane*)

Jane responded positively to being teased and enjoyed feeling
different, whereas many girls would have experienced this kind of
treatment as marking them out unnecessarily and would have found
it discouraging.

For some of the women, the pursuit of a university place in
engineering led into a year of technical drawing before they left
school. But for others, the reverse was true: it was technical drawing
which attracted them into engineering.

> The high school that I was involved with was a vocational technical
> school, and I was enrolled in my shop area, which was in addition to the
> regular high school [classes]. I was involved with commercial art and I
> took a year of drafting in my senior year and that's when I really decided
> to go into mechanical engineering. (*Elaine*)

Interestingly, although engineering sounds highly specialised to the
layperson, at school some of the women had perceived it as a
broader alternative to a more academic or theoretical discipline
such as pure mathematics or physics, for which they feared they did
not have the intellectual ability. Studies on groups of young people
of this age have shown that boys are much less likely than girls to be
afflicted with such a lack of confidence. Other women saw
engineering as offering a career alternative to becoming a teacher in
science or mathematics. Margaret's account of her attempts to
make a career choice combines both these elements:

> At fourteen it was the first time I started thinking about careers. My
> sister-in-law was a secretary and I thought this would be great. I could
> imagine myself sat at a typewriter. This was my idea of what a good
> career would be. Fortunately, my teachers persuaded my parents that I
> shouldn't go into a secretarial course, that I should continue doing
> science and maths, so I went for the science course at school.

The next step was then A levels – maths, physics, geography and art – a mix really, science and art. The next point that made me think about something more unusual was in the lower sixth. The [local] dockyards opened their apprenticeships for girls for the first time. A visit there very much impressed me on the engineering side. I think that was a sort of landmark. If you like, what surprised me a lot was that a lot of the girls going round were still taking the attitude: 'Oh, no, these are jobs for the boys.' I didn't think that, so I applied for one of these apprenticeships. Later I found out that it was the teachers again that stopped me from getting it. So I was very much pushed by my teachers. I think they put a block on the application, because I applied at the same time as another and she got interviewed and so on, and I heard nothing more about my application. At the time I just thought I'd been rejected, but it was the maths and science teachers wanting me to finish A levels. I think they probably spoke to the recruitment people at the dockyard . . .

I didn't think I had the ability to become a professional engineer, so then I started thinking about being a maths teacher. So then I applied to [a college] to do teacher training in maths and got accepted there. Then my maths mistress persuaded me to enter for some of the engineering degree courses. I think she had gone into maths teaching and had then regretted it. I think she would have liked to have gone into engineering, and she very much influenced me.

So I actually applied at the same time for some engineering courses at universities. And when the A level results came in, I got a place on this course which appealed to me because it was a mix between civil engineering and architecture. Because my A levels were very much an arts/science mix, it seemed ideal. I didn't really know what an engineer did, I very much felt that. So this course was very broad-based and it wasn't until I was actually at university that I decided, 'Yes, I did want to be an engineer.' (*Margaret*)

Margaret's teachers were concerned for her and pushed her towards a goal that they perceived as appropriate to her skills. Their belief in her potential led them to argue, persuade and cajole on her behalf, and they provided sound careers advice in a timely way.

Careers advice outside school

For the sample as a whole, careers advice and counselling on engineering at school ranged from excellent, through unreliable and individualistic, to non-existent. The role of school as a negative force as well as a positive one will be explored in Chapter 5.

In the face of a vacuum or opposition at school, some of the more determined sought help from other sources such as local authority

careers services. This worked well for Claire, who was counselled towards an Ordinary National Diploma (OND) in Technology at a college of further education.

Audrey received no careers advice at her boarding school, but was sufficiently independent to obtain a great deal of help from the careers service of the university nearby. Anna's school, though good in other respects, was not geared to sending pupils to university, so she went on a residential course where she got careers advice. Valerie became aware of the possibilities of engineering through membership of her local branch of the British Association of Young Scientists, which ran careers conferences; subsequently she received support from her headteacher.

Both Alice and Rebecca heard about the societies for professional women engineers, SWE and WES, almost by accident, but then acquired reliable careers advice from them.

> I graduated [from high school] with honors. That's how I started – it wasn't until I graduated that I knew about engineering. Because at graduation I had gotten one of those awards sponsored by the Society of Women Engineers. I really didn't know anything about it. It wasn't any kind of money award or scholarship or anything. I was just a simple plaque saying that I was rewarded for my outstanding achievement in science and math. And I said, 'Hmm, what's an engineer?' And they had given me all this literature on engineering. So that's why, at that point, I just thought that if marine biology didn't work out I'd probably go for engineering, because I love a challenge. (*Alice*)

Rebecca's introduction to WES was similar. By chance, she heard an item on a radio programme about women engineers and decided to follow it up by writing to the WES address given on the air.

Sometimes, two sources of information distressingly provided conflicting advice, as Tanya, who went to an all-girls Catholic school, describes:

> I wasn't quite sure what I wanted to do except that I had this feeling that I didn't want to do just a run-of-the-mill job. I wanted to do something more of a challenge and something that was different. I didn't just want to be a teacher. We had a careers convention . . . where a lot of people came into the school – you know, people from different walks of life – and we were supposed to go and talk to them about all the careers available . . . There was a man sitting there with a card that said 'Civil Engineer', and he looked extremely lonely. I know I should have walked round and looked at all the other careers [but] I hadn't seen anything that caught my

eye or was very exciting, [so] I thought I'd to and talk to him. So I went and asked him what civil engineering was and then he started showing me pictures of oil refineries and bridges and it all looked very exciting and romantic. He started talking about, you know, connections in far-off countries, and I started to think that it could be quite exciting, because the thought of travelling appealed to me and the thought of working outside would be really nice, better than being stuck in an office. I asked, 'What subjects do you need to do this?', and he said, 'Maths and physics', and I thought, 'Well, I am very good at maths, I always come first in the class' . . . everyone was telling me that really you had to go in one direction or the other, sciences or into the arts, so whereas ideally I would have liked to have done maths and English, I couldn't see where it was going to lead me except perhaps into teaching. I thought if I did maths and physics, you know, I could possibly get into engineering, but I still didn't know very much about it and I didn't have very much encouragement from anyone at school or at home.

Later on we had a careers lecturer who came in . . . and we all had to go in and see her when we were doing A levels. She said, 'What are you planning to do?', and I said, 'I'm planning to be a civil engineer', and she said, 'Don't be silly, you'll end up crawling down the sewers!' and she completely laughed at me.

And then our careers mistress at school was very keen on getting us all to apply for teacher training college and she'd been round with the forms, and I said: 'I really don't want to fill one of these out because the last thing I'm going to do is go to teacher training college. If I don't get into university I'd rather try and go and do an HND or something in a polytechnic and still do something more technical.' And she got most upset with me and said, 'Oh, so you think you're too good for training college?' So really I didn't get much sympathy . . . I think that it was just sheer stubbornness, you know; I decided I was going to do this and I didn't really care what anybody else thought I should do. To me this was a challenge. (*Tanya*)

Having opted for something she saw as exciting and different, Tanya became more committed to it the more opposition she faced. Her father, a primary school teacher, was also disappointed with her choice. He felt that civil engineering was unladylike, that she should become a solicitor or an accountant. So Tanya was in conflict over her decision both at school and at home.

Choosing at a later stage

Some of the other engineers had routes to their choice which passed through other occupations first. Most research on women in

engineering has been done exclusively on either school-leavers or mature students. Among our sample were six engineers who, with differing motives, had been mature entrants to the profession.

Ella wanted 'to be a diplomat and travel and learn languages, eat foods and see the world'. After a degree in international studies she applied to the Peace Corps but was rejected because she had no technical background. She then went on to study for another degree in engineering in the hope of being accepted second time around.

Lin had always wanted to be an engineer, but grew up in Malaysia and encountered Chinese prejudice about the irrelevance of education for women. So, faced with only the option of nursing, she came to England to train. Six months after qualifying she was able to switch tracks and enrolled for an OND in electronics as a prelude to a degree and PhD in medical electronics.

Julia became a secretary on leaving school, but liked the technical environment of her firm and wanted to know more about their engineering projects. Pauline, in the same position, was widowed very early and then studied engineering in order to provide a better future for her two young daughters.

Pattern breaking

In her book *Blue Collar Women*, Mary Lindenstein Walshok studies women in non-professional non-traditional occupations, such as mechanics, plumbers, electricians and welders. She writes of turning points:

> Most people, when reflecting upon adolescence and early adulthood, can remember certain critical turning points in their lives: personal experiences, significant relationships, or special events that touched their lives in a way that they began to see and feel things differently thereafter and often began to live quite differently. The end of adolescence is a predictable time for such experiences. (Walshok, 1981, p. 97)

Walshok describes how such turning points are expected and accepted of boys who are coming to terms with their own identities, but how, until recently, women were expected to acquiesce in the life-path defined for them by fathers and husbands:

Unless there is something about their circumstances, abilities or interests which pulls them into those 'masculine' worlds and demands that they 'take charge', girls have very little such opportunity outside of their own family experiences. (p. 98)

She found that the blue-collar women workers she interviewed had experienced turning points similar to those that men go through, which usually have the following features:

(1) they represent opportunities or demands for new sets of behaviors and perspectives; (2) they involve having to make often difficult or conflicting choices, and then acting on those choices; and (3) they often involve shifts of responsibility for oneself or others. (p. 99)

Walshok describes her sample as 'pattern breakers' – women who felt the need to take charge of their lives.

Our women engineers can also be considered in the same light. Many of them took new opportunities which gave them a fresh outlook on life. they often took and acted upon difficult choices and they took firm responsibility for their own lives. Yet we find it difficult to take these definitive events and state categorically that they are universal truths for women engineers. Walshok's model provides a useful framework for understanding what happened to about two-thirds of our sample when they took the critical step. For the rest, chance and circumstance led through a gentler, remarkably passive path to a non-traditional occupation, in which they were sometimes startled to find themselves regarded as unusual.

5

Education

Introduction

In this chapter we look at what our sample of engineers have to say about their experiences of education. We concentrate mainly on their experience of post-school education, since this is the point at which they began to study engineering in some form, and saw themselves as being 'on track' for a particular career. Because our sample are professional engineers, all but two (UK engineers who are pursuing professional development through a technician's route) have at minimum a bachelor's degree.

There are significant differences between the education systems of the two countries. Figures 5.1 and 5.2 illustrate the proportions of women among full-time undergraduate students enrolled on engineering courses. If the similar categories of engineering are compared for the two countries, the UK proportions are consistently smaller than the USA: 12 per cent as compared with 14 per cent for civil, 8 per cent as compared with 11 per cent for mechanical, 7 per cent as compared with 12 per cent for electrical. However, the trend during the 1980s has been one of gradual improvement on the UK figures. From the information our interviewees gave us we discuss whether apparent differences in the two national educational systems contribute directly to this.

In the 1960s in Britain schooling for children, over the age of 11 was usually selective, with grammar schools taking children who had passed a selective examination. These were usually single-sex schools. Changes of policy have meant that by the mid-1980s most state secondary schools are co-educational comprehensive schools. Since many of the British women we talked to were at school during

Figure 5.1 *Full-time undergraduate enrolments in engineering by selected curricula, 1984*

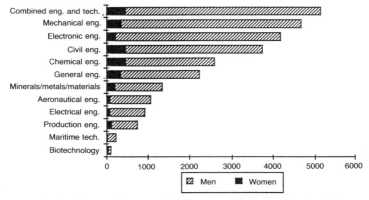

Source: Women in Engineering, *Engineering Manpower Bulletin*, No. 76, August 1985 (American Association of Engineering Societies Inc., Washington DC)

Figure 5.2 *Full-time undergraduates studying engineering at UK universities, 1986–7 (excluding overseas students*)*

*overseas students have not been excluded by the authors out of choice, but because they are dealt with separately in the UGC statistics and are not classified by sex. *Source*: University Grants Committee, *University Statistics 1986–1987, Vol. 1, Students and Staff*, Universities Statistical Record 1987.

the 1960s or prior to that, most went to single-sex selective schools. Thirteen of our British sample went to girls' schools, and of these eight went to state grammar schools, one to a Catholic girls' school and four to private girls' schools (one as a scholarship student). The US system is non-selective and co-educational, at least within the state or public system. Only two of our US sample came from single-sex private schools.

In this chapter we enter the debate about the value of single-sex education for girls. This controversy is a perennial one in Britain, which has a long tradition of single-sex schooling, and where recent research on co-educational classroom interaction has suggested that girls can be intimidated by their male peers in ways which can reduce the quality of their experience of subjects, particularly science (Stanworth, 1983; Kelly, 1985).

Secondary schooling

In Chapter 4 we discussed the important influence of school on career choice, and the effect of enthusiastic and well-informed teachers. However, for many of our engineers their schools, especially girls' schools, were not well-informed about careers in engineering, and could offer only limited subject options. Alice went to a small, mixed high school and she felt that the quality of the teaching and information she received there had a detrimental effect on her future higher eduction:

> I went to a Catholic high school and they didn't really gear the girls to technical courses. It was a small high school, but they kept the girls mostly in typing classes and steno [secretarial] classes and accounting, where they kept the boys in physics classes and math classes and drafting classes . . . I wanted to take a drafting class . . . they had a 'mechanical drawing' class, it was called – and I wasn't allowed to. (*Alice*)

The issue of access to technical as opposed to pure science subjects is important to potential engineers. Claire was allowed to take technical drawing in her co-educational school, but not without a struggle:

> I thought, well, I quite like maths and physics and I want to do something different, so I chose technical drawing. And I had to go and see the headmistress who made this fuss about a girl wanting to do a boy's subject. She put me on a term's trial basis to see how I would get on because she knew the boys already had a whole year of it, you see, while we did cookery, so I had all the catching up to do. So I said, 'All right, then', and went to the lessons. I didn't know how to use the drawing board, with a lever down at the bottom that you tilt for the angle you want. And you had your instruments, your set squares and your T-squares and things. I didn't know what any of those were so I was a bit embarrassed. Anyway, after the first lesson the teacher kept me back and said, 'Are you really serious about this?' and I said 'Yes'. So he sketched a few drawings on a bit of paper and said, 'Go home and solve those.'

And I did! I think he helped me an awful lot; he encouraged me . . . and it was then that I started to think, Well, I want to be an engineer. (*Claire*)

In a girls' school it could be impossible to study this subject at all. Joyce's school was not equipped for it, and she and a friend had to go to a nearby boys' school for lessons. Jennifer studied it at a local technical college.

In some girls' schools the discouragement came not only from the non-availability of certain subjects, but from an ethos which was against a 'masculine' subject or career choice:

My school was an all girls' grammar school; it thought science wasn't terribly respectable unless you were going to be a doctor. They persuaded me to do English, French and history at A level, and I was very unhappy because I couldn't see what I was going to do with those qualifications. I had a place to read history at [a university]. I was almost sure I didn't want to do that. It took a lot of heartache and a lot of battling and effort and everything else to find out about engineering, to decide to go in for it, to get the apprenticeship . . . When I brought this forward at school, having found out about it, the school was very much opposed to it, but my parents did say to me, 'Do it; if you don't do it you will regret always that you never tried.' (*Sybil*)

Only Margaret (see Chapter 4) described her teachers as pushing her to study maths and sciences and to go on to university.

Some girls' schools were wise enough to know their shortcomings as far as careers advice was concerned and used outside agencies to help:

When I was having to decide which degree I was going to do I went to a lecture in London at the Institute of Mechanical Engineers. I went to an all girls' school, you see, and they took us to a lecture where they had representatives of each different subject, mining engineering, electrical engineering, civil engineering, and they all gave a ten to fifteen minute talk on their subject. A woman who was lecturing there came up to us afterwards and said, 'You know, if you're doing A levels why don't you consider doing applied science?' And it was from there [I got interested]. There was me and another girl who decided we'd do engineering. In fact, she was keener than I was, then I got very keen, decided to do aeronautical and changed to mechanical, then she did metallurgy. So we both did sort of an applied science, but it was really with a view to a career in the end. (*Joyce*)

Although there were disadvantages in being at small, single-sex

schools, there was one particular advantage that was rated very highly by our interviewees: once they chose science subjects they were taught in very small groups, especially in the two years prior to university.

> I think there were six on the A level physics course and about the same number on the A level maths course. But that was enough. That was rather nice because we got individual tuition . . . [It was] very good teaching. I certainly wouldn't criticise the school in terms of what they taught people. (*Victoria*)

Although girls' schools had little experience of getting students on to applied science or engineering courses, they had considerable experience of the university system in general; they did expect good pupils to go on to university. This could have positive or negative effects.

As we saw in Chapter 4, a teacher could provide an inspiration for a particular subject. Eileen described the interesting situation where the person most *unenthusiastic* about her choice of career was a woman teacher who had herself trained as an electrical engineer:

> Most of the teachers were fairly OK . . . they weren't helpful, but my pure maths teacher was quite sceptical because she'd trained as an electrical engineer, and although she never said anything I think she had problems when she first graduated. The standing joke was that when I said I wanted to be a civil engineer, she said, 'Oh that's really difficult. You'll never get into university for that.' And when I went to university she said, 'Oh yes, but you just try and get a job.' So I got a job without any problems. Then I went back to visit the school and said, 'So there, I got that job.' She says, 'Yes, but you try and get a permanent job.' And when I got a permanent job she said, 'Yes, but you try and get promotion.' (*Eileen*)

To summarise, in most cases schools concentrated on getting girls into traditional female careers and the subjects appropriate to these. Reseach in the UK is ambivalent about whether girls' schools have a better record of examination success in general, and in science and maths in particular. Certainly a high proportion of our UK sample came from girls' schools, and although few schools encouraged girls to study engineering, the atmosphere in the school seems to have fostered the self-confidence to pursue their chosen field of study.

Parental support

As we discussed in Chapter 4, parents could be crucial in determining career choice. Very few of the parents of our engineers were hostile to their daughters going on to higher education, but few understood enough about the areas their daughters were studying to give informed support. By the time their daughter was eighteen, some parents felt that it was time for her to become independent; for Sybil and her parents this meant leaving home, although as we see later in the chapter, Sybil was thoroughly miserable when she did.

Fathers, especially, were pleased that their daughter was studying for a degree, but sometimes they would have been more comfortable if she had been studying in a more traditional field.

> My father didn't bat against it because basically my father thought, 'Well, it's a degree and anyone who gets into university and gets a degree, that's something anyway.' So he didn't actually discourage me from doing it, he was just slightly disappointed, I think (*Tanya*)

Only a few of our sample's fathers retained traditional attitudes about the education of women, and in these cases the daughter needed the support of her mother.

> My father is very much a traditionalist. He thought education was wasted on me – well, not wasted on me, but certainly when I was younger it was the case that I had to be quiet if my brother was working, but if I was working he'd come in and say, 'There's a good film on the TV.' He didn't see it as important for me to get a good education. So that was something my mother thought – that I should have an equal chance with my brother. She sort of tried to keep my father in check, I think. (*Margaret*)

Only Pearl described a situation where academic success was put in jeopardy because relations with a parent had broken down. She had the opportunity of staying at university a little longer and getting a joint major in civil and architectural engineering, but her relationship with her mother, with whom she had been living, was so tense that she left.

In general, parents supported, both emotionally and practically, their daughters' decision to study in higher education, even when they were dubious about the subject chosen.

Getting into engineering later

Six of our sample – Lois, Ella, Julia, Pauline, Hazel and Lin – came to engineering after trying another career elsewhere. However, maturity brought other responsibilities: husbands and children complicated student life.

Lois does not have an engineering degree in the strict sense. She did her first degree at a prestigious women's liberal arts college in the USA, and then went on to a law school, which she left because it bored her. Finally she decided to develop her interest in communications through a master's degree.

Julia, Pauline and Hazel left school without any intention of pursuing higher education of any sort. Hazel's teachers had not seen her as university 'material', and she took a job in a laboratory. It was her boss who suggested she go on to university. Julia became a secretary when she left school. None of her family had gone to college, and her school did not expect her to. She had a very traditional ambition: to marry her childhood sweetheart. She was good at her job and got promoted fast, but thought that the engineers she worked for had more fun, so she began to study herself. She became an independent student and financed herself through two scholarships, an equal opportunities grant and a state loan.

Pauline decided much later in life that she wanted a degree. Of all our mature students she was the only one who began to study engineering after a career break to bring up a family. By the time she returned to study she was a widow in her mid thirties with two daughters to support. Her high school, like Julia's, had never suggested that she go to college, and it was the financial pressure of being the family breadwinner that made her consider it. At first she took whatever courses she could fit in until she began to see that those she liked best were considered to be 'engineering'.

There is a tendency, especially in the UK, to feel that one is either a science or an arts person, and specialised schooling reinforces this. The subjects you didn't study must have been those you were bad at! These women, however, demonstrate that it is possible to begin to study scientific and technical fields as a mature student. There is nothing special about technical subjects which makes them inaccessible to mature people who are well motivated, and these women were.

The financial consequences of higher education

The economic position of students in the UK and the USA has been traditionally quite different. Prior to 1989 UK students who got accepted on a university course would have the qualifications which guaranteed them a financial grant. This covered the fees of their institution and a subsistence allowance and was paid by the Local Education Authority (LEA). Parents were expected to contribute towards the grant according to their level of income, the contribution being stipulated by the LEA. Sometimes parents did not or could not contribute towards the grant. This happened to Audrey. However, she obtained financial sponsorship from a company and managed by living frugally.

Mature students – that is, those over the age of 25 – are given a grant which does not take their parents' income into account. Lin came to Britain to train as a nurse, which is on-the-job training and salaried. At the end of her training she had been resident in the UK long enough to claim a grant as a UK mature student. Students may also be sponsored by employers and receive salaries and retainers which make them much better off than their fellow students on a grant.

In the USA, on the other hand, students work their way through university. Noreen worked in a hardware store. She was there for so long that she worked her way up from cashier to manager. Universities often run what amount to placement schemes. Frances's university found her jobs in the games room and as an information clerk. No grants are available and scholarships are usually small; some students take out loans. However, university timetables are designed so that students can arrange their attendance at class around their paid employment; classes run during vacations and in the evenings. Students like Elaine, who was the youngest of six children, often attend local universities so that they can continue living with their parents and so save money. For most American students there is a fine balance to be maintained each semester between the amount of course work undertaken and the amount of paid work done. Ella describes how she financed herself from a variety of sources and how the need to work affected her academic performance:

[I financed my studies with] substantial loans. At the end of the year I found out that my Grandmother had a soft spot for her granddaughter to

become an engineer. There was a time when it didn't seem that the loans were forthcoming and all of a sudden Grandma flew in with a $3000 contribution to my education, which was quite a bit, although the school was a private school and was fairly expensive. So I worked full-time for most of the time I was going to engineering school and I took one year where I went to school for final work part-time, but basically most of my engineering courses were taken at night, in addition to whatever job I had at the time.

It was difficult in the sense of trying to arrange it all so everything got done, and certain compromises had to be made. At times my performance at work wouldn't be as good or my performance at school wouldn't be as good. (*Ella*)

Working is so much a tradition for US students that even those who don't need to for financial reasons, like Zena, were likely to take on some. She did a job in the university library, ran a doughnut stand, and in her final vacation got a technical job with a chemical company. The repayment of loans for our US professional women was much less of a burden than we might have imagined, with relatively small repayments, at low interest rates, staggered over a long period once women were earning.

At the time of writing the UK system of higher education grants is being converted into one of grants plus loans, in which the parental contribution will be abolished. The effect of working while studying, on our sample, was to extend the length of time they took to complete their degree. This is compatible with the US system of 'credits', but would not be compatible with the present UK university system. If it took a UK student longer to complete her degree, and she then had to complete the extra training for her registration as a Chartered Engineer, this could be a discouragement from entering the profession.

The greatest inequality between the two countries is for mature students. Mature students in the UK are much better off. Had she been in the UK, Pauline, once she qualified to enter her degree course, would have received a grant which took into account the fact that she had two dependants. And yet we found more US than UK women studying engineering as mature students.

The first year experience

There is much literature on the difficulties that students experience in coping with the first year of university life (Miller, 1970, and

others). It is during this time that the greatest proportion of withdrawals and failures occurs. Our interviewees had all the usual adjustments to make, as well as learning how to cope with being one of a small minority of women in a mainly male environment, and for some women this was the first time since primary school that they had worked alongside men at all.

Tanya went to university from a girls' convent school and she remembered vividly her first engineering lecture:

> I remember the first day I walked into my engineering lecture theatre. I was absolutely trembling because I was a very shy little girl a the time. I was slightly late and, you know with lecture theatres, you usually walk in the bottom and everyone's sitting. Well, of course, I walked in the bottom and this theatre was full of boys. I was absolutely petrified. I walked up the aisle with head down and I couldn't find anywhere to sit. It was all full up and in the end I just sort of shoved my way in at the end beside someone. I was so shy and nervous I didn't even look at who I was shoving up, because nobody seemed to move to make any room. And when eventually I opened my eyes and looked up I happened to be sitting next to another girl. It was a bit of a relief. (*Tanya*)

She also described the problem she had in getting on top of the course work during the first year, particularly in technical drawing, since she had been to a girls' school which didn't offer it.

> Generally I found that the first year was a little bit of a doddle. The only subject which I had difficulty with was technical drawing. Now technical drawing was completely new and I did get some help from a boyfriend. I was going out with someone in engineering a year above me. When I was in the first year, he gave me some assistance in technical drawing. I think he coached me and I managed to scrape through the exam because I really didn't understand it very much. (*Tanya*)

Jane had carefully observed the difference between both the performance and the confidence of her fellow students, and she felt that the advantage the men held in the first year because they were better prepared was lost by the next year when the brilliance of the women students overcame their initial disadvantages:

> One of the very noticeable things about the girl scientists, and myself included, was that it took us about a year to establish ourselves. We didn't do very well in the first year, and that was partly sort of developing our confidence at just battering away at the system. For example, in

electronics practicals there used to be a large number of boys who'd done electronics at school. We hadn't and you tend to get this terrible inferiority complex because you get all these blokes around muttering about these queer names for components. They say, 'Oh, you need a so-and-so and a so-and-so', and you think, 'I haven't the foggiest idea what a so-and-so and a so-and-so is' (*laughter*). And especially in the first year you had to take your courage in both hands and keep on battering away at the demonstrators (all men) until you understood something. That didn't really filter through in the results in the first year, but I think that what happened by the time we got into the second year was that people who'd sort of been surviving on what they knew from school in the first year, began to lag behind, and our persistence started to come through. We developed the self-confidence to keep on asking these ignorant-sounding questions until we understood something. And we also supported each other quite strongly. I was at a woman's college and that made a big difference. We had women supervision groups and I think we weren't afraid to say, 'I don't understand this, I'll go and ask so and so about that, within the supervision group'. We very much acted as a joint group, whereas we found when we were working in a mixed group with the blokes in town, that they would be sometimes not so willing to admit that they didn't understand something. It was just a different approach. I mean, there were very bright blokes around obviously who understood everything automatically, but we tended to work at it. (Or perhaps they just gave the impression of understanding everything without working at it.) In the end it showed through quite dramatically in the results, because in our year I think there were eight girls out of thirty-three doing metallurgy and materials science; I got one of the three firsts in the year and the other girls took a relatively high proportion of 2.1s, considering how many girls there were. (*Jane*)

Both Jane and Tanya mention the importance of other women in that first year. For Jane, her women's college was a crucial source of support.

Despite their problems, for many of the women university was the place where they first flourished. For these students, the first year may have been hard but it was extremely successful. It is often the first time that young people live independently of their parents. Although they are still in a relatively protected environment, they are responsible for budgeting for their living expenses and organising their time for themselves. It is a period for many of personal growth:

life started for me when I left school, life became happy and I enjoyed it more. (*Audrey*)

I became my own person. (*Nicola*)

However, achieving this independence was not always easy:

> When I first went I was worried that I wasn't going to be as good as the others, so it was quite traumatic, I suppose. At the same time my father was moved to a job in Malaysia . . . my sister went to boarding school . . . and I went to university, so we all dispersed at that point. I found the work very different from what I'd been used to. I realised I'd been molly-coddled at school. The teachers had really done everything for you. You did really need to do extra reading and be very independent in the way you organised your work to actually get through exams, and I'd always done just the minimum to get through, rather than pushed myself. I really went absolutely mad the first year I was there. I stayed out late a lot. I suppose I really made full use of the social life, went absolutely mad and missed lots and lots of lectures, and in fact just blew it the first year . . . When the first year had finished and I came round to revising for exams . . . I didn't even have notes to revise from for half the stuff, so I either didn't go in for the exam or did pretty badly in them. So I failed my first year. I had to go back to my parents and admit that I'd completely blown it. So I felt very bad about that. Health-wise I was a wreck – I'd drunk far too much and really not looked after myself. I suppose I'd never thought about it much before I left home and suddenly I discovered, at the age of 18, I wasn't mature enough to look after myself. So, amazingly, my parents actually agreed to pay me to re-sit the whole year . . .
>
> Anyway, that next year I moved out of the hall of residence and got a small flat with a couple of friends. I got down to organise myself and then when the exams came round I had no trouble at all. (*Wendy*)

What our engineers described was going to university lacking in confidence. The reasons for this are both academic – they are entering unfamiliar fields of study – and social – they are working in a predominantly male environment. This second point is a dis-advantage which is especially hard for women from girls' schools, as we witnessed with Tanya's first lecture. Women studying sciences in mixed schools had already experienced being in a minority among their male peers, and had learned to survive. We do not wish to ignore the fact that many male students also experience trauma in their first year, and fail or withdraw from their course, but we have tried to identify some of the particular entry problems faced by women.

Industrial experience and sponsorship

The thing that I think frequently is missing from typical undergraduate

engineering school is conveying to the students some sense of what does an engineer do. And I don't think I ever really felt what an engineer does in the course of my curriculum. (*Ella*)

Ella's comment was similar to many made by women studying full-time university courses. They began their course feeling vague about what the nature of work as an engineer was like, and many became only marginally clearer as their course progressed. If these students had been following a course which contained required periods of work in industry they would not have made such comments. However, most of the American women, as we have seen, worked their way through university at unskilled jobs which simply provided an income. Although co-operative education programmes (equivalent to a British sandwich course) exist in many colleges, none of the sample had been encouraged to participate in one. Suzanne was extraordinary among the American women in that she did find herself engineering work every summer of her undergraduate course.

Partly because of the membership requirements of the engineering institutions in Britain, a high value is placed on acquiring industrial experience during the period of the undergraduate course. All our UK interviewees had done some industrial work during some part of their course. This was likely to be during the summer vacation, since this was the only time they had available for a significant period of work. Jennifer's university sent her to work on a building site in Sweden at the end of her second year. Veronica's university specified that she get particular kinds of practical experience, but she organised her own placement through her personal contacts.

A small number of the British women did sandwich courses, where six months of university study was followed by six months' practical experience. Audrey was accepted as an apprentice by a company on condition that a particular university accepted her on to its course, while the university would only have her on condition that she was sponsored by the employer. She told both that the other had accepted her and began her course.

Claire got an excellent and varied training from a company who sponsored her, and despite failing the first year of her course, the company continued supporting her financially as she transferred to another lower level course:

I did a sandwich course: six months on and six months off. So it meant that when everyone else at the college was searching around for work experience I had a place to come back to. It also meant that at that time I was very well off. I was being paid for studying, whereas everyone else was living on a grant and having to make ends meet . . . And there's no strings attached to the sponsorship that I received. I didn't have to stay with the company after I finished studying. I was free to hand in my resignation and leave and say, 'Thank you very much for the training', and go elsewhere. But I didn't. I stayed on and throughout the industrial training sessions I've been literally all the way through all the engineering sections with the company – in sales and installation and commissioning, and I worked in the panel shop, and I've been an inspector, and I've worked on the assembly line. So I've done everything. (*Claire*)

The advantages of being a sponsored student doing a sandwich course appear so strong that it is surprising that so few of our interviewees had chosen to study in this way. This could be because degree sandwich courses exist primarily in technical universities and in polytechnics, and these have tended to have a much more vocational and masculine image than older, more traditional universities. It could be that it is harder for women students to get industrial sponsorship – certainly, fewer women study sandwich or day-release courses of any sort. Many of our British sample deliberately aimed to get into older, more established universities because they felt that the quality of the course or status of the degree would be better.

Postgraduate study

Although in general more American students study to a masters degree level (Emmerson, 1973)), there were roughly equivalent proportions in our sample in each country who had studied to postgraduate level. In both cases this was mainly due to a perception that employment prospects would be better with greater specialised knowledge.

I'd applied to a couple of places and been rejected and thought perhaps if I had a masters qualification it might help with being a woman in a predominantly male field. So I thought if I go on and do a masters it would be something extra that I would have to offer, and the fact that it's an engineering subject, so it was very much that was the reason why I went on to do it. (*Margaret*)

It was Suzanne's father, on the other hand, who from his own experience felt she would have better job prospects with a postgraduate qualification. She saw further study as a chance to see a bit more of the world, so she went to do her PhD at a British university.

For Zena, her masters was a practical course, equivalent in many ways to the practical training component that British engineers are obliged to undertake to qualify for Chartered Engineer status.

Audrey did a masters as a way of updating her skills after a career break:

> I started applying for jobs and I got a couple of interviews which when they were technical interviews was a disaster. I was totally humiliated. I just didn't know what they were talking about, so I thought, I'm not putting up with this! So I looked at the *IEE News* and saw an MSc advertised and wrote off. They said come in and see us. And in fact one of the lecturers there is a man I used to work with, so I got on the MSc . . . It was sponsored by the Manpower Services Commission, so they said try us for a grant because it's more generous, which indeed it was, and I did get one. As it was it covered most of my childminding fees, so actually doing the MSc didn't cost us anything – well, not too much. (*Audrey*)

Many of the engineers were married by the time they began postgraduate study. This, combined with the greater demands of the work, put them under a lot of pressure. Jennifer, for example, lived an hour's drive from the university and tended to go home to be with her new husband as soon as lectures ended, and was therefore much less involved in university life.

Audrey had not only a husband but two school-age children:

> Now, my being at university was a great strain on the family because I didn't get back [home] till gone six. Usually the labs went on and then each night I had to go into the study and study. And at weekends when Pete took the kids out and they said, 'Are you coming Mum?', no, I didn't. I studied. So when the MSc stopped it was glorious for a little while. (*Audrey*)

The possession of higher degrees is important for women engineers. It is a recognised indication of excellence which helps them compete with men in the early stages of their careers.

The male classroom

It is acknowledged that at all levels of education the people who make life most difficult for girls and women breaking into areas which have traditionally been male preserves, are male students. A paper by Roberta Hall (1982) describes the various ways in which this occurs, in what she describes as the 'chilly climate' of the classroom for women.

There were only a very few complaints about unfair treatment from staff, but many about antipathy from male students. Suzanne and Alice both found that they were not taken seriously for the first year, and this came out in male students asking them if they were doing the course to find a husband – not a sensible question, they both felt. Suzanne did well and felt that all but one of her professors were very encouraging. However, her fellow male students were not:

> I was in a class with 120 students. There were four women including myself . . . I still felt rather an oddity in my classes, and the [male] students, I think, treated us as an oddity. I was asked shortly after I started in engineering – this was in my first year – if I wasn't there to find a husband. I could have chosen a better profession to do that in than end up with an engineer as a husband! . . .
> As I recall, there was a certain kind of male momentum in the class which was not particularly receptive to incorporating women in the social groups. And I felt rather on the outside at that time. (*Suzanne*)

This occurred despite the fact that Suzanne has attended a co-educational school previously.

Sybil found that her success at practical work increased the antipathy of her fellow apprentices, while at the same time increasing the encouragement she got from her tutors. She needed that encouragement to keep her going:

> I was very successful at workshop technology. That in turn made the relationship with my fellow apprentices more difficult. It's a bit like scoring a goal on a football field when all the other players are men. It doesn't tend to make you terribly popular because it's their home ground, if you like. So I found the academic work and the technical aspect not difficult or not over-taxing . . . but relatively speaking I sailed through the apprenticeship academically . . .
> I wanted to learn, which tends to endear you to your lecturers. Many of

them found it a novelty to have a woman in the class. Many of them wanted to encourage me, but they didn't positively discriminate. (*Sybil*)

Aspects of university work which were more directly to do with professional practice were areas where male students most jealously guarded their privilege. Pearl found that there was little hostility from her fellow male students until she joined the local branch of the Society for Professional Engineers; then that hostility was expressed 'verbally in meetings'.

Laboratory work has sometimes been recognised as a difficult area for women because often they are relegated to doing the report writing while their more confident male colleagues actually get to carry out the experiments. However, in our sample, only Rachel described being put in the position of being the recorder by an instructor, who seems to have felt that she was *too* proficient and needed to give the others a chance! She was also in a women's dormitory and found it difficult to gain access to important files which were vital for satisfactory performance but were housed in the male technical engineering fraternity house. She managed to get access but only through the goodwill of the men. Dora, who is of Rachel's generation, found that society in general was suspicious of the morality of women who studied with men:

> They suspected you of being slightly immoral. In fact [the University] didn't have dorms for women. You had trouble getting a room . . . I tried to get a room at the YW which would have been near . . . and the woman said, 'I don't want you girls. I know what you're here for, and I don't want any part of it.' This despite the fact that it was a co-ed school almost since it was founded. (*Dora*)

For the first time at university, many of the women felt conspicuous. This is something that is referred to even more frequently when the women talk in Chapter 6 about their present work. Women are not always sure whether there may be some advantages attached to their conspicuousness, and whether there are ways they can take advantage of it. However, what they all note is that because it exists, they feel that they are always being evaluated and they can never relax and merge anonymously with the mass.

> In college I was the only girl in almost all my classes. I got the usual stuff people get; there were always insensitive professors and they comment.

There were always the kind of professors who made blatant sexual advances. I kind of took it in my stride, I kind of managed. I didn't really let it get to me. I wasn't going to let them get me down. And once I decided I was going to do it, and once I saw that I was able to do it, and once I saw that I was as bright as most of the guys doing it, I was able to do it. The parts that were uncomfortable in college for me, were [that] I always felt scrutinised. I always felt that I had to prove myself, which is uncomfortable.

I don't know if I had to work harder. But I certainly felt that the choice of settling for what they used to call a 'gentleman's C' or a 'lady's C' wasn't really open. People were watching. When you had an exam, people were interested in what I got. Teachers made comments. I really was pressured to do well. (*Anne*)

Despite this, Anne did not feel resentment towards her male colleagues, because she did not see it as a situation of their creation; she felt that she had got on well with her fellow students, and many of them were still friends.

This feeling of conspicuousness was also described by Alice, who didn't do very well in job interviews at the end of her degree course, because, although she was an average student,

When it was time to go on interviews, the companies would look at your GPA average and not interview you because it was not high enough . . . I don't know how true this is, but they made you feel like being that you're a woman you had to be exceptional in your class. Because if you're not, you're real dumb. It's not like you were an average man. If you were a woman and you were an engineer, you had to be exceptional. (*Alice*)

We see at university the male student engineers engaging in the process of masculinising the subject area, and therefore marginalising women students. The women who were in co-educational schools did not seem to be so aware of this occurring at school. Reflecting on their school experiences, they seemed to see the behaviour and attitude of teachers as more important than that of fellow students.

Race, class and age

It was hard enough being a minority as women, but some of our women engineers were aware of other disadvantages during their education, to do with their race, their age or their class origins. It is

acknowledged that success in the educational system correlates highly with class. Students from working-class backgrounds may feel much less well prepared than their middle-class peers. Hazel discussed at length during her interview her sense of class background and how she saw it influencing all sorts of areas of her life, but especially education:

> I am only really now coming to appreciate how you cannot change your background, and it has a tremendous influence on the way you develop. And when people talk about class structure I don't believe it's class for its sake but I realise it's the atmosphere in the home, the presence of books around that matters. My parents were always so tied up with working in order to keep a roof over our heads and [us] fed and clothed, and yet at the same time I was never conscious of being deprived of anything. I really do appreciate it now.
>
> I went off to grammar school and, of course, if you look back over both my mother's and my father's side I then became, once I got to O level stage, the most educated person in the family. I took ten O levels and I only passed six. So the school I went to, they didn't bother to encourage me to stay on to take my A levels because there were so many people that had ten, nine O levels, the sixth form was filled. So I then applied for a couple of jobs, and I was offered day release to do my A levels. I eventually did get my A levels and we then had a new general manager here who said, 'What about going to university?', and I thought, 'Oh gosh!' You know, I've never known anybody personally, apart from my immediate boss, who had been to university. So I applied and went as a mature student. (*Hazel*)

One of the women who went to a high-status college from a state grammar school, became aware of the advantage that a privileged background could give to a student:

> I had to adjust to the fact that I was with a large number of people from relatively privileged backgrounds, and that was quite difficult, particularly when you saw people flourishing academically, because they'd been prepared to flourish academically in the Oxbridge system, via their schools, especially the public [i.e. private] school system. (*Jane*)

Race also seems to have been an issue for some of our black interviewees:

> I did go to a very common sort of comprehensive school, and of course coming from Trinidad and being brown you get called all the names like 'Paki' and all the other names under the sun. You had to put up with all of

that as well as them picking at you because you're female . . . But I had to
sort of stick with it, you know, and when they called me names I had to
think of names to call them, and after a couple of weeks it all stopped . . .
they accepted me because once they realised I was on my own in this
physics class, and I would have to get on, I did get involved. And being
the only girl I would get picked to take part in all the experiments, do
some little thing to help with the results and that kind of thing. I think
after all the aggro the boys settled down and you gained their respect and
they were willing to work with you. (*Claire*)

Earlier in this chapter we looked at the experience of the women
who studied as mature students. Although there were problems
attached to studying when they had other family responsibilities,
most said nothing about feeling that they had been discriminated
against because of their age. Hazel, however, did feel that the sense
of conspicuousness described earlier was increased by the fact that
she was obviously older, signified by the fact that she had grey hair.
This put a lot of pressure on her, which was only released when
another, even older, student joined the course.

Hazel's feeling is not likely to have been simply self-generated,
since Joyce, in discussing how well she related to both male and
female fellow students, remarked that mature students were 'the
only people I was sort of more wary of'.

Hall (1982) reports on the extra pressures put on non-white or
mature women students. Racialist undercurrents have not disap-
peared from the education systems of either country represented
here. Hall reports on minority women being either ignored or
singled out, like Claire, as representatives of their ethnic group.
Older women, she reports, are often not taken seriously or
patronised, or they are looked on with suspicion by staff or students
who are younger than them, which appears to be what Hazel and
Joyce describe.

As far as class is concerned, Florman (1978) has argued that one
of the reasons why there are so few women in engineering is that it is
not a high-status profession like law or medicine. It can attract men
because of its connotations with masculinity, but middle-class
women aim for higher-status professions:

Until upper-class aversion to engineering is overcome or until lower-class
women get out of the kitchen and into university, engineering will remain
a male profession. (Florman, 1978, p. 58)

Whatever one feels about Florman's statement, the issue of class is a complicating variable.

Girlfriends – the critical mass

> Q: How many people were there in your class?
> A: We started out with about 60.
> Q: How many were women?
> A: There was two.
> Q: And at the end of four years?
> A: Twenty graduated.
> Q: And how many women? Both women?
> A: No, just me. (*Noreen*)

This exchange with Noreen illustrates the kind of situation many women studying engineering found themselves in when they arrived at university. The increase in the number of women studying these subjects in the 1980s means that although women are still a minority, they are less likely to find themselves being the only woman on a course.

Universities could be sensitive to this situation. Audrey was on her course with one other woman, and the university organised their timetables so that they were both in industry at the same time. Audrey got on well with the other student, and felt that without her she might have been lonely.

There were, therefore, advantages in choosing a course or a university which was known to have a high proportion of women students:

> One of the reasons why I chose [my university] was [that] there were over thirty girls in the civil engineering department . . . It was definitely a snowball effect. Once they got a few girls, more girls went. Like me. Another reason why I chose it was because I felt that as there were lots of girls there I'm not going to be treated as anything strange . . . Plus they did a very active publicity campaign. I remember them writing to my school, and they wrote to all the girls' grammar schools, I think possibly the mixed grammar schools as well, saying: 'Civil engineering is a possible career for girls. Please get your girls who are doing science to consider it.' Which, you know, was forward thinking for fifteen years ago. (*Eileen*)

Women students did seem to provide support for each other, sometimes in a very casual way simply by providing someone to sit beside, especially in that first difficult term. For some, their fellow women students provided support networks in a very deliberate way:

> When I started all women had to live in the one dorm that was for women. And we were very close. In fact I knew most of the women – I knew all of the women in my department, and I knew most of the women in my class. And I knew hardly any of the men in my class, you know, maybe a few from my department, but none from outside the department. We used to study together, the women. When we were on projects, then we ended up with other people, but, for the most part, especially the first two years when we weren't working on projects with other people, we really stuck together. (*Zena*)

For Julia a SWE group in her university provided a support network, but Pauline and Alice, who were later very active in SWE, were not when at university. They felt it would have increased their conspicuousness.

Many of the American women lived in single-sex dormitories while they were at university; some of the British women went to old collegiate universities and to single-sex colleges within them. Members of a college shared not only facilities such as accommodation and catering, but also women personal tutors and a set of traditions. College membership in the Oxbridge system is of prime significance. However, women in these single-sex colleges attended subject lectures with male students from other colleges.

Although many of out interviewees talked about the lasting friendships they had made at university, for those at single-sex colleges the small group of women friends they made there were significant in their later lives:

> I knew [my husband] at university but we didn't go out then. I think I got most of my support from friends. I moved in different circles – I moved in [my single-sex] college circle and I also belonged to a Christian group . . . And I got a lot of support via the girls that I worked with at college, of which maybe three or four were quite close friendships, people that I keep up with, and still get support from now. (*Jane*)

One way of coping with being in a minority and feeling conspicuous is to team up with others who feel the same, and this seems to have

been the way that our women coped as students. This is not to say that they set about doing it with any deliberation; most of them remarked on its simply happening. Belonging to a group of female friends at college seems to have been less problematic than belonging to a female group later in work (see Chapters 6 and 9). We also have to say that our samples were not always saintly in their sisterliness, and could be extremely critical of female staff or students who were not living up to their high standards. However, Gardner (1976) at Cornell argued in the mid 1970s that the most important factor in improving the performance of women students in engineering was not special programmes for them but an active recruitment programme which increased numbers to a 'critical mass'. At that point there would be a large enough group to provide the support they all needed. This seems to have been what Eileen was describing, and women's colleges also functioned to encourage this critical mass.

Boyfriends – the special relationship

Another way to cope was to develop a special exclusive relationship with one other person, and since the women we talked to only discussed heterosexual relationships, this was invariably with a man, usually another student. Many of the British women, though not the Americans, talked about the importance of boyfriends both in the final years of school and during university. For some girls, especially those coming from a single-sex school, a boyfriend who was interested in engineering could provide them with crucial information and encouragement unavailable from any other source:

> [at school] the only clues I got really was from this boyfriend, but he was the same age as me, at the same stage in his career . . . but he really told me what engineering was about. At that stage I thought engineers all wandered around in overalls with spanners. He told me engineering wasn't like that. I suppose it was he that I followed, but I didn't know any engineers at all. (*Victoria*)

A serious boyfriend could determine the choice of a particular university for a woman:

I did engineering science. My husband . . . did engineering. He was at university as well, three years ahead of me, so I suppose I knew what to expect. I went to E University because he was working in a city nearby, and I did apply for universities that would be near [him] . . . because we were quite serious even at school. Having got a place at [my first-choice university], that's where I decided to go . . . I think the school tried to dissuade me . . . They said why didn't I try for a 'better' university, because they realised why I'd applied to that one. (*Angela*)

In a university where there were very few women, setting up a close relationship with a man could provide crucial emotional and practical support.

The first year at university I had a very steady boyfriend who was doing a similar course as me but mechanical engineering. He was a mature student . . . I had known him in fact as a child. I hadn't seen him for fifteen years but on our first day at university he said, 'I know you', and I said, 'Yes, I know you.' And we sort of got on well. So, for a year or so I had quite a lot of support from him, and then I had a lot from my mother. I had a very good tutor. When that first romance ended she was extremely good as I nearly dipped out of the course. I am glad I didn't, and then I met another man and that was about it. Basically it was my mother and both boyfriends. I hit lucky. I had very pleasant men. And my husband as is now, he was the second one I met. (*Audrey*)

Sybil, who had gone from a single-sex school to be the only woman apprentice on her course, found working with her fellow apprentices very difficult. One solution to this was to marry her boyfriend and create for them the sort of comfortable retreat that is somewhat similar to the sort of retreat provided by single-sex colleges and dormitories:

[my husband and I] started spending a lot of time together and decided that life would be infinitely more comfortable if we got married, so we did and it was a bit of a pragmatic decision. We were very good friends, more than we were ever boyfriend and girlfriend. It worked out very well. It was like having somebody to go home to at night . . . living in digs was not comfortable, but having our own front door that we could shut on the world was a lot more comfortable . . . First there was the emotional security and there was a physical comfort, which should never be underestimated. (*Sybil*)

The existence of these sorts of pressures and needs could explain why so many of our sample married while they were still students.

However, the importance of women's relationships with their male partners is an area that has been little explored by research on women engineers.

Summary

Despite the problems that women students felt, they did not envy their female friends studying other courses. Julia compared herself to her room-mates who studied journalism and Spanish, subjects that she felt were unlikely to provide lucrative careers – unlike, she hoped, engineering.

Noreen wasn't tempted by the future careers of her friends either:

> One of my room-mates was a dental hygienist, and I don't believe I could put my fingers in other people's mouths all day long. I was not very excited about that. (*Noreen*)

The educational advice that young women receive in school still leaves much to be desired, but at least as important in determining future study is inspiring teaching of maths and science, which provides a good grounding from which young women can go to university. Unfortunately, in the past girls' schools did not provide the same curriculum options as boys' schools or mixed schools. The establishment in the UK of a 'core curriculum' should overcome this to some extent. It should also help overcome the problem of girls in co-educational schools opting out of the sciences. However, it will not necessarily change what happens in the classroom, which girls can find so discouraging.

There are advantages to be gained from single-sex schools: small group teaching and no hostility from male peers. We wondered whether women from single-sex schools might find it more difficult to adopt to the masculine environment of engineering at university, but women from all kinds of school backgrounds seemed to find similar problems. All our women found adapting to university work and the social context difficult but exciting. They were not helped by the attitude of the majority body of male students. They coped by forming close relationships with a heterosexual partner or a group of women. The advantage of single-sex accommodation is stressed by the experiences of our sample.

There was little feeling of overt personal discrimination at an individual level. This could be because the standards applied to success were mainly academic and less open to bias than the standards applied to the workplace, where discrimination was reported much more, as we shall see later.

6

Public lives

We have chosen to examine our engineers' lives under the categories 'public' and 'private', *not* because we see these as natural categories, where women belong naturally to the private world where reproduction occurs, and men naturally to the public world where production occurs, but because they are useful analytical categories. They are power categories.

> an activity when performed by men is always more highly valued than when performed by women. When men act it is defined by them as acting within the public sphere; when women act men define it as acting within the private sphere. (Imray and Middleton, 1983, pp. 25–6)

The woman engineer represents an anomaly: she has crossed an invisible but well-defined boundary from the private, feminine world of women and entered a masculine world where she is competing with men on their own terms. Dale Spender discussed the public/private dichotomy with respect to the profession of women writers:

> Females who take up their pen have, at least, the potential to enter the public spheres and thereby cross and confound classification boundaries. This makes the woman writer, like the woman speaker, a contradiciton in terms, and a contradiction which not only has to be accommodated by patriarchal order, but by women writers as well. (Spender, 1981, p. 191)

The engineer is in a more contradictory position than the writer, since one cannot funtion privately as an engineer. It is an occupation *which only takes place publicly.*

How, then, do women engineers resolve the contradictions of their presence in a male world? What strategies do they use at work to establish and confirm their participation in the power group? None of our sample entered engineering because they wanted to transform the profession by their presence or because they wanted to be different from their friends. In Chapter 3 they described the nature of their work; there and later in Chapter 9 they talk about the satisfaction they get from their careers. However, while acknowledging the rewards their careers bring, the women identified problems which they had not expected, due to the fact that they are an embodiment of Spender's 'contradiction'.

Recognising the gendering of work

If they had not already been made aware at university, most of our sample were soon made aware when they began employment that their gender mattered to other people. It overrode some people's perceptions of any other aspect of their work. At some point they faced the fact that because they are women, the organisations they work for, and their male colleagues, may not have the unproblematic accepting perceptions of them that they have of themselves.

> Because there had been so may girls at university the shock of being in a male-dominated profession didn't really hit me until I started work . . . And it was a little bit of a culture shock – for the men as well as for me. (*Eileen*)

We asked Eileen what she remembered as being the things that shocked her:

> The fact that they reckoned I was different. I didn't think I was. You know, I had never been a women's libber or anything like that because I just didn't consider there was an issue. I was the same as the men (*laugh*). See what I mean? It took a bit of getting used to. (*Eileen*)

Imray and Middleton argue that it is the male definition of the two spheres that is dominant, and women as individuals cannot cross boundaries by simply ignoring them. It can be very hard to ignore these male definitions when the men you work with have created an

environment where women are objectified as sexual objects, for example by pin-ups:

> [While I was at university I wasn't aware] that there was any disadvantage [in being a woman]; at that time it didn't occur to me. Men were sort of exciting company rather than competitors. It wasn't until I went out to work that I started to become much more aware that there were women being discriminated against. It was lots of little things that began to come into my mind. When I first got to work on my first job, I was told it had been around the building that there was this new young woman starting, 'so I expect we'll be getting lots of visitors in the office in the next couple of weeks coming to look at you'. Then there were the calendars on the wall. I increasingly found these quite disturbing. (*Wendy*)

In Chapter 5 we described the problem of conspicuousness that our engineers suffered as students. There can also be advantages in being so instantly identifiable, in that you are likely to develop a personal reputation faster:

> I think now a lot of people know me and are actually 'phoning me up. They're actually asking for me rather than anyone else . . . possibly because I'm a woman engineer and that's probably part of the reason – they remember a name. (*Joyce*)

A competent, highly visible woman can also help publicise the company she works for. Tanya felt that the management of her company deliberately used her as an ambassador; for example, at conferences she represented the company to the outside world.

Only one woman, Suzanne, had obtained a job (in an academic institution) under a positive discrimination initiative, and since then she has been given a great deal of support by her Dean. Abigail hoped that she had achieved her present position due solely to merit, but she suspected that because she was a woman and black there may have been some positive discrimination:

> There are particularly successful women in this agency. And sometimes it's difficult to sift out if it's because you're a woman, because you're not in a crowd, because you're part of a minority, because you're black . . . Sometimes those kinds of discriminations are hard and very obvious, but for the most part, people are sophisticated enough to not let it through. And therefore you try to let it rest with the rationale that you're best for the job. (*Abigail*)

Most of our sample felt that their gender had been an issue in work. They were made to feel that they were different, and this applied even to those who felt the difference was irrelevant and had not affected their career. Being in a minority brings with it high visibility.

The professional image

To be accepted professionally our engineers felt that it was important that they presented the appropriate 'image' of a professional. But for an engineer that image is male:

> I conform . . . The men wear suits with collars and ties, so I wear a suit. I have a female colleague who wears jeans and kaftans and strange things, but I conform because I think it gives a good impression and helps you get accepted as a professional. (*Lucy*)

Conformity in appearance is important especially in companies where there is a 'corporate image' (Kanter, 1977). However, the rules for male dress don't make a statement about the gender and sexuality of men in the same way as they do for women. The image that the women engineers were trying to project had to reflect femininity and yet be serviceable for the number of different and sometimes dirty tasks that their work entailed.

> I try and dress professionally. If I know that it's going to be up to my ankles in mud, I wear jeans. But nine times out of ten I have nice slacks that I wear outside. If I am going to be inside, very seldom do I wear slacks, but that's professional, I feel. I wear a lot of suits . . . [with] . . . a nice blouse or a sweater. And I think coming across to people seeing me for the first time or anything like that, or even my supervisor seeing me every day or his supervisor who's right there too, seeing me every day looking professional, I think that would have a certain aspect on it if they decided somebody was going to be advanced. (*Noreen*)

What women wear also depends as much on *who* is going to see them as on the tasks they have to do. For instance, Pauline described how casual dress was more acceptable in the relatively secluded environment of a laboratory where she could wear shorts, but not when she had a visible management task.

The work tasks of an engineer do not fall conveniently into dirty,

invisible jobs and clean visible ones. Doris, for example, might spend some part of one day in her office, another part visiting a sewerage works where there has been a disaster, and then have lunch in an hotel with a visitor. Dressing to cover all these tasks and still look 'feminine' takes a lot of thought.

Zena was in the rare, and she felt enviable, position of having to wear a uniform: Levis, blue trousers and white shirts, which then solved the problem both of thinking about what to wear, or laundering it, because the company did that.

> you don't have to worry about what you're going to wear to work. I generally show up at work in something I'd work out in the garden with, and then I change into my uniform. (*Zena*)

Even women who rebelled against the conventional image most of the time realised that there were occasions when it was best to play down their individuality and present the expected image, which is also a racially white image:

> I have my own sense of what works and what doesn't work. I am by choice not your typical female bureaucrat. I do not like the business suit for one thing. There are days when I do wear the uniform because I've been at things where I don't want my clothes to interfere with what I have to say. Therefore I wear my 'power suit', I call it, if I have to go to a board in the conference room on the top floor with senior officials. For the most part I don't. I don't like that kind of wear, I think God designed my colour to make me wear colours, beautiful vibrant colours, and I take advantage of that. (*Abigail*)

The problem of having serviceable and feminine clothes is further complicated by the fact that engineers felt that they had to dress in a way that signified their difference from female clerical and secretarial staff. They had to reinforce the 'professionalism' of their image; they had to 'dress for success'.

> Some days I wear dresses and stuff. Or if its a quiet day I'll put on a skirt and be a little laid back. But it's easier – it's funny, though, when you dress like that – if it's those days when you're working around the secretary's desk, and strangers come into the office – they'll assume you're the secretary. (*Alice*)

This assumption is often implicit in the way a person addresses the

woman, rather than explicitly stated. And when the communication is by phone, the engineer finds it harder, without the signals of status given by dress, to assert her professional status. She feels that she has to deal with the problem implicitly, perhaps by demonstrating, by her grasp of the subject, that she is technical staff.

> they often assume you're the secretary without knowing, and they will try and explain things in too much detail; [then you] do a unit conversion in your head – if they say a unit in cubic feet per minute, say, you've converted it into metres per hour just to show that you know what the difference is and you do understand what they're talking about, without saying, 'I'm an engineer, talk to me'. (*Joyce*)

Kanter (1977) notes that presenting a professional image is not only restricted to clothes, but is also associated with other physical attributes, for example, skin colour, hair style or physical size.

> In the kind of work I'm in, a person's appearance carries a lot of weight, and I'm pretty small, and I think they immediately look at you and think, 'there's a lightweight.' (*Zena*)

Working style and the ability to project a certain kind of personality are also crucial. Although women may wear versions of the male suit they feel that they must not ape male styles of behaviour, but have to find someway of being feminine *and* demand respect. Margaret spoke for many of the sample who felt that they were better able to project a good image with the benefit of age and experience:

> When you go out on site you almost feel that you should be one of the lads, you know, and I have come across one or two girls that start swearing and this sort of thing, which I think is sad. And now if I'm on site and I'm climbing over a pit and there's a man there I will ask him to give me a hand, and I don't feel that it's the wrong thing to do anymore. As a woman I'm quite happy to be a woman, and if a man will give me a hand to go up a ladder or over a ditch then I'll do it. I think that's probably something to do with age and experience and confidence or something, whereas I think probably when I was younger I wouldn't have done that. I would rather have fallen down the pit than ask a man to help me over it. (*Margaret*)

Our engineers learned to obey unspoken rules about their appearance and behaviour to pass as engineers. However, the persona

they projected had also to declare their physical femininity, since being a 'masculine' woman would be even more unacceptable to their male colleagues.

Gender as an issue for male colleagues

> I don't tend to see myself as female, whereas I am a member of the team. So I hope that's how other people see me as well. (*Claire*)

However, our engineers gave many examples of situations in which being a woman/feminine was used by male colleagues to undermine them as professionals. These varied from outright refusal to accept the woman engineer, to a bantering jokiness. The former was rare but reported by our sample; the latter was a more common experience. It was received without malice by the women themselves, but it served to undermine them. Most had learnt strategies to handle this humour in a way in which they felt they retained their professional dignity, without being seen as difficult or humourless. In a few situations they felt defensive or even threatened. It appears to us that the range of behaviour described was potentially damaging, since the message the engineer is being given by her male colleagues is that, no matter how irrelevant she thinks her gender is to her professional activities, *they see her primarily as a woman and therefore out of place in the public domain.*

> I think there have been advantages and there have also been dis-advantages. Certainly working alongside as a female isn't easy. It is continuously difficult. It's personalities that make things difficult rather than the actual job. I mean physically I didn't see any reason why a woman couldn't do the job, but it was just working relationships that you could build up, particularly on site where they think they are very tough and not used to dealing with women. Also in the office as well, relationships can be difficult. I have found difficulties with my boss. You end up working for a man and relying on him to delegate work to you, and if he has certain reservations or prejudices it can be very difficult to get on with your job. He won't delegate work to you or trust you to do something or involve you in things . . . But I've never found anything that was totally insuperable. If you get into a situation where you're bashing your head against a brick wall, then what you do, obviously, is get out of the situation and move on to something else, which I have managed to do. (*Tanya*)

In the case of engineering, gender becomes an important issue around particular tasks – for example, managing manual labour. It could be the reason why a woman might not get a particular post, or be promoted:

> Then there is a big problem that I still haven't overcome: that one job I didn't get, or I wasn't even interviewed for, was in charge of manual labour. And there was another job which I didn't get. I was interviewed for it and I think it . . . a lot of the reason why I didn't get it was because again there was a lot of supervision of manual labour. (*Claire*)

The engineers felt that their male colleagues meant to be supportive and mostly were, however, under pressure more deep-seated prejudice could come to the fore.

> I was in a situation where there was considerable resentment; it was created by the management, and I went into a situation where I was portrayed as the high flyer who was there to fix the problem – which would have put anyone's back up. The avenue where resentment was shown was prejudice against, and obstruction against, my doing the job . . . the way that people showed their resentment was sexual, but I don't think that that was the root cause. I think the root cause was bad management . . . I would have had the same problem had I been black. The same problem would have existed, but the method of showing it would have been different. (*Sybil*)

Some male engineers report to their female colleagues that their wives are unhappy that they are working together. Curiously the men do not report that their wives have the same feelings about their working relationships with their secretaries. It is impossible for us to know what the wives actually said, but Kanter (1977) reported that female managers were the target of the sexual fantasies of male colleagues, that wives were aware of this, and the men played on the concerns of their wives. This can be a significant problem, especially for single women:

> How do you deal with the wives that don't want their husbands working with you? There's very little except . . . the ideal way, of course, is to bring your husband around for them to meet. They love that. But that's certainly an unfair requirement, since I've never had one. But I do find that attending things with them and making an effort to get acquainted with them is nice . . . in most cases you see enough of the fellows around the office that you wouldn't want to be carrying on with them anyway.

Their wives should not worry, but they will. (*Rachel*)

Male engineers, because of their own fantasies, suspect each other:

> One of my male peers said, 'You know I can't go to lunch with you'. And
> I said, 'What do you mean, you can't go to lunch with me?', and he
> explained very carefully to me that he couldn't go to lunch with me
> because it would be viewed very personally by his colleagues. They
> would assume that something was going on. And I said, 'Well, you know,
> my husband goes to lunch with other women and I don't think
> something's going on . . . but you think that your fellow engineers here at
> the lab will think that you and I are having an affair just because I go to
> lunch with you?' (*Pauline*)

These problems have to do with the elusive yet pervasive nature of
the sexual in the workplace. Hearn and Parkin (1987) argue that this
occurs in all workplaces and all organisational structures. In terms
of our discussion of the public/private domains, the sexual, which is
viewed as belonging to the private, is really very much present in the
public domain. It is brought here by the thoughts and actions of the
male engineers – 'the male sexual narrative', as Hearn and Parkin
call it – and projected on to their female colleagues.

Some of the most awkward times can be social situations both
within and outside of work. Our engineers described how their male
colleagues had problems finding topics of social conversation
outside work.

Competency and competition with men

When we asked our sample whether they had ever experienced
overt discrimination at work, few of them felt that they had, but
most described how they had to demonstrate their professional
proficiency in a very visible fashion, and they talked about their
deliberate efforts to gain the respect of their male colleagues:

> When you start off you've got to prove yourself, anyway, to begin with,
> and once you've proved yourself you just get on and progress. (*Claire*)

Sometimes the engineers began to suspect that they were not only
having to prove their competency but also having to prove that they
were even more competent than their male colleagues:

I don't think that I'm treated a whole lot, let's say, worse than the men. He [supervisor] goes over my jobs with the same fine-tooth comb that he goes over theirs [male colleagues] with. The way I feel sometimes is like you have to do twice as much to get half the recognition, and I do feel that way sometimes. But I can never say for sure that that's exactly what it is, because I don't think that the men always get the best treatment either. (*Noreen*)

Some of our sample would have worked extremely hard under any circumstances.

It's in my nature to work very hard. I think I'm not quite a workaholic but I'm close to it . . . I haven't thought, 'Well, I've got to be better than he is because otherwise I won't get promoted'. I'm just naturally somebody that likes to work hard and picks up on projects like that. So it hasn't been a conscious effort to be 'better than'. I think there is still unfortunately a need for women to do that; I think they're often more criticised, especially in environments where there are fewer of them and where historically there have been fewer. In this field and in broadcasting a lot of people working are engineers, and traditionally engineers have been men and therefore they work with other men. But my experience of working with engineers is that they are generally open minded; and that you have to prove your credentials are real. (*Lois*)

The need to prove oneself and be 'aggressive' is counter to what many women hold as admirable personal values. Pearl felt that the competitive nature of her company made her behave in ways she did not like:

[my work] is never good enough, it's never right. It may depend on the office. When I was in my last company they didn't care two cents whether I was male or female, it didn't matter then. I was sort of out of the engineering field. But it depends, I've had some very good engineering bosses. But the people in my office now are more of the same age and there's this constant fight to see who's going to get to the top first. So they bring a lot of personal things in and I don't think it's professional at all; they lie a lot just to manipulate their positions and I just don't like that . . . I'm not a mean and nasty person – I can be, you know, if you push me a lot. I've had more than I ever intended to take . . . and now I think that I might be a little too sensitive. (*Pearl*)

At the early stages of their career, while they were establishing themselves, women accepted changing their behaviour. Later they sometimes reached a plateau of satisfaction with work and their personal lives where they felt safe to reassert their personal values.

I'm not in the climbing mode any more. There are other things I'd rather do than be totally aggressive about the job . . . I like to read. The kids are older and more important than the job now. An aggressive posture isn't a good posture and I don't like to go into it. I want to back off a little. It wouldn't be a catastrophe if my career didn't go anywhere now. (*Abigail*)

On the other hand there was a tendency among others in the sample to see the problem as lying with women engineers themselves – as being one of women having less confidence, rather than men having prejudice:

I think it all comes down to having confidence in one's ability, and . . . women who go on and on and on about their rights . . . not getting a fair deal or being persecuted for their sex, so on and so forth, to a larger or lesser extent it is because of insecurity, and if they could only be confident in their own work and their own capabilities to do the job they are trying to do, then all these little minor irritations they just go away . . . I am not aware of having suffered any [discrimination] – I mean, you get the odd person who is antipathetic, but I have found consistently that if I can prove that I can do the job then eventually they accept me just like the rest. (*Victoria*)

Audrey believed that she benefited from the fact that her male colleagues were so competitive among themselves:

I would say that I probably get on with most of [my colleagues and junior staff] better than the lads. I have the advantage to them that I wear skirts and they like that. I am a great believer that good management is good manners, so I would like to think that I am extremely non-aggressive. Men are quite competitive about work, I have found. It's been quite a shock. And also I don't care even if I don't know how anything's done, I'm more than willing to be told now . . . There's no pride on insisting on being right.

Sometimes between themselves [men are quite competitive] but I've never found it particularly with me, but it could be because I haven't got a sufficiently senior position. But I've also been told that I have a fairly deflective manner that doesn't encourage this sort of thing. I'm just not interested in competition. I just want to get the job done, preferably correctly. (*Audrey*)

Setting up boundaries between home and work

A problem that women have to come to terms with, especially if

they live with a partner or have children, is the one of fulfilling their professional demands as well as the practical and emotional demands of being a partner or mother. The professions are renowned for being 'greedy' (Spencer and Podmore, 1987) in the sense that they demand an overriding commitment from members. The demands of the job are described, usually by the professional male, as primary, although a gender analysis raises question about both the real necessity of such commitment as well as the hidden agenda that lies behind it. Woman are more likely to be frank about the primacy of personal relationships.

Members of all the professions experience their work as demanding, and women engineers accept that success in their chosen profession will only happen if they appear committed to their work and responsive to the demands made by it. Because the work is task-oriented rather than time-oriented there are great pressures to stay late or take work home, and to be available on the 'phone while at home. Nearly all our sample were in full-time work, and that meant almost infinitely elastic hours, depending on the demands of a particular 'job' (or contract) at any time.

Women working for private companies where profits depend on completing jobs quickly, were under the most pressure with regard to the amount of control the company exercises over their hours. Rebecca, a UK aerodynamics engineer (with no children), works very long hours as a senior project supervisor. She is in charge of testing designs, and during the testing period she will work from 8.00 a.m. until 10.00 p.m., including Saturdays and sometimes Sundays. She remarked that she tried not to do more than two consecutive weeks like that. When she is involved with another part of the cycle of the job, she can relax, and is back to working from 8.00 a.m. till 4.30 p.m. However, she has up to nine projects in one year, which means nine such obligatory intensive periods of work.

Other woman have posts of senior responsibility, for example in public health work, which means that they may have to be 'on call' regularly over weekends. These kinds of pressures become extremely onerous if the same woman has the major responsibility for young children.

There is, then, a practical reason for setting up boundaries between professional life and personal life. The woman engineer is expected to be fully committed to each sphere, an impossible task, so the boundary between the two serves to identify which set of

priorities are primary at any one time. There are also contradictions in wanting to be seen as feminine and as a good engineer. Boundaries are set up to allow the different aspects of life to coexist with the least amount of conflict. It is also important for the career progress of the woman engineer that she is not *seen* to put her commitment to her personal life above that of her job. She must keep references to her private role and commitments out of the work context.

The engineers erected and maintained boundaries between these two parts of their lives in different ways. One common strategy was to reject the demands of the job after a certain time of day, and optimise the time spent 'at work'. Very few used their lunch breaks to do family chores like shopping. They tended either to work through their lunch or they would give themselves an hour's relaxation, by reading a book, going to a gym, swimming or running, or in one case playing patience with a computer. They compensated for such tight organisation of their professional hours by being more relaxed when they got home.

However, despite their best efforts they were likely to find themselves dealing with the mundane practical aspects of their personal lives on one level while they were intellectually engaged in a work-related problem. Meg, an older aerospace engineer, remembered lunch-time shopping trips when her children were young:

> usually when I was standing in line just waiting for the groceries to check out, I'd still be thinking about a technical problem. The same thing – I used to have thoughts, you know, and I'd do planning things or look into longer range what I wanted to do with something. I used to call those 'the things I kept in mind while I peeled potatoes' – you know, looking out the window. (*Meg*)

This comment also indicates the relative satisfactions of the two tasks.

The issue of the need to have well-defined boundaries between public and private demands is one reason why part-time work for professional women is not necessarily the optimum solution for women who are trying to reduce the pressure of demands from both spheres. Only two of the UK sample and one of the US sample had adopted part-time working after the birth of children.

> One thing I found working part-time was that other people in the office found it very difficult, I felt, to appreciate that I was not working the number of hours they were working. And they didn't seem to scale down that sort of element. (*Angela*)

Angela also found that she had to be willing to take on smaller and less important assignments.

One engineer had established a part-time routine that she felt happy with. She described having to be strict with herself and her colleagues about the tasks and responsibilities she took on. She accepted that colleagues would need to 'phone her during the working week, even though it might be her day at home, because she did not define her work in terms of the hours she did, but in terms of having fewer responsibilites, and doing fewer hours in the office.

Women had not only to restrict the demands of work; they also had to restrict the demands of home. How successful they were at this depended to some extent on their partners, many of whom in the UK sample were also engineers, but also partly on whether they had responsibilities towards children. In the next chapter we show that taking part-time work usually leads to an increase in domestic responsibility.

One of the most dramatic statements which illustrated the notion of deliberate boundaries between aspects of their lives was made by Claire, single and young. She conducts her relationships with her male colleagues in the public arena only:

> because I've always had to study with a group of men I've never wanted to become too heavily involved with anyone. I didn't want to mix business with pleasure . . . I won't go out seriously with anyone from the company. I go out with a group of friends and have a good time and certainly I will not get involved. (*Claire*)

Pregnancy, childbirth and children

All professional women have a problem when they come to have children. In Chapter 2 we described the differences between maternity leave provision in the UK and USA, although in both countries a supportive employer was open to negotiation with an individual woman to be flexible about it. Veronica and Angela both

have two children and both work for engineering consultancies. They both feel that their companies have been flexible and supportive of them. Veronica, with another female colleague, was instrumental in getting her company to formalise what had previously been informal and individually negotiated maternity arrangements, so that they became a publicised right of employees. As more younger women enter engineering, the issue of maternity provision becomes crucial in determining whether they continue their professional development and have children.

Angela, who earlier outlined some of the problems with part-time work, describes the arrangements she made with her company for the part-time work that she now does while her children are small:

> I was full-time with them for three years, and then I had Adam, and went on maternity leave like I am on now, the sort of statutory maternity leave. When he was about three months old, I started doing a little bit of work at home for them – an hour a week, something like that, and gradually built up. And then we had some staff changes at work and they wanted more qualified engineers in the office, so I went into the office to try and help them out there, and I also looked after a number of sites which gave me the freedom of working from home. So I did more supervision at that time than I would normally do, supervising jobs I haven't designed as opposed to supervising the ones I had designed . . . I started off doing calculation checks for them, which is rather a boring job to do and perhaps I would have resisted had I been in the office. So that helped them when I started, but at the same time I worked at home and did it at times to suit me. So it was very much a two-way thing. And then when I finished work [to have the next baby] I was doing about twenty-five hours a week. (*Angela*)

Angela went on to explain that her intention after the present maternity leave was to go back under the same arrangement. This was only possible, she argued, because of her full-time work there previously. Angela was working part-time when she took her second period of maternity leave. She was paid according to UK Association of Consulting Engineers conditions of contract, on a *pro rata* basis. She got full maternity leave and *pro rata* maternity pay.

When a number of women are in a similar position, as happened in Veronica's company, they are likely to achieve better conditions for themselves and for others. Or they make it easier for those following later:

I started full-time as an engineer, and the manager in my department had a baby the following December six months later. And just four months after that another woman who was pregnant had a baby. So it's sort of nice because two women have broken ground in my department. (*Julia*)

However, the time when women were pregnant or had young children were likely to be periods when their male colleagues defined them primarily as mothers, and in some cases they overtly discouraged them from continuing their careers. Not all employers were as supportive as the ones we have just described.

Yes, I think that on the whole [their attitude was] what made me more determined to go back, really . . . the attitudes of the man always take for granted that when you have a child you're gonna stay at home. And I think I get annoyed with some managers because I found that they replace my work-sheet straight away. It made me determined to go back. I think the company has been working as if you are not coming back to work. They have given me my P45 [a statement of taxes and earnings during a period of work, usually given to an employee when he or she leaves a job] and I signed off my security – the Official Secrets Act. They had my pass until I come back. But I insist that my desk should not be moved, they should not move my desk. (*Lin*)

Items such as Lin's pass and her desk are important symbols of her status within the company. The fact that the company tried to take them away from her with indecent haste indicates how strongly they felt that she should no longer be there.

Travelling

Travelling can be one way of gaining experience within a company and a route for promotion: to reject the opportunity to travel is to put promotion at risk. It is another aspect of the engineering profession that is highly influenced by gender. In certain branches of engineering, liaison with clients and their sites can mean a significant amount of travelling for the engineer. This may be relatively short distances of 50 to 100 miles and back in a day or, particularly in the USA where distances are much greater, it may mean periods of a few days or even months living away from home. This would obviously cause problems for women with young children, or for engineers of either sex who wanted to share a home

with a working partner. Decisions made by one partner can affect the career decisions of both.

> I suppose there might be places that I wouldn't be sent to, being a woman, or perhaps for being married. But I think that's partly up to me. If I let it be known I wanted to be sent abroad then I'd have as good an option as anybody else. In fact my husband and I have always felt that we didn't want to go anywhere unless it was somewhere where we could both pursue our own careers. That's probably affected him more than it's affected me. (*Veronica*)

Although single women and women with grown-up families are sometimes quite keen to travel, they can find that the company or their male colleagues have decided it isn't appropriate for them. In the past Rachel's employers had used an argument about the absence of facilities to avoid offering her options to travel. Travelling is also a situation where male sexuality and male sexual fantasies are involved. The hearsay worries of the absent wife are often used by men as a reason for not wanting to travel with women colleagues.

> I've always travelled alone when I've travelled. And at first I was afraid to go out to dinner by myself. Then I got over that. That I got used to. When I first started working, my boss passed a remark – he was joking – he passed a remark saying that his wife wouldn't appreciate me travelling with him – his wife would kill him. I got annoyed with that. And I said, 'Well, that's not going to help.' Next day he came in and he apologised to me. He goes, 'You know, I didn't mean anything against you; if we need to travel together, that wouldn't be a problem, because I was just teasing about my wife.' (*Alice*)

Since the work needs to be done, the trip needs to be made, more senior managers sometimes override the stalling tactics of male colleagues. But both the male and the female engineers then go feeling ill at ease with each other, she especially, knowing that she is not wanted.

Eventually the woman professional can begin to feel that it's all much easier if she travels alone:

> First of all, when I came to this job, the men didn't want me to go, 'cos there's a lot of feeling from one wife that she didn't want me to go. She'd never met me, she only knew I was a woman, and she didn't want him with me. And my office – I was surprised they just put their foot down –

just said she goes . . . I'd rather not travel with anybody any more than they want to travel with me. (*laughter*) No, seriously, I'd rather be alone, because when you're in the field, if you're not particularly friendly with someone, you spend a lot of time, because they expect you to go to dinner with them. I mean, I'd rather they just said, 'I'm going to get something to eat, or if you like we can eat together'. I'm a loner, I feel very comfortable by myself. (*Pearl*)

But Pearl seems unusually self-sufficient. As Alice has said previously, it can take some time for women to feel comfortable travelling alone:

I like travelling. It does need a certain amount of confidence to walk into a hotel dining room on your own. It's practice as much as anything else . . . No, I don't think I've ever been propositioned in a bar or anything like that, but it's a strange feeling that you're somehow on show. It's weird. I keep telling myself nobody's looking at you, they're worried about their meetings too. (*Lucy*)

Jokes and sexual harassment

Women professionals cannot afford to relax for too long with their colleagues. Imray and Middleton (1983) note the way that jokes are directed by men at women – jokes which stress their biological sex – and so attack that boundary between public and private which the women are attempting to maintain. The engineers in our sample reported this happening frequently. Most of them felt that they could handle it and that it was at the level of friendly '*badinage*'. But the effect is constantly to trivialise the engineer's professional status.

I was sat at a meeting the other day and it was the first time I'd contributed to the discussion because it's not usually my consultants who do the work. I was told, 'Oh yes, you're going to say something. I thought you were just here to look pretty.' And these sort of things sometimes come as a surprise, because I tend to forget that I'm a woman, so it sort of brings you back to reality that you are not just the same, you are somebody different . . . I know I once came in with some problems from the Department Manager and he said, 'come and sit on my lap, Margaret'; so I did, much to his embarrassment. He went very red in the face. I must say he never did it again. I just took that as a joke; so did he, but he felt very uncomfortable and he didn't make that sort of joke again. A lot of it isn't meant maliciously. I don't know if it's intentional because if you're the only woman they've had dealings with during their forty

years of working life its going to be difficult not to treat you as a secretary and not treat you as they would their wives or their daughters. (*Margaret*)

Such jokes are almost identical on both sides of the Atlantic. Like Margaret, Alice feels that she can hold her own, and she fights back:

> One of the guys came in to my office and asked me for some documents that I'm responsible for issuing. And I said, 'Phil, I haven't had a chance to send them to printing yet; you can have these, but I need them back.' He said, 'Okay, I'll get copies.' I said, 'Well, okay, here', and handed them to him. He looked at me and goes: 'Well, you can make copies, you're the woman.' So I took the papers and gave him a swift kick. But he – in a sense he was joking – it didn't bother me because I knew – he goes: 'You hit me.' I said, 'That's right, you say something stupid like that again and I'll hit you even harder.' We kind of had a little tease back and forth, but there's little remarks like that.
>
> In fact, we're trying to find out now . . . in a meeting a couple of weeks ago – I wasn't there, and my girlfriend that's also single wasn't there – but one of the guys told us that one of the engineers from another group said that he had never met a woman engineer that was worth her weight in salt. And everyone got a good chuckle out of that. So we're trying to find out who that is. (*Alice*)

Jokes can have strong long-term effects. Rachel was put off joining the Society of Women Engineers for many years by a joke:

> I was a member of the IEEE when it was IRE, Institute of Radio Engineers, and I was first invited to join the Society of Women Engineers about ten years before I did . . . but it was a case of . . . my peers dismissed the idea with the usual tactic of ridicule. Their reaction was: women engineers – well, I've heard of radio engineers, aircraft engineers, aeronautical engineers, but how do you engineer a woman? That kind of little thing, you know. And since I didn't know any others, it was easy to think, 'Oh, I don't want to belong to that.' (*Rachel*)

When the 'banter' becomes more than trivial it is obviously an attempt to undermine the engineer, and is perceived by her as an encroachment into her privacy. When we spoke to Audrey she was working her notice with a large multinational company, and the events described here were part of the reason for her leaving. She also described these events as occurring in the context of a working environment in which there was a great deal of social life surrounding work, and much of this involved heavy drinking and drunkenness, activities which she avoided:

I haven't suffered physical harassment in a sexual way here, but I feel a lot of the office banter [towards me] has gone beyond the acceptable point. One fella has pretended that he has fallen in love with me and has made life very awkward. He has made it obvious to everyone in the factory, so they always refer to it whenever I go to the pub . . . And when I handed in my notice a lot of people's first reaction was, 'Have you told him?' Well it's, you know, to me in an old-fashioned sort of way very impertinent. It's nothing to do with them and the fact [is] that at no time has this been encouraged. Everyone talks about it. I've found it very difficult – not helped by the fact that he is an extremely pleasant man who I have to work with. So you can't shoot your mouth off. You cannot say that you object because basically you have still got to get on with them and work. I think that on the whole I have handled the situation fairly well. Which doesn't mean to say that I have liked it . . . I have had to ask one of my bosses to refrain from putting his paws – sorry, hands – on me, which I have found awkward and I have not enjoyed. But when you get men individually, not as a group, there is never any trouble . . . I just want somewhere where the atmosphere is slightly more professional.'
(*Audrey*)

A British trades union study (Leeds TUCRIC, 1983) found that women working in non-traditional jobs were much more likely to report sexual harassment than those in traditional jobs – 96 per cent as compared with 48 per cent. However, the workers reporting were in the main unskilled and semi-skilled. We found few examples of overt harassment among our sample of professionals. It is not usually quite so public as that described by Audrey, but most working women have probably come across the type of person Joyce describes:

There's the odd person who you've had to sort of freeze out and be a bit careful about what's between you and the door.' (*Joyce*)

Hearn and Parkin discuss how defining sexual harassment is difficult. It can be defined as a set of

activities and actions; eying up and down; suggestive looks at parts of the body; regular sexual remarks and jokes; unwanted cheek kissing on meeting and parting; asking out on dates despite refusals; unwanted touching or patting; pinching or grabbing; direct sexual propositioning; forcible sexual aggression; the pinning up and maintenance of pin-ups. (1987, p. 43).

It can also be seen more subtly as a process more to do with men exercising power over women.

Wendy described a range of incidents which would certainly be classified as sexual, but apart from the problem of pin-ups, the men involved are likely to have felt that they were flattering her rather than harassing her. The incidents certainly illustrate the difficult ground that many sexual harassment arguments get on to.

> There's been, oh you know, hundreds of little incidents through my working life that have jarred. I think one of the ones that upset me a lot – when I first came here I felt generally the atmosphere was more sexist. I hadn't been here more than a few weeks. I was in the little area where we make our cups of tea and coffee, and one of the men from the office nearby came in and said, 'You're looking nice today you're looking really rapeable.' I just couldn't believe what I was hearing, and I said, 'What do you mean?' He said, 'You know, attractive.' And I gave him the benefit of my opinions and told him why I thought it was an appalling, insulting thing to say and short of murdering me I couldn't think of a worse insult. But at the time, as I say, I hadn't been there very long and I didn't say anything about it to any supervisor or anybody in charge of that man, and that did upset me. Well, I'm not sure I want to work in an environment where there are people thinking things like this . . .
> There were offices where there weren't just calendars with naked women on; there were whole walls covered in photographs that had been carefully put up – yards of photographs. And I hated walking through those offices. They were places where I had to go to get data and meet people, and I felt very self-conscious in those places and again, well, not at all confident. I know my behaviour was affected by that sort of thing. It was a bit of a joke in the office around the building that various women had at various times retaliated by putting up calendars of naked men to sort of make their point, but they'd actually been threatened with disciplinary action for doing that, or been told, 'Well, we're going to take them all down soon, but if you could just take yours down first as a gesture.' Of course, the ones of naked women never did come down. (*Wendy*)

Working with women

Although there could be problems with male colleagues, there could be different problems with female colleagues. In a response to a question about who provided them with the most support at work, none of the engineers mentioned female colleagues. Women who had got support and friendship from other women while they were students did not establish the same relationships with women colleagues in the workplace. They had complicated and contra-

dictory attitudes towards other women, both as a group and as individuals. For instance, if there is one other woman engineer she may detract from your special status. The fact that women can feel jealous or perhaps more precisely envious of each other is something the Women's Movement is only beginning to come to terms with. Maguire (1987) argues that it is only through admitting to our envy can we come to terms with what it is about. Nicola tried to understand why the only engineer she'd ever felt envious of was a woman:

> [I think there are advantages in being a woman in engineering] because if you're as ambitious as I am it's important to get noticed. It really is. I mean, don't get me wrong, if I had been a bad engineer I would have been noticed very soon and marked down as a bad engineer. So if you are going to stand out in a crowd and you're going to get on, you are going to be good. OK, I'm a good actress I suppose . . . The men have to be substantially better to really get noticed. So I've always thought that we were at an advantage. And if you carry that to its logical conclusion, women in engineering are not all that keen to see a lot of it. On one side of the coin you don't want too many other women in there because you lose your uniqueness. Now, yes, I would love to see more women in engineering in a way, but I don't think it makes any difference whether they are women or not. From the other point of view, I would say that the one person I really felt jealous of was another woman. I mean I just didn't like her and I couldn't get on with her. I felt that she had got much more charm and she was younger as well, which made it all the more galling. But I'm still sure it was because I was jealous that I didn't like her. And I think that I'm probably not the only woman who'd ever feel that. (*Nicola*)

Anne is the only woman in such a senior position in her organisation, but there had once been another:

> Very interesting, she was the one I had the most difficulty with. (*Anne*)

Kanter (1977) discusses the problem of prejudice against women bosses, by men and women. It existed in the work environments of our engineers and among the engineers themselves:

> partly encouraged by the men around, women were very suspicious – both at work and not. And a number of my very close friends, ultimately, they would really worry when they were going to have to go to work for women . . . including – a group including me, because we just thought, 'I'd be terrible to work for', and that sort of thing. (*Rachel*)

Of the three engineers who had female bosses, Claire and Lois felt
that they had received a lot of support from them, whereas Abigail's
comment was more cryptic:

> Let's say I get along with her, it's reasonable, we stay off one another's
> back. (*Abigail*)

It can also be difficult for engineers to establish good working
relationships with their secretaries, because secretaries hold the
same myths about the difficulties of having a female boss.

> I don't get along well with some secretaries, because they are used to
> taking orders from men and seeing men in my position. There's one
> especially in the office that resents my position tremendously. And I've
> told her that if you want what I have, you have to work for it, you don't
> just get there, but she should know by now that what she needs to do is to
> go and take some college courses. (*Pearl*)

Anne had, she felt, managed to deal with the initial mistrust of the
secretaries by being more informal:

> But one of them said, 'I always thought women bosses would be bitches,
> but you're really a very nice person.' (*Anne*)

Summary

We have identified those aspects of the public professional lives of
women engineers where their gender was significant enough in their
own or others' eyes to affect their work in some way. We have also
looked at the way in which the women set boundaries between their
private lives (as sexual beings and mothers in particular) and their
public lives; and the way in which some of their male colleagues
constantly cross those boundaries, invading both the women's
privacy and undermining their 'personae' as professionals.

The picture we have presented here seems a bleak one, since we
have demonstrated that the 'contradiction' identified by Spender
exists for women engineers. This is not something that the women
themselves feel, but they are made aware that it is the perception of
many of their male colleagues. This perception is no longer to do
with the nature of the work – if it ever was; it is the result of the

power of the male engineers to impose a social construction on the profession and endow it with gender. The effect of the 'double day' on women is wearing enough, but the strain is increased when the engineer is made to feel self-conscious at work and sometimes undermined. Erecting and maintaining barriers between the public and private aspects of life demands energy and vigilance.

> The solution to the problem of why women do not do better lies in integrating the private (feminine) and public (masculine) experience of the world, for it is the split between the two which breeds the idea that they are inherently opposed and that achievement in one can be gained only at the expense of the other.' (Baines, 1988, p. 43)

Baines's argument corresponds to much feminist literature: the integration of both domains of life, for men and women, would make a better world. However, most of the women in our sample would most likely find that a very risky prospect to attempt at present.

Despite our analysis, most of our engineers felt that they *were* achieving professional success and personal satisfaction. Many of the practical problems that non-professional working women face, such as organising childcare and housework, can be solved by these women, whose incomes are large enough to employ others for such work, although guilt and responsiblity are not sloughed off so easily. Freed of some of the more practical burdens, they had great enthusiasm for the intellectual and personal satisfactions of the work, which is why they wanted to be interviewed. It seems to us that in this context the 'critical mass' theory certainly applies – that is, that the situation would get better for all women engineers if women formed a significant proportion of the profession. Professional relationships for women are those which are characterised among other things as not acknowledging the gender of the people involved. This is not so for their male colleagues, who appear, even in the 1980s, to connect professional ability to masculinity. Increasing the proportion of women would not necessarily change the minds of the men, but it would provide a less hostile atmosphere for women engineers. We look at positive strategies to bring this about in Chapter 10.

7

Private lives

In the previous chapter we described how important it was for women to keep their private selves and their public selves separate. In this chapter we illustrate the ways in which the private sphere is paramount for many of our engineers, and for their immediate families. The private sphere is the place where women feel the most guilt about their performance – as mothers and as housekeepers. Whereas the problem in the last chapter was that many colleagues used the engineer's gender to undermine her work, in this chapter we see that the woman herself and her immediate family make few allowances for the effect of her professional work on her private responsibilities.

About a quarter of our interviewees were single and childless; most of the rests – who were married – had children. We are therefore, in the main, looking at lives which contain a lot of responsibility for others, as well as benefiting from the support and pleasure these others provide. Almost all the married engineers were members of dual-career families, where the husband too was developing a professional career. Only one engineer had a husband who had given up his job to be the primary carer of their child. A small number of engineers with babies had worked or were working part-time.

The problems faced by dual-career families have been well researched since the Rapoports coined the phrase in 1969. Much of what we will describe is not specific to women who are engineers. Our research supports the Rapoports' assertion that couples in the 1970s (and in the 1980s) plan a dual-career life much more deliberately than those in earlier generations. They

engage more in a dialogue that involves planning and equitable exchanges or balances of advantage. They accept more the need to make explicit as many as possible long- and short-term costs and benefits for both partners in major life decisions. (Rapoport and Rapoport, 1976, p. 298)

We see this happening, as the plans, strategies and tactics the engineers' families have evolved in their private lives make possible the engineers' continuing careers.

We start with children and childcare, because for those women with children this was the area of their lives which was most difficult to balance with professional commitment. It also provided the most satisfaction, equal to or greater than the pleasure they got from their career. Also (and perhaps because of this) children were the source of most stress and anxiety.

Children and childcare

Because of the responsibilities for childcare before and after work (see Chapter 3) our engineers work a very long day. If they are lucky their husbands may be able to relieve them of the childcare before they leave for work in the morning, but they are usually responsible for it in the evening, when they combine cooking for themselves and their partner with cooking for their children. This is a familiar pattern for professional women (Rueschemeyer, 1981).

The engineers make sure they still have energy for their children after a day's work. They help their children with their homework, take them out, play with them – activities which they find pleasurable and even refreshing. Many had work tasks they had to do after the children were asleep. Margaret, who commented that by the time she got her little boy to bed she often felt too tired to do anything, usually got second wind and then did work connected with WES and her other professional associations. Despite the amount of hours they are obliged to spend away from their children, in their evenings and at weekends the women compensate by engaging in all those things that non-working mothers do. They have to believe that it is the quality of the time spent with children that matters rather than the quanitity.

The combination of commitment to a career and commitment to children can leave a woman with no time for herself:

> We, I guess, got into the habit of being stay-at-homes while our children were small because you're not there during the day with them, you tend to spend your evenings and weekends [with them] . . . and maybe what accounts for my not being more enterprising – doing more things for myself now – is all of my time when they were growing up was devoted to making sure that they got to their ball practice or their soccer team, or wherever they were going. (*Meg*)

Our engineers have the prime responsibility, if not for doing the childcare, then for arranging that it is done by other people. This was most obviously the case for Angela, who was working part-time, and for Jennifer, who was self-employed. She found it hard to secure the privacy to work during the day while the nanny looked after her son in another room in the house. It appears harder for a woman *not* in full-time employment outside the home to delegate her childcare responsibilities, and to stop them encroaching on her work. This is also to do with the fact that being with children is often rewarding, and women who take up paid work have to forgo some of those rewards.

Hazel's childcare arrangements were very different from the rest of the sample: her husband gave up work when she had her baby. At the time he was earning less than her as a blue-collar worker, and although he wasn't qualified as a teacher he had spent time studying at a teacher training college. These were some of the factors which led them to decide that he would look after the child.

> I have a little boy who is six and a half . . . When I knew I was pregnant, we were thinking that maybe we could get a nanny. But my background is very much working class, and I never thought of having a nanny, but my husband, he had a nanny when he was small, so he said, 'Don't worry about being pregnant', because I definitely didn't want to finish work because I went to university late. But he said, 'Don't worry, we'll get a nanny.' Well, then as time went on the little boy became so special, before he was even born, that I was concerned that the person would bring him up the way that we wanted him to be brought up, and then my husband volunteered to look after him. So it's pretty unusual. . . . So in fact I took maternity leave only up to the maximum. I took five months off and went back to work, and my husband looked after him. (*Hazel*)

All the other women relied on paid childcare of some sort. Other family members, usually the child's grandparents might be a back-up, as was Audrey's mother. In some cases parents are not around or are not willing to be the the main carer, but in others women had

learned that an arrangement based on obligation can work out at a
higher price than a paid relationship.

> We started off by really feeling that my mother and my husband's mother
> would take care of our first child while I worked. We quickly discovered
> the price one pays in gratitude is too great. And it's not good for them –
> it's not fair to them and it's not fair to us. I had discovered the only way
> one can manage this is to spend a lot of money for really good and reliable
> household help. And I have been very fortunate. One pays top dollar and
> one gets really good people. And you don't worry about cleaning; what
> you do is hire help to help your regular housekeeper, and you find
> someone who is wonderful with children. And I found such a lady who
> worked for me for sixteen years. (*Anne*)

When children are of school age, arrangements have to be made to
look after them during holidays and between the end of the school
day and parents returning from work. Complicated strategies have
to be worked out. They frequently break down, and mothers end up
relying on one 'special' woman, who obviously has a commitment to
the family or children which goes beyond what would be expected of
an hourly paid worker.

Where there was no back-up, parents had to juggle with their
job commitments:

> [The toddler] was quite poorly before Christmas and had to go into
> hospital for a few days to find out what it was. We have to take holidays
> and we work it out between us, who can take a day off whenever. We
> were almost, 'Well, I've got a meeting this morning', 'Well, I've got one
> this afternoon', and we spent two weeks in and out of the office. I
> managed to cope that way. We split it 50/50 almost in the end, so that
> there was one of us with him all the time. (*Margaret*)

Margaret also went on to surmise that their arrangements could not
deal with more than one child. It is not just illness that causes young
children to be such a strain; babies often cause broken nights, most
frequently for mothers:

> There is a problem with us because he is still waking up at night – I would
> say 99 per cent of nights he wakes up, and it tends to be me who goes in to
> see to him because if my husband goes in to see him he tends to wake up.
> If I go he'll cuddle and go back to sleep and I quite often bring him into
> bed with me (because I'm like a zombie at night); he'll go back to sleep
> and that's the end of it. It tends to be always me that gets up to him. This,

I find, is another strain because I get pretty tired. That's a bit of a problem. (*Margaret*)

It is not only small children who are very demanding; older children are demanding in a different way. Pauline was a mature student when her children were teenagers:

> Some of the hardest times were when we were all in college together because they would show up – they lived in dorms – and the weekends that they would show up invariably would be a weekend that I had a test on Monday or things were really hectic. But if they showed up I knew there was a problem. They didn't come home just for a lark. Normally they came home because they wanted to talk. And so those were the weekends where I just sort of had to put the books away and say, 'Well, yeah, I'll do the best I can on Monday because I really need to be a mother this weekend.' And sometimes those were the roughest weekends. (*Pauline*)

Despite the obvious commitment the women have to their children, and the amount of energy they expend in trying to organise their families, they are often left with a sense of guilt that they have not done enough. Comments made by people outside the family contribute to that sense of guilt. Lucy described fighting against accepting the guilt that other people wanted to impose:

> No, they don't make me feel guilty any more. I think other people ought to do them – oh, everything from ironing shirts to going to jumble sales. I never go to jumble sales any more because I hate them. I'm sure there's people who really think I ought to do my bit – like my mother! (*Lucy*)

Domestic work

This is another area of their private lives where our engineers felt under pressure. They felt that it was ultimately their responsibility to see that homes were clean and comfortable places for all the family. Research from the Rapoports onwards has indicated that although the sexual division of labour in the house may not be as strong as it once was, domestic work is not apportioned equally between partners, even when someone else is paid to do the bulk of the work. The symmetrical family described so hopefully by Young and Willmott (1973) is not the norm.

All the women described how there was a sexual division of tasks: some they always did and some their partner always did. The situation can be influenced by the constraints of a particular period of the couple's life and by the husband's job. Jane is married to a clergyman, and when we interviewed her she had just finished working on her PhD. These circumstances helped relieve her of some tasks, because the daytime flexibility of her husband's work meant that he could do many domestic tasks while she was at work. However, the expectations others had of what Jane should be doing as a clergyman's wife created pressures she had to resist. For example, it is usual for a clergy wife to provide food not only for her own family but for the many parishioners and visitors who come to the house. When visitors were expected, Jane's husband cooked for them.

For many of our sample a division of labour evolved as their relationship with their husband developed, without there being a conscious decision to do so:

> Before I got married I used to do a lot more. I'm pretty lazy now. I used to even work on my own car . . . but not any more . . . Lately all of my non-work-related activities involve, you know, quite domestic things: washing laundry, dishes, cleaning the house, gardening – the very, quote, 'female type' activities . . . My husband does all the cooking, so he does that job. And he does most of the heavy outdoor work. He'll clean once in a while. When things get really bad here he does some cleaning. It's kind of evolved into [a division of tasks]. (*Zena*)

For others it is the arrival of children which forces them into performing 'gender appropriate' tasks:

> What's tending to happen is, I do the general domestic chores and he does the maintenance of the house . . . When we first got married we used to do everything together. One of the first houses we got had a lot of building to be done on it. It was the case that I was smaller to go under the floorboards, so I was the one who went under the floorboards and did the rewiring and things like that. This split in domestic duties has really come with the baby. I'm more efficient at cooking and getting organised in that role because I've had more practice at it since I was a child, and he has more stamina in the garden. You know, it's just logical to do it that way. I'm quite happy doing the redecorating inside, the interior painting and decorating which I really quite enjoy doing. But I am not as fast as he is. It's time and motion, you know. (*Margaret*)

Hazel, whose husband had given up work to become primary carer for their child, seemed to have one of the largest responsibilities for housework. At the time of the interview their child was at school and her husband was working as a self-employed joiner, while still taking major responsibility for looking after the child outside of school hours. This might explain why Hazel felt that housework was her responsibility, although she explained it differently herself. She previously had four hours a week cleaning help, but the cleaner had become ill and all the work now fell to her.

> I don't sit down on Saturday until about six o'clock because I'm involved in getting this house ship-shape, shopping and sometimes I do some cooking for the freezer, you know, beef in red wine to help life for my husband during the week; just to try and get organised. And again it's very much [on] my conscience a the weekend. I try to ease my conscience as a woman. I have no pressure from my husband – I don't want you to think that – but to me in this role of working and being the mother, I ease that by working on Saturday and Sunday. And I can say to you that my conscience is clear only if I'm not in the house. So I tend to whiz down and see my mother for a cup of tea – she just lives very close – or go to see my Aunties or go to see a friend for a couple of hours at the weekend. Because if I don't, my conscience doesn't allow me to sit down and do nothing. Again I think it goes back to my background, you see, my working-class background. It's really, nothing really, to do with being a woman. (*Hazel*)

Zena described the division of labour as evolving in a non-deliberate way. Margaret described it as evolving in a 'logical' way, to do with 'time and motion', justifying it as far as she could outside explanations of gender ideology. Hazel denied its connection with gender but related it to her class origin. But such a consistent pattern of behaviour suggests a cause beyond the range of personal explanations offered by the women themselves. It appears to demonstrate, rather, how hard it is for women to break through the ideology of housework as women's work, even when they do not consciously accept it.

Most of our sample were keen not to represent their husbands as unhelpful, yet they felt they carried the larger burden. The following comment was typical in terms of describing an attempt to share domestic tasks:

> Well, I take off early on Fridays if I can and I do the shopping, and I think my husband probably would do the shopping if I asked him – one starts to

get into these routines where one chore happens to fall on to someone. So I've done that. I'm sure I do more than my husband when it comes to domestic chores around the house, but I would not like to characterise him as not being very good and helpful about helping . . . We split things pretty evenly, and it's not as though we have set tasks which are women's tasks and set tasks which are men's tasks by any means. If two things have to be done then we just split them and it doesn't particularly matter. He cooks dinner and he cooks breakfast, things like that. We take turns, and so it's good that way. (*Suzanne*)

Only Meg who is now in her sixties, was comfortable in admitting that her husband did nothing, due, she explained, to his upbringing:

His mother had never had him do anything like that, and while I've known women whose husbands did their own laundry and stuff like that, certainly not mine. He still doesn't. (*Meg*)

The responsibility for housework and childcare was wholly hers, and she carried out the tasks involved with the help of a paid housekeeper. Her children are grown, but the domestic responsibilities are still hers.

Even when women felt that there was equitable sharing of the tasks involved in housework, the responsibility for seeing that tasks were done was theirs. Nicola knew that it was her standards of cleanliness and presentation that determined whether tasks were done:

Cleaning happens whenever one of us can't stand it any more, which generally means that I do it. (*Nicola*)

Victoria was most conscious that the issue was one of delegation. She had obviously spent some time thinking about the problem and discussed it at length with us:

I read a wonderful book called *Paths to Power* . . . The author said in there what I think is so true; you can delegate work but have you delegated the responsibility for that work, and that is the big thing. I can tell my husband to do the washing 'cause I'm going to be away, but the responsibility for the washing being done is still mine . . . As hard as I try, it's always me that worries about whether we've done the housework or the washing or the shopping has been done . . . When I do get to the stage where I've actually delegated responsibility for it, then if he does the shopping and makes sure it's got, we're on a whole different ball game. (*Victoria*)

Later in the interview Victoria discusses her ability ·to delegate successfully at work:

> I surprised myself at how good a delegater I am. I always thought that I would regret not doing it – a practical task – myself, and in fact I found it incredibly easy to tell somebody else to do it. I think it's wonderful. The only thing is, I suppose I worry about whether they'll do it as well as I would, but that doesn't stop me from giving it to them. (*Victoria*)

The issue is not that Victoria cannot delegate, but that there is something about the nature of domestic work which makes her unable to delegate that.

Most of the women, especially those with children, employ someone, usually for a few hours a week, to do the basic cleaning in the house. Only the older American women had a full-time domestic 'maid' or 'housekeeper'.

Many of our interviewees mentioned their guilt about housework. Anne referred to the 'superwoman' myth: the pressure to be a professional and do all the domestic tasks a non-working woman would do. She referred to it as an issue of guilt, and guilt to be fought against:

> I think that I see too many working women who feel they have to live up to the myth of the superwoman. I felt it somewhat, and I had difficulty with it; that when you're at home you have to be superwife, have to be supermother, have to be superhostesss. You have to do everything. I'm discovering as I get older that I can have dinner guests and not have every single thing on the menu prepared with my hands. You know, you can buy wonderful breads – you don't have to bake them. You can buy wonderful cakes and not have to bake them. But I also still see too many working women reluctant to spend money on adequate help, out of guilt . . . they shouldn't . . . if you can afford it, for God's sake, get help. There's very little satisfaction in scrubbing floors and windows and cleaning and doing the laundry. If you can hire someone to do it for you, do it. It improves the quality of your life. (*Anne*)

Because it was the woman who felt the guilt, it was usually she who saw the necessity of having domestic help and she who organised it. Husbands were less bothered, and in a few cases were initially against the idea.

When domestic help is employed it may be the case that she takes over the husband's responsibilities rather than the wife's. Jennifer

employs a nanny/housekeeper. However, two regular and time-consuming tasks that she still does herself are the shopping and the cooking, whereas the two tasks her husband does are the car and emptying the dustbins. The one housework task the nanny has removed completely, the vacuuming, used to be her husband's.

The engineers are not cavalier in their attitude towards the women they employ to do part of their domestic work and childcare. They are aware of their reliance on them. Dora, who had employed someone full-time for many years, accepts that she now has a responsibility to that woman until she is old enough to receive her government pension, despite the fact that she has no real need for her any more:

> Well, mostly I have this maid. She had worked with me and she stayed . . . When they had a retirement party for me, I brought her to point out that behind every working woman there's a working woman. And I'm afraid that's still true . . . Really the problem is now I don't need her with the boys grown. But she is in her sixties, and [I need to support her] until she's 65 and can draw social security. So I'm in a situation where as long as I can have her work for me, she works for me. (*Dora*)

Involvement in traditionally male interests

We do not want to paint a picture of women workaholics, who spend the rest of their time only on childcare and housework. Our engineers, especially those without children or with older children, managed to enjoy many other activities in their free time.

We were interested in whether their profession of engineering influenced in any way the kinds of activities they did outside work, especially whether their expertise in a traditionally male field might encourage them to pursue hobbies or attempt tasks which have been traditionally male, like repairing their car, or playing with a home computer.

One idea of which women wanted instantly to disabuse us was the notion that there was any necessary connection between their professional work and such activities:

> I always thought that being an engineer meant being good with your hands. That's not true. A good part of engineering is applied mathematics. That was what scared me about going into engineering. I became

an electrical engineer, by the way, because I was terrified of machines. I never fixed cars, I hated chemistry. I thought that civil engineering meant that you had to stand in a hard hat and boss a team of construction workers – total ignorance. That left electrical engineering, and I said, 'Okay, it's mathematical; okay, I plug things in, how bad can that be?' (*Anne*)

This point was also made by Victoria, who did enjoy a bit of technical tinkering:

Well the job I do is a very industrial job and it's not really applicable to home, apart from maybe a thermostat on a central heating system is the closest you can get to what I do in domestic circumstances. But I am sort of *de facto* chief electrical bits at home . . . and I maintain my own car. I've always done [it]. Again I learned from [a previous boyfriend] . . . Every now and again somebody says, 'Can you have a look at my radio', or whatever, and I might have a look at it. I mean, if something technical doesn't work at home I will pull it apart before I send it away to be mended. (*Victoria*)

Pauline found her non-competence embarrassing, mainly because other people did not expect it of her:

My husband thinks it's really bad because I don't know how cars work. And he thinks since I'm an engineer, I ought to know how an engine works. In fact, Saturday night, he was talking to me because I used the words 'motor' and 'engine' interchangeably. And he made a point of telling me that if you're an engineer you should use the words 'motor' and 'engine' correctly. I guess that's just a segment I've never been interested in. In fact, I burned out one motor in one automobile – one engine – because I didn't put any oil in there. (*Pauline*)

In general the engineers felt that they knew theoretically about the devices and systems, but they were no good at 'doing' work on them, and they didn't really have any desire to do it. Their knowledge also made them wary of meddling with things that they knew to be dangerous, and they were conscious of the limitations of their physical strength when dealing with equipment designed to be used by a physically powerful man. They regarded activities such as care and home maintenance, not as pleasurable pastimes but more as tasks impinging on the small amount of precious time they had to relax with their friends and family. So, as with housework, they paid someone:

Both my husband and I feel that if we wanted to do [car maintenance] we could, but our time at home is very, very precious and we want to use it on pleasurable pursuits rather than work pursuits. So if the washing machine breaks, then you call in the washing machine man. (*Joyce*)

Dora, therefore, stands out as the rare example of an engineer who was practically oriented and enjoyed exercising her technical competence:

I repair my switches. Would you like to see? I can show you my installation upstairs. There was a nasty light switch in the linen closet and my husband was always going to get around to it. The first thing when I quit, the first thing I did, was to repair it. And I went around repairing light switches, re-installing them. I regularly repaired the TV sets . . . The thing had about five thousand parts and I was afraid that some of the parts would be missing by the time I got to put it together, but I did it. (*Dora*)

Some of the engineers had once pursued technical hobbies, but the demands of work and other domestic priorities pushed these into the background. The level of technical expertise that the women operate at work is not applicable to domestic artefacts. None of them were interested in aspects of new information technology for its own sake. The one who had a micro-computer at home and worked on it a lot was the self-employed consultant who worked from home. For some women their professional competence helped them to deal with those men they employed to maintain the technical aspects of their personal lives. The women were keen to deny the necessary connection between their work and technical hobbies. This is important with regard to designing educational strategies to encourage young women into the technological professions.

Apart from Dora, none of the women we talked to was a hobbyist of any sort. So what do the engineers do in their non-working hours apart from spending time with their partners and children – those who have them?

Non-work-related interests

It seems to be a truism that women with busy working lives have busy private lives. It is also interesting to see how many women

engineers are involved with a variety of activities, especially in the arts, which suggests that they do not fit neatly into C. P. Snow's 'two cultures' dichotomy. As one would expect, single women have the most leisure activities. These often involve music and activities related to the theatre. Doris, for example, produces an amateur operatic company and performs in amateur opera and drama, as well as producing a variety of events for charity. Some of the women are active in their local community: Sybil is treasurer for the local branch of the Guide Dogs for the Blind, a school governor, and works for WES.

Frequently our younger engineers had leisure activities involving strenuous physical activity. Wendy goes mountaineering and has involved her boyfriend in the sport. Audrey plays competitive squash and Victoria plays badminton as well as going sailing.

When women had children it was these kinds of leisure activities that they abandoned. If possible, they might continue their activities in their lunch breaks. Julia described using a gym at lunchtime in order to keep the evening free for her son's leisure activity: she and her husband take him swimming. However, some kinds of activities, for example Veronica's involvement in local politics, cannot be moved to other times and have to be abandoned altogether when children are young.

The pressures of work cause some women to look for an 'escapist' leisure activity.

> I read a lot. I kind of chain-read murder mysteries. It's the way I unwind. So I will go through about five murder mysteries a week – I read really rapidly. Compared to the technical stuff I do it's really very, very easy . . . I will pick up a murder mystery – and I'm sounding like a trivial person, it's embarrassing – rather than a technical journal in the evening. (*Anne*)

Wendy mentioned the importance of physical activity as relaxation. Pearl talked about running and walking at lunch-time to 'work off the stress'. She then described her other leisure activities, which she developed as an outlet for the stress of her job:

> On Tuesday nights at 6.30 I take scuba diving . . . I couldn't swim when I first went in and I've almost passed the swimming test. And I get two and a half hours' swimming at the pool on Tuesday and a two-hour lecture on Friday. I try to stay very busy. I did the whole yard myself, and that used to be how I worked off my aggravations. So when I ran out of yard space I had to find something else. (*Pearl*)

The American women were more likely to mention the issue of stress, and the pressure for the job to take over their whole lives. Ella and Abigail felt this so strongly that they engaged in activities which could lead to different careers and at least give them some feeling that they have options. Ella (who has no children!) described herself as a potential workaholic, who developed other responsibilities to get her away from work:

> I need to build in responsibilities to other things so that I can get up and leave my job at the end of the day, otherwise it's almost like if I can't think of a good reason to go home I'll stay. So you have these things that are responsibilities. Even if it's the dog has to be walked at the latest by 10 o'clock if he hasn't been walked all day. It's a responsibility, and that's why I've got to be at home. (*Ella*)

Women mentioned the importance of having time for themselves. For Jane this actually meant time to be alone 'with' herself, whereas for Hazel this was the time she went to have her hair done, a chance for a little private luxury that she thoroughly enjoyed.

Our engineers were 'cultured' women in that commonsense meaning of the word. They were often interested in the arts and active performers in various aspects of it. The younger women were likely to engage in active sports. It is impossible to know how far these sporting interests are encouraged by the masculine working environment, where active sport is much more common; how far they were done with male partners as an opportunity to be together; how far they were part of the women's self-image of active 'do-ers'; and how far they were taken up deliberately to alleviate stress. However, as the women moved into the phase of life when the responsibilities of work and family increased, these activities were regretfully abandoned, but looked forward to in retirement.

Partners

Partners and children are not only a cause of more work for women, but also a primary source of pleasure. The Rapoports have noted that as women become involved in their careers, they risk losing their traditional sources of social support, especially of other women in their local community and in their family. They become more dependent on a limited range of people close to them, and

most importantly on their partners. Gower and Legge (1978) discuss the ways in which working couples establish contracts between themselves to deal with practical day-to-day tasks and priorities over career development and mutual support. Weingarten (1978) develops the concept of interdependence to describe a coping strategy of successful couples, which allows them to help each other and deal with the stresses of two careers.

We were not surprised to find women speaking in glowing terms about their relationship with their present partners. The survival of the relationship under the pressures of two careers and children suggests a very strong and successful relationship, in a society where it is still exceptional for a woman to have a career and a family. Those women who do so are conscious of the unusual level of support received from their partners.

How did the men support their partners? The least they did was to adopt a *laissez-faire* attitude or one of deliberate non-interference so that the women felt free of pressure. Meg described her husband as operating in this way. A partner can also provide a refuge and a sense of worth beyond work.

> I tend to think that if I weren't married I would become the classic workaholic. . . and luckily I'm spared that because I have a husband who restrains me. (*Ella*)

Husbands can make demands which, depending on the particular circumstances of the women, can be a source of extra pressure, or can help erect defences against work pressures. Anne described how her husband made demands on her to spend time with him; these demands helped her resist becoming completely submerged in work, which was something she did not want to do:

> It's very, very important to my husband that I make time for vacation. And since the commitment to my husband is even more serious than the commitment to the school, I'm going to take the four weeks this summer . . . I must say he's quite jealous for preserving time together. (*Anne*)

Although many of the women's partners were engineers, they did not spend much time at home discussing each other's work; they seemed instead to make a deliberate effort to keep work at a distance. Nicola described how although she and her husband talked about setting up in business together, she felt it might be

damaging for their relationship to have it so closely tied to work, since one of the functions of their marriage was to provide an alternative world where they could escape from work.

There is no doubt that a man has a price to pay for having a professional partner. In the early years decisions have to be made about whose career has priority at any one time; this especially affects the decision about where to live and work. Sometimes decisions are made in favour of the career progress of the wife:

I had no future in that company, they weren't going to offer me a job, and I was desperate for a real management experience so that I could find a job elsewhere. My husband had accepted a job in B and started working there last February. It was principal design engineer with a power supply company, which is his speciality . . . This is when we still thought we desperately wanted to start our own company (and if we ever do it will be in power supplies). So he needed that design engineer experience, to meet customers, if we were ever going to do it. And he'd found this job and it seemed fine. Off he went at the beginning of February to do the job. We couldn't afford to buy property in both places, and at this point I felt that I couldn't tell my firm what was going on in case they ever wanted to offer me a job . . . so I said, 'Okay, right, we won't tell them anything about it, we'll go on as though nothing has happened'. He was living in digs [cheap rented furnished accommodation] and coming home every weekend. February last year was a very cold month. We couldn't afford very nice digs for him, not even on our combined salaries, because effectively you're paying rent twice, 'cause we had the mortgage and we had, well, £35 a week for his rooms . . . and his petrol to come home . . . and they weren't centrally heated. They were on the top floor of an old house and he was very cold and very miserable. And he also had a crisis of conscience about whether he could really do the design work they wanted of him, so he was a bit depressed about that as well. And, of course, whereas I could cheer him up and support him at the weekends, there was, you know, those four nights during the week when he was away, when he was on his own . . . And then I was offered this job which meant I had to make a commitment to my company that I would stay to the end of the fellowship. That was when my parents sort of said that 'you're not thinking of accepting it?' I said, 'I've got to. I can't not take it, because I'm being offered the opportunity I've been asking for all this time, how can I not take it?' And they said, 'But you're married.' Well, my husband sorted it out . . . 'cause basically I was given a weekend to think about it so I could discuss it with him . . . Anyway, I went in on the Monday morning and said, 'Okay, I'm taking it.' The following weekend he came home and said, 'I'm going to see my old boss on Sunday morning, because I want to go back.' And that's what happened. But I didn't make that decision, he made it. And I felt guilty at the time because it was my turn to move and follow him and not his turn to move to follow me. (*Nicola*)

There is also a psychological price to pay. In a society where the norm for heterosexual partnerships is for the male to have the higher status, in terms of career and success and income, a man married to a brilliant wife can have his own success completely overshadowed, even in the eyes of his children. Meg felt this about her husband, and because of the way she talks about it, it's fair to presume that she feels some sense of responsibility for this:

> We're two loners who met each other really. He's a very independent self-motivated individual. He doesn't have any jealousy about what I do . . . It's funny because of having been in engineering so long, and the recipient of many awards – you know, the kids tend to think that I'm much smarter than him, but this isn't true. My husband is just so totally understated, you know, that it takes a long time to realise how truly intelligent he is. It doesn't take a long while, but takes a little while. And I think now the kids are grown, they fully realise how smart he is. (*Meg*)

There is a price in terms of losing the traditional role of head of the family. This was more the case for the partners of older women, who themselves were socialised into more traditional roles. Suzanne understood how hard her husband had worked to over-come his traditional socialisation:

> I was particularly lucky, I think, because I had no brothers, so there was no division that these are boys' chores and these are girls' chores. We were expected to help out with everything, and my mother being very practically oriented probably gave us this feeling also. In my husband's family it was a very traditional role, and there were some things – even though he had no sisters – there were some things that women did and men did not do, and he has – oh, this sounds dreadful to say – I was going to say risen above his background, but that's not what I mean at all . . . but he has perceived that this is not the way that he can live and it's not the way that he wants to live either. (*Suzanne*)

Anne appreciated how hard it had been over the years for her husband to learn a non-traditional role, and how that had put strains on their relationship:

> I very often think it would be much easier for my husband if I was an elementary school-teacher – someone who would look up at what he's doing with proper awe. You know, he's a professor of physics, he's probably the brightest person I know, but there's still not that kind of mystery and awe in looking up to him. And no matter what they say, I think there isn't a man alive who wouldn't love that. The other part of it is

that I really think he would like me to be home more. He would prefer that I get home before him – you know, I greet him at the door in a negligée with a martini in the hand. I mean why not, why not? With a drink in the hand for him, seat him down to these wonderful candle-lit dinners, you know, take care of him and spend a lot of my time taking care. We don't, we lead a very hectic lifestyle. Has it harmed our relationship? I think he had to help in the house much more than husbands of women who have a nine-to-three conventional school-teacher job. He's been super understanding, and I think there have been problems, and many of them we've worked out; but we're still working on them and we're still together. Easy for him? No. Not always easy for me either. Part of it is that at the time that he grew up, when a man helped you when the children are in the house, what he was doing was he was helping you, not that both of you were doing it together. And that's kind of a lot of years and a lot of sensitising to make those changes. (*Anne*)

Pauline too feels that it has been harder for her and her husband to make their marriage work than if she had a traditional role, although she knows that the personal rewards for her have been much greater:

When we go sailing [our hobby] there can only be one captain. And my husband very much thinks he's going to be the captain when we're sailing. And in some ways I think life could be much simpler with a more traditional role. And there are times that, you know, I think, 'Why have I done this and do I really want this much responsibility?' And the way I look back and remember what life was like and all the things I do now and as much – the people I've met and the travelling I've done – I don't believe I would [want to change]. (*Pauline*)

For the women we interviewed, the support they got from their partners was crucial to their general well-being, but they were aware that the support was gained at a price, and as they often took responsibility for the price they could see was being asked of their partner, this left them with an additional area of life for which they felt guilt. An important part of the notion of interdependence is reciprocity: the desire not to exploit one's partner too much. This could underly some of what appears to be expressed by the engineers as guilt.

Support from family and friends outside work

Apart from their partners, few other members of the engineers'

family were able to offer practical support. Although most of the sample had received tremendous support from their parents when they were still involved in education, when they began work there was little parents could do except demonstrate their pleasure and pride and offer occasional childcare.

As far as their own children were concerned, most of our engineers had children who were quite small, and could therefore play a limited role in the sort of support they could offer. When some of the older women looked back on the attitude of their children, they decided that it was a mixture of pride at having a clever mother and resentment that their mother was not 'ordinary'. Dora remembers her son deciding he was not going to have a wife like his mother, and Meg's son, when small, indicated that he would have preferred her not to work, although conversely he was also very proud of what she did.

Friendships with people who are not work colleagues are difficult to maintain, first because there is so little time to do anything beyond work, especially if there are children, and second because professionals are likely to move around and lose touch with similar friends who are also mobile. Pauline said that this means her close friends are professional women who are very much younger than her and who don't share her family interests.

Lois described the self-selecting process that goes on, so that she has ended up having professional friends very similar to herself. She has no children, which might account for her exclusive friendships with professionals, whereas Dora's closest friend stayed home and 'reared four men'. Having the shared experience of children made it possible for Dora, who is exceptionally enthusiastic and committed to her work, to have a close friendship with a woman who has had no career at all.

Without realising it, women engineers can find that they no longer develop friendships with women, perhaps because they meet so few, or because their interests are shared by so few. However, Orbach and Eichenbaum (1987) have analysed women's friendships for the damage done to them by envy and competition. They argue that there is an ethos in women's friendships that cannot comfortably allow difference or unequal success. Successful women can be seen as dangerous and threatening by other women, and they might find themselves needing to make new friends who are less threatened. When Sybil realised that she no longer had any women friends she decided to do something about it, and made a deliberate

effort to find new ones; she joined an international women's service club and made new contacts that way.

The problem of finding like-minded friends in a mainly masculine world is aggravated for those women who are part of a minority in any other way. Abigail found that being black meant that for her there was an even smaller group of people who she felt understood her problems:

> Early in my career I was aggressive, cold nosed, and it was managing the household and managing my career and doing all these things together. And I found that talking to women about the frustration of doing all these things, sharing ideas with them, was a help. Not because they said, do this or do that or why don't you do this, but just as an outlet, just understanding, that was sufficient. It's very hard for a man to understand what it's like to be a woman. It's very hard for a majority person, a white person, to understand what it's like to be black, and to be the focus of things not because of what you bring, but what you are. It's been extremely helpful to me to talk to a group of people who understand just by virtue of being different . . . I seek out individuals, not the same individuals all the time . . . [those with] the capacity to understand or to listen, because listening is something I want. More often than not I don't need advice (*laughs*), because I'm very particular and I know what I want to do and I don't need to be told that I can't do it. (*Abigail*)

As we discuss in Chapter 9, these women are in the main not self-identified feminists; they were very wary of the Women's Liberation Movement and campaigns for women's rights. Their choice of women friends reflects where they felt most comfortable rather than any conscious political decision to form a female support network. Our engineers could be very wary of female colleagues, and of being seen as belonging to a women's 'group' of any sort. It is also likely that other women were wary of them. They had so little time outside work, feeling that this time belonged to their partners and children, that women friends ceased to be a priority. It would seem that for various reasons the network of potential practical and emotional support of other women which has been identified as so important for the non-working woman, is unlikely to be available to the successful professional woman.

Summary

Our interviews show us women trying to make the commitments to

their partners and children during time which is being squeezed constantly by professional demands. The Rapoports identified dilemmas which affect all dual-career couples, with regard to how they cared for their children. A prime dilemma for all working women is that of overload, and how to deal with it. How do women cope with the demands of the 'double day', what strategies and support can they bring to bear, where do they get their domestic back-up from? As far as childcare is concerned, professional women have to rely on paid care. Professional partners can do little; grandparents or other relatives can be called on in an emergency, but for reasons which are only touched upon here parents do not wish relatives to have that much involvement with their children, nor do they want to set up the kind of network of obligation that such caring would involve. Friends are rarely used as carers. The paid carer was, in all cases in our sample, another woman. So although the engineers themselves may have rejected the traditional role of full-time carer, it remains a female role in the family.

Almost all the younger women with children had planned their children very carefully, although a few of the older women joked about their accidental pregnancies in 'pre-pill' days. They had dealt with the normative dilemma: should they stay at home or not after the child was born? There were times when they suffered an identity dilemma: were they good mothers? Many were conscious of the unreasonable demands that guilt about being a good mother made on them. At home, children's needs always took priority over their own.

The childcare needs of professional parents remain no closer to being fulfilled than they were twenty years ago, and are perhaps further away than they were in the first thirty years of this century, when professional incomes were relatively greater and nannies were much cheaper. Although men appear to be doing more childcare, the responsibility for organising it remains that of the working mother.

Our engineers also remain responsible for doing, or organising others to do, housework tasks. Oakley (1974) and others have shown how the involvement of men in housework is restricted to certain 'male' activities, and that this is still likely to be the case when women do paid work. Although most of our engineers felt that their partners were doing a good share of the work, two things were happening which were a cause of inequality. The women were

responsible for seeing that the work was done and for setting the standards. As a couple were together longer, and especially after children were born, a sexual division of labour began to occur even when it had not previously, and men did 'male' housework tasks and women 'female' tasks. As with childcare, when others were employed they were the appropriate sex for the task: maids and cleaning ladies and repair men. Unlike their attitude to childcare, women do not enjoy housework (by this they usually mean cleaning), although they still feel guilty when it is not properly done. Because certain household jobs like cooking and preparing packed lunches are much more directly done for partners and children, they remain the tasks of wives and mothers, even when someone is employed to do the housework.

Our sample plan their private lives very carefully to give themselves as much as possible of their precious family time. The price of this is loss of spontaneity. They can never just drop things and go off with friends for an evening out. Partners are seen as the main source of support, and young children are discussed mainly in terms of the work and worry they generate. Our research supports Rueschemeyer's comment:

> Changes toward new, more egalitarian roles of husband and wife in dual-career families are less than complete. Especially when there are children, there remains an asymmetry of family roles in nearly all dual-career families. This may be understood as a persistence of traditional sex roles which give the wife primary responsibility for the children and housework and induce in her a stronger commitment and concern with personal relations and openness with her husband. (Rueschemeyer, 1981, pp. 173–4)

In this chapter much of what we have said could have described women from any profession. However, there are particular problems caused by belonging to a traditionally male profession, chief among which is the compounded difficulty of finding female friendships. This partly helps to explain why their partner's support is so crucial to them.

8

Commitment to a career

The acquisition of engineering skills and qualifications is a rigorous process. Everyone in our sample felt that it had been worthwhile. So positive and enthusiastic were the engineers about their work that, in all the pages of interview transcripts, one quote is notably missing. No one said to us: 'engineering is just a job like any other job'.

In accepting the self-definition of the engineers as professionals, we were also making the assumption that they had careers rather than jobs. Most working women do not have careers. As we showed in Chapter 2, their jobs are poorly paid with few benefits, of low status and responsibility, and carry little prospect of advancement; often they require no commitment on the part of the worker. By contrast, a career implies the prospect of steadily improving pay, the gradual accrual of associated benefits such as holiday pay, and advancement to work of higher status and responsibility. It also demands commitment from those who engage in it.

We were curious, though, about the extent to which each woman saw her current position as part of a career pattern. Was she making a planned progression along a selected path or up a particular ladder? What were her sources of information and advice? How did she measure her progress and find out when to sit tight and when to move on? How did she feel her own career compared with those of her colleagues? Was she ambitious? In this chapter we probe these questions and describe or speculate on some possible answers.

Looking back

The three oldest women in our sample, Rachel, Meg and Dora, all

looked back over their progress in their careers with a certain bitterness. Despite the fact that they loved their work and had been totally absorbed in it, the perception of each of them was that she had achieved less status and recognition than she now felt she had deserved.

Rachel had retired to become a consultant after thirty-nine years as an electronics engineer in the defence industry. She was employed as a civilian to work with the armed forces.

> I was a grade below [when I retired] and, therefore, without as much power. I was also not in the part of the management chain that I thought I should have been, because I could not get from branch to division level. And I got essentially, as I say, shunted out because it was kind of left to younger ones who were going to be there longer. You had to take the military courses they send civilians to – business accounting and so forth . . . They had an upper limit on the age you could be when you went because they wanted to prepare people to move up. And I missed the curve. So there was no potential. I left earlier than I would have because there was no potential. (*Rachel*)

Rachel felt that she had frequently received bad advice during her career. The first of two specific instances she cited was the lack of encouragement for her to take the examination for professional registration as an engineer shortly after she had finished her degree:

> And I didn't. And since then I've never quite gotten to the point of taking it. At the very end, not registered, all those years later . . . But they automatically assumed, quite a lot more consistently in those days, that, well, of course you couldn't, you won't be able to do that. (*Rachel*)

The second instance related to a promotion opportunity:

> a group of us were qualified for an opening in a supervisory position. I was advised that, well, of course, a woman can't manage people, so you will automatically not be able to move up to that. And what really bugs me is that I believed it. That's the way everything was then. You automatically think it's true. (*Rachel*)

'Bad' advice in these cases was, in retrospect, blatantly sexist, though as Rachel says, it would not have been recognised as such at the time. We suspect, too, that 'a woman can't manage people' really meant 'a woman can't manage *men*', a common belief both

then and now (see Chapter 6). Rachel also described how the
promotion issue could be side-stepped by an employer.

> Looking back I probably did some really neat things, but I didn't
> recognise them as deserving of the attention they should have gotten.
> Occasionally, they would do things like give you an outstanding
> performance citation in lieu of a promotion, because, you know, that's a
> piece of paper, and they could do that, and/or submit you for some kind
> of award . . . They did a lot of that and, as I say, they would consistently
> not find it in their hearts to promote . . . So then, in the early seventies,
> they were developing very suddenly, a promotion for me, and the fellow
> that was actually writing up the material came up and said to me; 'This is
> ten years late.' And that was roughly true, because my peers were
> moving up and I was not. (*Rachel*)

When Meg was interviewed she described her job title as follows:

> I'm a staff engineer, which is what's called a dual-ladder career position. I
> have a position equivalent to somebody who is a manager, but I don't
> directly manage a group of people. (*Meg*)

After about twenty years at her company she left for a brief
interlude of two years at a government agency, where the work,
which had seemed attractive and technically demanding, turned out
to be uninspiringly bureaucratic. She described the effect the move
had had on the more recent phase of her career:

> I guess I really lost my status in a sense when I left, because everybody
> was so shocked. I had a managerial position when I left, working in a
> program office, and the propulsion systems that I built for this small
> navigation satellite proved to be highly successful. But, unfortunately, I
> left two months before the first model flew. And so I tended not to get the
> credit for all the hard work I put into getting it built. Everyone knows that
> I really did that, but they sort of lost track, so that, when they invited me
> to come back, it was clear that it was not to a managerial position.
> [Two years later there was] an opening for a manager of propulsion,
> and as I told you, I applied for that job and they elected not to give it to
> me for reasons I do not really understand. (*Meg*)

Meg also thought she detected a change in management style from
the period before her absence:

> Many of the senior staff sort of seem to have been relegated to a very
> back seat. They're just sitting there and their capabilities are just not fully

utilised. And I think that I'm beginning to feel that I'm falling into the category of these people. I just don't want to end my career that way. And that's really what's motivating me to get out one more time. (*Meg*)

In encouraging the advancement of young employees, a company may well overlook the career needs of its older staff, who consequently feel frustrated and perhaps embittered. For both Rachel and Meg, a key feature of their career dissatisfaction was their feeling of being barred from management positions which they knew they were capable of holding and which they felt they deserved. Dora's source of frustration was exactly the opposite. She had been pushed into a management role when her own inclination was to stay in a technical position. Her perception of mismanagement and incompetence at a higher level only served to add to her distaste for the job:

In the last years [at the institute] the paper I published I typed myself, did the illustrations myself and so forth, because reports to the management took precedence because they were dated material, but a publication which gave results was right at the bottom of the queue . . . And I sat and I typed it up. 'It's costing you guys a fortune to do it this way, but if that's how you want it, that's how you're going to get it.' And at the end, my recollection is that in the two very unhappy years that I was section chief, I filed something like five five-year plans, none of which we did. If I hadn't had any prior work going, I couldn't have started anything. And finally, I just refused to do it any more and they let me hang around another year and then they canned [sacked] me. (*Dora*)

At the time, Dora was on the top federal salary scale and she was forced into early retirement.

For all three of these older engineers, the move from the technical side of engineering into engineering management presented a serious problem, even though two of them would have welcomed the move, and one of them would have preferred to resist it.

Moving into management

For both women and men, the normal route to seniority in private engineering companies which have a hierarchical structure is traversed by moving into management. Among the rest of our

sample, only Lin and Zena expressed a strong desire to stay in technical jobs:

> [From] the career point of view it's better for me to do management. But I don't think I would want to – job satisfaction I'm talking about . . . If you want to stay technical your pay is not as good as for managerial responsibility, and I think quite a lot of people want to go into management. I want to stay technical. (*Lin*)

> Most of the people that move up and are recognised as moving up are in management. The company has tried to develop a technical ladder . . . but it's not something that you see . . . The other thing is that they're not really averse to technical management, and I know that our plant's going through a reorganisation right now and I've already heard that they're going to have project leaders. So I could see myself doing that sort of thing. But I don't want to be corporate president. I don't even want to be plant manager. You know, I really still want to stay with the technical work and so that's going to mean that I'm not going to progress much beyond where I'm at now (*Zena*)

Both these engineers recognise that if they make a technical choice, higher status and higher pay will probably be closed to them.

Almost all the other women, however, sought to progress their careers by moving into management eventually, if they were not already in a managerial position. Ella felt that her bosses had pushed her into management before she had had time to consolidate her technical expertise and that they were 'more than regular in their attention' to her responsibilities and career. But her experience in a very small company was unusual.

Typically, progress into management was made through promotion within the same company rather than seeking a post elsewhere. Engineers in very large companies sometimes moved to another division or region for a management post. For example, in the same week as her interview, Eileen, who was working in a divisional office of a water authority, was going for an interview for a more senior position at the head office; she felt that there was a promotion blockage in her division and she was looking for a way round it.

The mechanism for finding and securing the new appointment varied widely from formal to informal and from systematic to random. Noreen's company had a career ladder, and information about how to climb it was readily available. The human resources [personnel] department also operated a data base:

Any job that comes open is posted on the board, on a community-type bulletin board. And you can apply for it or, if you're qualified for it, your name automatically comes up. (*Noreen*)

Noreen has regular review sessions with her immediate supervisor, who then recommends a salary increase. When she first joined the company the reviews were six-monthly, but they are now annual. The annual increase is partly based on merit and partly on length of service. Noreen hoped to move into a planning group in a project management role within three years and saw herself as being firmly established in middle management in ten years' time.

Victoria joined her company as a trainee engineer. She described herself as 'drifting along' from one promotion to another. Yet after five promotions in eight years she is now head of a section. She is not at all clear about how she reached this position, and it seems that her company does not have a clear staff development policy:

Careers advice? I wouldn't say it's terrific. If you look at me, yes, promotion is wonderful. However, all my staff, while I sit here, have got very limited options. I don't know whether I've been lucky; maybe I haven't been lucky, I don't know. I'm not very perspicacious about myself. (*Victoria*)

The lack of self-assurance which Victoria expresses here is similar to that of Judi Marshall's women managers, who were also reluctant to accept credit for their own success (Marshall, 1984).

Pearl's organisation has a defined promotion and advice procedure for staff employed on lower grades, but this fades out at management level, which she has already reached:

They will call you in and counsel you . . . I don't think it's very effective; I guess they do, but as I see it, it's not very meaningful. As a matter of fact, I hate it, simply because it's an invasion of my privacy. I know they don't like me and I don't feel they're willing to help me. (*Pearl*)

Pearl was unhappy with many aspects of her current job situation and felt that she was not valued as an individual or for the work contribution she was able to make. She was looking around for other opportunities at the time of the interview. Other engineers, however, had a positive response to a similar procedure which usually took place at regular intervals. A few spoke of the excellent

support and advice they received from their immediate superior –
generally a man – who seemed to be fulfilling the role of mentor in
their careers.

Pauline talked about her prospects of promotion from middle to
top management. Her anomalous position arises from her late entry
into engineering.

> I'm in what I would say is called the top of middle management. And I'm
> in a funny position right now, in that if my technical background were
> stronger – I haven't been in a technical area long enough to establish, and
> I never will – a real strong research background to where I am world-
> known in research. The next slot above where I am is division director,
> and in my division the person who is division director would be that well
> established in research. So I'm in a funny position in that, even though
> from a management capability and from my own capabilities I would be a
> good candidate for that; that's not an open avenue to me . . . And my
> division director interfaces with me as though I am his peer. I enjoy a
> more privileged relation with him than with some of my peers who,
> probably in the hierarchy, will go further than I will . . .
>
> If an opportunity develops in one of the more service-oriented
> organisations, like Information Resources, then I'll probably be con-
> sidered for division director. But when you get to those slots, those
> opportunities don't happen very frequently. So it's going to be more a
> function of what openings happen when, for me to go any further. Salary-
> wise and treatment-wise, professionally, I'll continue to rise and I'll be
> getting promotions and make good salaries and all. But in areas of
> responsibility it will be a little different, so . . . I'm probably considered
> either the top of middle management or the lower rung of top
> management. But I enjoy a first-name, personal relationship, basically,
> with top management. (*Pauline*)

Despite her unusual position, Pauline spoke with the confidence of
someone who is valued personally for the contribution she is
making to her company, a marked contrast to Pearl's sad situation.

A question closely related to the mechanism for promotion is
whether there are promoted positions to which one can move. Since
most organisations have a pyramid structure which narrows as one
progresses up the management hierarchy, vacancies in the higher
echelons of management are rare, as Pauline recognises. Rebecca
described the happy but unusual situation where her company is
now thirty years old and most of the senior staff are within five years
of retirement, which will leave several voids to be filled. For her the
next step is open.

Three of the engineers were not only content enough in their work to have no embryonic long-term plans, but also saw themselves as doing exactly the same job in ten years' time. They were Suzanne, an academic, Frances, whose work is essentially research with a problem-solving focus, and Doris, a public health engineer. Doris was perhaps cheerfully resigned to the lack of more senior positions because she had already reached the top of her field, but Suzanne and Frances both felt their work offered them sufficient autonomy and variety to be fulfilling for many years to come.

Training opportunities

Training was a topic which the engineers raised in three contexts: in their early careers, in moving into management, and in developing their skills with new technologies or in new directions.

The availability of training of any kind was variable. As we saw in Chapter 5, the UK engineers had received more industrial training as undergraduates. Few of the US engineers mentioned structured on-the-job training of any kind, either as undergraduates or as new employees. But they had had pay reviews at more frequent intervals during their early working lives, perhaps every six months instead of annually. The US employers tended to encourage their engineers' development by sponsoring their return to higher education. Typically an employer would pay the fees for a masters degree in a specialised field of engineering relevant to the employee's job or, at an appropriate career point, in business administration. However, attendance at classes and home study would come out of the engineer's non-working life. Most US graduate schools, unlike those in the UK, offer the facility for students to take classes in the evenings. Julia was working on her masters in electrical engineering at the time of the interview and was finding the combination of work, study and a 14-month old child quite exhausting; but she was determined to complete the course. Alice was contemplating a similar masters course, but finding it easier to test the academic waters by attending one-week seminars on specialist topics held during the working day and paid for by her company.

Several of the UK engineers had been taken on in their first jobs at a graduate trainee grade. Their work was carefully monitored for up to three years and they were moved from task to task to get

experience of different types of work. Schemes such as this enabled them to fulfil the practical, experiential requirements for becoming a Chartered Engineer with a particular engineering institution, for example the Institution of Civil Engineers.

Jane had not been involved in this type of scheme but, as a new graduate, had chosen to work for her employer because of the scope for moving around and learning that the organisation offered. At age 26 she had already held four jobs within it, and had completed a PhD on full salary, which appears to confirm the accuracy of her perceptions about her training opportunities.

Management training seemed to be harder for the UK engineers to acquire. Hazel was lucky in being able to attend a senior management development course run in a series of two-week residential units held at intervals; she was the only woman present at these events. Audrey, who hoped to go into management within five years, felt that some management training would be essential. Claire had actually suggested to her employer that she should go on project management courses but had received no encouragement. She remarked that she would even contribute to it herself if she had the cash. The engineers made it clear that they saw their male colleagues as having less difficulty in persuading their employers to provide management training. Certainly, experience in our own institution, which offers part-time management courses for distant learners, confirms their observation; the proportion of men students who receive financial support from an employer is far higher than the proportion of women students. In Britain this difference applies to training at all levels (Equal Opportunities Commission, 1988).

We were struck by the expectation that engineers should absorb new technologies into their work almost overnight. No one referred to special training in the use of word processing, new computer hardware or software, or even Computer-Aided Design/Computer Aided Manufacture (CAD/CAM) systems, despite the fact that their introduction into the workplace nearly always had a far-reaching impact on methods of working. Such is the pace of developments in new technologies relevant to engineering, that engineers can now expect to face many technology-related changes during the span of their working lives.

Because an engineer is a technical being, it seems she is expected to appreciate the value of a new technological development without

question and to use it in her work as soon as it arrives, by dint of long hours of studying manuals, lengthy experimentation and very hard work. No training appeared to be forthcoming at all to ease implementation and reduce the early learning process. Nor did any allowance seem to be made for time that familiarisation might take or disruption of the normal workload. Nevertheless, the engineers tended to welcome new technologies which facilitated their work, and some criticised their employers for lagging behind the current state of the art in their particular field.

Occasionally someone mentioned training in other new skills: for example, Veronica had completed a course in civil engineering law and contracts which she felt was very useful in her work and something she might continue to study in the future.

Union membership and professional identity

None of the US engineers were current members of a trade union. A few worked in companies where shopfloor workers or technicians were unionised, but membership never extended further up the organisational hierarchy. Only Frances had had direct experience of trade union action when she had worked in a unionised chemical plant on the west coast.

Many of the UK engineers belonged to unions, though the majority did so without enthusiasm because their company was a closed shop and membership was therefore obligatory. Eileen had chosen to join because she had had problems earlier in her career and had received union support. She attended meetings but was not active in any other way. Wendy was exceptional in that she had been a shop steward in her previous post at a time when restructuring was a major issue; for about nine months she found herself spending as much as 50 per cent of her time on her union work.

This lack of trade union identity among the engineers is not surprising when one considers that primarily they indentify with other members of their particular branch of engineering through membership of one of the professional institutions (in the UK) or professional registration (in the US) or through membership of a specialist professional society. These provide such a strong sense of professional identity as an engineer that support from a trade union is not viewed as important in further confirming that identity. This

attitude seems to prevail even where unions have the negotiating rights for pay and conditions of service in the engineering workplace as well as on the shopfloor, as commonly occurs in Britain. It can only have been exacerbated by the historical reluctance of the unions to admit women members (see Chapter 2).

Professional indentity is also enhanced by a sense of an employer having trust in an engineer's ability and commitment:

> I worked hard and I worked long hours. The philosophy of the company is, if it needs to get done and you see a need to do it, you can do it. The management style is pretty unstructured. So I guess I just took advantage of it. And I did my job and I gave suggestions and I did well. (*Alice*)

> I always have some component of my technical society work that I'm doing something with at some level – that's just part of being a professional. I belong to a women's civic group devoted to civic projects in the community. I'm on the board of our local psychiatric centre. All of those kinds of activities involve some of my work time. And as professionals it's anticipated that we do those kinds of things. If I'm doing them during the day . . . then I would do equivalent work at other times. I just don't have an eight to four-thirty schedule. (*Pauline*)

Ambition

We asked all the engineers whether they saw themselves as ambitious. Many of the younger US engineers were able to say 'yes' firmly and without a trace of embarrassment. Despite their country's culture of individualism, we felt that this was an unusual response for women. We noted, too, the difference between their positive approach and the rather negative self-image of the older engineers quoted at the beginning of this chapter. It seems that in the last thirty or forty years, social movements for civil rights and women's liberation have contributed to changes which allow young US women to be publicly proud of their professional identities.

The UK engineers seemed to feel greatly at risk in declaring themselves as ambitious. As we have already seen with Victoria, they downplayed their capabilities and displayed high sensitivity to the stereotyped expectations of other people. They were reluctant to admit that they personally were ambitious, but often felt uneasy that their colleagues saw them as such; they found the image unflattering.

My previous boss retired from the job I'm in now, so I mean I could sit here and it's where an awful lot of engineers finish up. The fact that I'm still looking must indicate that I'm ambitious, I suppose. But I don't think of myself as such. Does that sound funny? (*Eileen*)

I think that people have got the wrong idea about me and I think it is because of my upbringing. When I feel strongly about something I will express myself very strongly and positively. Now men have interpreted that as being a superhuman woman – you know, much better than they are. But I'm very ambitious . . . The last thing I want to be is a centre of attraction, but I believe that most of the men around see me as this very pushy ambitious woman. And it isn't me at all. (*Hazel*)

As the engineers got older, they seemed to feel more relaxed about their ambitions – they could ease up on themselves.

I'm moderately ambitious. I think a little less so as I get older. I think I'm more inclined to say, 'What do I like to do?' and 'What must I do as the next step to get another step nearer?' But then I think my options are continually broadening as well. (*Lois*)

I see myself as someone who's making more money than she ever dreamed she would, who's living a life-style that I never thought I could aspire to . . . things fell into my lap rather than I actively sought them. And I even see myself as someone who doesn't see all of that accurately. I'm still in a stage of, 'What do you want to do when you grow up?' I don't know! Maybe what I really aspire to is becoming a swinging eighty year old who runs around, does great things, has loads of young lovers and God knows what else. (*Anne*)

The pull of the family

Here we return once more to a familiar theme – that of the difficult balance of priorities between work and family. This time it relates to choices that have yet to be made. For many of the women personal ambition in an engineering career was tempered by a commitment to a partner or to children or both. In a dual-career couple the balance between the two careers is a matter for continual nego-tiation and compromise, as Noreen describes:

I see myself as pretty ambitious. There's a big reservation in there because my husband will be out of law school and who knows what he's going to do, where he's going to work . . . But I don't see myself as

having a hard time finding a job, and I don't mind coming in at a level that
I think is maybe below what I worked at before, because I work hard.
There will be a mutual decision. I'll tell him how I feel about it and he'll
tell me, and we'll make our decision because that's how we got here. I
said, 'Do you really want to go to law school?' That's how we got here
because, you know, we're a family. And that really comes just about
first. (*Noreen*)

Ella's thoughts on whether she expected to be in the same job in
three to five years' time reflected more of a dilemma. She and her
husband had yet to deal with their perceptions of themselves and
what kind of life-style they were seeking:

Well, I don't know. It depends on my husband and I, what we decide our
priorities are going to be. We're sort of on the route to being fairly typical
yuppies kind of scene – both professional, both working hard, not
enough time and very sort of rote list of complaints. We're struggling
right now with our view of ourselves and whether or not we want to
perpetrate that, so I can't say 'yes' with confidence. I think that if we
decide that this is for us, then the opportunities are there and I certainly
have more of a lingering interest in seeing my career through and
working hard and building something and being influential within my
field. But I don't think it's obvious what the answer is. (*Ella*)

Jane, who hoped to be a middle management group leader in ten
years' time, introduced another family pull into the debate on
ambition:

In fact we have a decision point next year and we have to decide whether
Philip can get something in this area within commuting distance of [my
work] that suits him, so that's the key point. Also obviously we want – it's
not obvious – but we do consider having a family and that has to be
worked into the equation as well. (*Jane*)

Several more of the engineers spoke of the difficulty of making the
decision on whether or not to have a baby and balancing this pull
with their career ambitions. The dilemma was a distant one for the
women in their twenties, but more immediate for those already in
their mid thirties. Each person approached the decision in her own
way.

It's not that I'm not ambitious. I am ambitious, but I don't let myself
think about what I'd like to do in ten years' time because I don't know

what might be available. It's actually more difficult now that we're working in the same company. Before, when Bob was in another company, he was paid approximately half what I was, so that my career by definition came first . . . We did at one point discuss moving to Singapore for his job, and I was prepared to do that as well, so I don't think I can be hard and fast about it . . . I suppose it's a fact that my career prospects are far better than his, so if one could be purely clinical about it, it should be mine which determines where we're going really.

In terms of starting a family this is the biggest problem for me. I cannot and have not been able to decide what to do about it. I suppose it's the only big problem in my life because I don't want to give up work and I'm sure if I had a baby I would want to stay at home and look after it. So either I don't have one, so I never have the problem, which I don't know whether I will regret it or not; my parents would, and I think my husband might. I don't really want to have one and give it to a childminder. The only way I could really see is if [my company] decided to open a crèche, the only way I'd feel happy about it . . . I've actually written a report about it to the directors along those lines. Apparently there's so much support they can't do it. They would have to employ sort of twenty full-time nannies to cope with the demand . . . In the meantime I'm not getting any younger, and although I've still got a bit of time which I'm counting on, it's never the right time. I mean if I had one now it's not the right time because I've just begun a new job, and if I wait a couple of years it won't be the right time again because I may be promoted again. (*Victoria*)

Well, to be frank, I don't know [what I would like to be doing in ten years' time] because I feel I've got to make a decision fairly soon about whether I have children, and if so, can I go on working when they're small? And that is a decision I have not yet taken. But I know even with help I don't think I could do the job I'm doing now if I had children, 'cause I couldn't give it the time that it needs. So either I need to organise my department so well that they can manage on their own and I don't need to be there . . . or I go back into a systems type job – you know, which is not directing or shopfloor management, which does not demand my continual involvement . . . But whether I'd want to after the excitement of the job I've got now, I've no idea. (*Nicola*)

No one wanted to give up her job to accommodate children, although Joyce did speculate on working part-time as a technical secretary for a while. She felt she might do the job 'better than some of the secretaries who don't really understand some of the work they're given', but she recognised that she would find it boring and would want to tell her boss that he was making mistakes and should introduce changes. Joyce seemed embarrassed as she told us this. She realised that by invoking the 'safety net' of a traditional

woman's job, her commitment to a career would surely be called
into question. She seems to be another example of a woman who
lacks confidence in expressing her career potential and has difficulty
in valuing her own work as a professional.

Some of the engineers – Sybil, for example – had already made a
positive decision not to have children, and we thought that some of
those who were currently agonising over it might ultimately make
the same decision.

Yet another dimension of the pull of the family was raised by
Nicola, who talked about the expectations of her parents and her
husband's family:

> But no, they're not ambitious and they can't understand. Well, any of
> them will work for a specified object if they feel they want to attain it.
> None of the things they want to attain are terribly exalted. And I mean
> John's not really ambitious, but he is more ambitious than any of them.
> And, of the two of us, I'm far more ambitious. (*Nicola*)

Fortunately, there did not seem to be any direct pressure on Nicola
and John to alter their aspirations, but they obviously had to cope
with a family climate of incomprehension with regard to their
ambitions.

Women engineers in professional societies

As we describe in Appendix 2, we contacted many of the engineers
in our sample through WES in the UK and SWE in the USA; they
are introduced in Chapter 2. Both societies encourage and support
women engineers in their careers and serve as centres of informa-
tion for and about women in engineering.

Since our sample was partly self-selecting from the membership
of WES and SWE, many of the engineers we interviewed were
heavily involved in their local or national activities. If they were not
currently active, they had mostly been so for some period of their
careers. These activities included organising student groups of the
society on university campuses, public relations, speaking to girls at
secondary/high schools about engineering as a career, organising
conferences and exhibitions, and writing articles for the society
magazines, *The Woman Engineer* and *US Woman Engineer*.

Among our sample was one national officer of WES and two members of the SWE national executive committee.

Membership of WES or SWE was a professional priority for some of the engineers, but for others, because they are women's organisations and concentrate on women's activities, it was secondary to their membership of and activity in other professional societies which were more specialist in their orientation, such as the Institution of Production Engineers or the American Geophysical Union. These are regarded as key organisations for maintaining contact with one's peers, for providing revised codes of professional practice, and for publicising the latest research and applications in the field, but, without exception, they are heavily male-dominated.

Some of the professional societies, particularly in the USA, have women's interest groups or caucuses, but at least one mechanical engineer told us how unsatisfactory these could be. She pointed out that their effect was to ghettoise the women members and to make them appear less professionally serious than their male colleagues. At conferences where many sessions are run in parallel, a woman engineer might be unable to attend the women's group sessions because she feels the need to attend technical sessions to keep up with new developments and meet her peers in her specialist field.

One of the benefits of membership of a number of professional societies was emphasised by Anna, who had just been made redundant at the time of her interview. She was seeking consultancy or research and development work. She planned to use her contacts in the societies to which she belonged to find out who was recruiting at present and what the employment situation was like in the companies where she was interested in working.

Margaret was also using her high profile in WES to her own advantage. She saw her activities as a way of acquiring the management training which her employers were unwilling to provide. She hoped that in adding them to her curriculum vitae she would be giving herself the qualifications for a management post in another company, since she felt she had no prospects of promotion within her present organisation.

Career change

Finally, although the engineers in our sample were almost un-

animous in seeing themselves as career engineers, some expressed thoughts on a future which took them outside engineering altogether. This was not a step that would result from disillusionment with engineering, but one which would allow them to spend more time on other interests, at present squeezed out of their busy lives. Often they also aimed to spend more time with their partners.

Lucy was planning to retire at 50 to write physics books with her husband; he was already writing and using the royalties from his work to fund a word processor which they will both use. Jennifer, who described herself as 'ambitious for freedom', hoped that her consultancy business would become more successful, eventually enabling her to join her husband in his planned retirement in France. Abigail has real estate business interests which she thought might occupy her full-time within ten years. Pauline and her husband plan to sail round the world. As he is nine years older than her, she reckoned they would have to set out within the next two or three years. Zena and her husband are discussing setting up their own business, possibly a restaurant. Pearl, too, would like to open her own business, perhaps a kitchen renovation shop. How far their ideas are firm plans, fleeting thoughts or necessary fantasies is impossible to judge.

Commitment

In this chapter we have looked at the opportunities open to professional women engineers. The vital feature in their self-definition as professionals is their commitment to a career.

We have explored the career paths of the engineers and their routes for progression into senior management positions. Yet again the women seem to encounter discrimination, and their perceptions are that it is more difficult for them to rise within the profession than it is for their male peers. Their low priority in the queue for management training is a case in point. We find this unsurprising, since we have been continuously aware of the influence of the male environment of the profession in which they operate; but it is depressing, because we now realise more clearly how many more issues women engineers have to tackle within it.

A theme which recurs is the difficulty the women themselves have in expressing their ambition. This arises directly from the ambiguity

with which they feel they are viewed. In at least one case, this lack of self-confidence is almost enough to subvert a professional engineer away from her career into a secretarial job. This personal decision might perhaps be correct for her in view of the pressure she is experiencing, but it is one that would appal her contemporary women colleagues and very much limit her own horizons.

A woman engineer (or any other woman professional) should not have to feel guilty about her own career ambitions and how they are perceived by male colleagues. The question of balancing her career plans for the future and her ties to a partner or family is less easy to resolve. Commitment is not an easy issue for anyone.

9

Engineering, technology and personal values

What distinguishes engineering from other masculine professions is the machismo myth which surrounds it, and the aura of masculinity which is associated, by male engineers, with their role. We have seen nothing in the job descriptions or work tasks themselves which are especially difficult for women, but we have seen how social interactions with colleagues can make them so. We have also seen, in common with other studies of professional women, that fulfilling family responsibilities and professional commitments is extremely difficult. Since many of our sample complained that engineering, especially in the UK, was a low-status and relatively low-paid profession, we should not be surprised that other women who struggle to qualify as professionals choose fields in which they are likely to earn more, and which, although male-dominated, are less exclusively masculine than engineering.

However, very few of our sample planned to leave engineering; they found that their work and life-style contributed towards a strong sense of identity and self-worth. In this chapter we discuss some of the values and attitudes held by women engineers that help to explain why this particular profession can provide such satisfaction for women.

Attitudes to the future of technology

Feminists have generated much anti-technology literature and

initiated many campaigns around technological issues: for example the Greenham women's campaign against strategic nuclear weapons, and campaigns against specific birth control and reproductive technologies. There have also been arguments about why women are not entering technological careers:

> the possibility that the great majority of women, the absent millions, who do not set themselves on such a course at all, are not misguided, ill-informed or simply 'don't know what's good for them'. They may very well be consciously refusing a course of action which seems to them likely to waste their energies, prove a false start and not deliver what it promises. In other words we may be on strike. (Cockburn, 1984, p. 2)

Our women are certainly not on strike, but we wonder whether they might have some of the doubts about technology that Cockburn identifies.

Late in our interviews we asked our sample a very general question about their attitude to technology and the future. We deliberately phrased it in an open-ended fashion in order to pave the way for a wide range of responses. Apart from those who worked in education, they did not say much about technology in the abstract. They talked about their branch of engineering or of particular newsworthy events. We were asking this question at a time when there had been a major nuclear accident in the USSR at Chernobyl, and not long after a US space shuttle, *Challenger*, exploded on lift-off, killing the crew. The answers given by the women suggest that these incidents had worried them greatly, but that few questioned the nature of technological progress in the abstract.

The most wholehearted enthusiasm for engineering came from Eileen and Doris, both of whom work as water engineers. Eileen described herself as a 'woolly-minded Green', and she said that her choice of field was determined in part by her views on ecology. She felt she was in a job where she could retain her idealism and feel that she was engaged in something essential. Doris gave a vivid example of why she felt optimistic about technology. She described how she can see a river from her office window which, over the years that she had been there, had been restocked with salmon, and is now clean enough for fishing. Frances became a water resources engineer because of her disillusion, while at university, with her original field, chemical engineering.

The most pessimistic views came from those UK women who saw our question in terms of the future of British technology. They felt that education for the engineer and the layperson did not take technology seriously enough, and that industry was not responding to new challenges but was instead responding to economic pressure by producing poorer quality products and by paying engineers relatively badly.

> actually I wouldn't encourage my children to go into engineering. Now the reason for that is because of the low salary. It's very difficult, when you consider all the training that's involved. It's difficult to face the fact that you're not getting even half of what a doctor is getting. (*Jennifer*)

There was pessimism about the ability of state education to help people cope with the effects of technology as well as producing technologists:

> Our whole essence of society as a nation is going to be that we can sell sophisticated technology and services and we aren't doing what we need to do in manufacturing . . .
> I find it very depressing that our government and Western society on the whole is channelling less money into education. As society becomes increasingly sophisticated, our population must be increasingly well-educated just to be able to function in that society. I consider people like me and my husband to be very, very privileged. We've been well educated and have good jobs, so life for us is wonderful. We have things we want to do and I feel that we could make this very much more possible for everybody. (*Audrey*)

Anne, who worked as a senior academic in engineering education, had obviously spent a lot of time thinking about education:

> I'm very concerned about a lack of knowledge about technology in the general population. I think that people are too fast to say that engineers are uneducated and don't know anything about music or literature, etc. That's not true; it depends on the engineer. But I think the general population is too fast on the basis of a little bit of media information, from whatever famous actress or actor is touting whatever cause, to jump to conclusions. And, I really think we have to teach some sort of technology in society course to all students, both in high school and college. They've got to have a little more background on technology as a voter, as a citizen in today's world . . . I think one has to be very aware of the effect that technological progress has on society. I think one has to be environmentally conscious. I think accidents like the space shuttle

disaster, which turned out to be a push by managers to meet deadlines and quotas, are disgraceful, and I think all of us have to be more aware what life is about and what the world is about as people. (*Anne*)

Pauline had an interesting position: she seemed to feel that it was the job of women involved in technology to help other non-technical women understand what the technical issues were that society faced. But she wasn't sure whether they would be accepted enough by their non-technical sisters to do the job:

> We're going to have a hard time with technical women interfacing with these women, because they don't see technical women as the leaders. And I'm not sure that the professional women are going to be able to do the job that they need to do to bring the other women to the point where they understand the pros and cons of the trade-offs that we're going to have to make. (*Pauline*)

For the US women, their main concerns were to do with safety of technology. The recent accidents had made them very conscious that economic decisions were determining safety design. Zena had requested, as part of her job, to be involved with reviewing new legislation on environmental issues. Pauline worried about public ignorance – the public presumed impossible safety standards and simply did not know what was happening:

> the risks involved with the chemical industry, I think, are as great as anything with the nuclear industry. And I'm involved with both. I think that if the general public understood the relevant hazards of the chemical industry, they'd get mad as hell. Whereas people that have been involved with that industry for years and years know those hazards are there, and they're dealing with them. And even now, how you educate people for that, without causing the hysteria of the nuclear industry, I'm not sure. (*Pauline*)

On the other hand, Nicola, a UK engineer, felt that her main function was to create jobs in a depressed economy. She hoped that common sense would take a care of safety issues:

> I suppose I'm pretty optimistic really . . . again, I'm possibly naive, but I think most people are fairly sensible, and I cannot believe that people do not understand the dangers of the bomb or starvation . . . I'm creating jobs. I've got thirty people working for me now. I've taken on seven people in the last nine months. Some of those were on the dole. One of

them was a school-leaver . . . I think it's more important to keep people in work. I mean, that is the greatest social benefit I can give to anybody at the moment, give them work. (*Nicola*)

For many engineers concern was not so much about technology but about politics: Elaine, for example, saw the issue of nuclear waste as being a political decision rather than a technical one. Those engineers who worked on military projects had most internal conflict about their work and their politics. No one who worked on military work defended the production of weaponry, yet they continued with their work and found various ways to rationalise what they were doing or to avoid the full impact of it for as long as possible. Rebecca, for example, was shocked when she found that her work had been used in weaponry in the Falklands War. She knew what she was doing in her work, but its application didn't really sink in until she saw it on television news.

Some were aware that they did not let themselves spend long thinking about the implications of their work, or that they were not consistent in their attitudes to what they did:

Something I would like to have more time to [think about], so I could have an opinion, would be with respect to a lot of military issues that I'm involved in on a day-to-day basis. I think there is a lot of room for confronting them if you had time to think about it and get educated. A lot of the things I'm involved in worry me when I think about them long enough . . . I'm embarrassed about it. I'd really like to say something. (*Ella*)

It's a very complicated thing and I don't know how you rationalise it. I am working on communications and I find that relatively comfortable. I don't think I could work on missiles, although I am making communications systems for warships, which makes the rationalisation a bit illogical. I don't think I am totally logical in my approach. (*Sybil*)

Joyce did not do military work, but she worked in a different controversial area, that of the nuclear power industry. She knew it was both unpopular and the focus of much political argument. Her work led her to feel alienated from all forms of politics and to avoid discussions about nuclear energy:

I don't think I'd work here if I disagreed with nuclear power. I'm not very sure about nuclear bombs . . . I don't like getting into discussions on

the pros and cons of nuclear power or nuclear – full stop. I feel it's easier to argue against than for. I haven't got the facts and figures to sort of throw at people. I think I try and be non-political. I'm not either Conservative, Labour or Liberal or anything. I'm just someone who thinks whoever's in power is going to be equally bad. (*Joyce*)

Anna had once also worked in the nuclear power industry but was now cynical about it but for economic reasons, and said that she would not work in it again:

> I think when I started the job [in the nuclear power industry] I was very much in favour of the idea of nuclear power, which obviously I would have had to have been when taking the job on. Attitudes towards it have changed somewhat, not really because of the various publicised things such as Chernobyl, bad as that was, but because of the vast amount of money that's poured in, when we could probably make do with less energy.(*Anna*)

Anna also shared some of the pessimistic opinions about British industry that were voiced by the other UK engineers quoted above.

In fairness to the engineers, it is extremely difficult to remain working in particular aspects of the industry *and* act on your reservations about it.

> Engineers tend to be employees, and what you can do when you are is relatively limited. You're torn between getting out and trying to fight it, or staying in and trying to do something about it. Either way, you seem to lose your impact before you can do any good. And I think it makes it tough on engineers. (*Rachel*)

There is a trend in feminist thought which says that women who enter 'masculine' fields will take with them 'feminine' values, and this will change the nature of the field. We certainly saw our engineers incorporating traditionally 'female' values into the way they structured their work, and the attitude they had towards the relative value of family life and promotion, but we did not see that they were adopting different attitudes to technology in general. They believed in the positive value of technological progress and in the contribution that engineering makes towards it. They identified problems as arising because of bad management or bad political decisions. Thus they retained their faith in technology and became cynical about politicians or the decisions of the general public. The

one area where they did have a conflict of values was about military work. None of them admitted to supporting the development of offensive weapons, and those whose work involved this felt at the very least uncomfortable about it, and tended to engage in a kind of double-think about it.

We chose a sample of practising engineers, and therefore did not pick up those who had been disenchanted enough to leave the profession. Our engineers value technology and believe they are contributing to progress which benefits all society. It is interesting that disenchantment with the industry was strongest among the British women, whose views reflected opinions about the low status of engineering in a troubled industrial economy. Despite the worries that the US women had over safety issues in particular, they were more likely to be optimistic about the potential for engineering and technology to contribute to the progress of the world.

The special attributes of women engineers

Although our engineers believed in general that their gender was irrelevant to their competence, quite a few did think that women had special attributes to bring to engineering, which made women better at certain aspects of the job. There is some contradiction in the minds of our engineers about whether male and female engineers really are the same.

Alice believed that her good writing skills were to do with being female, and that women generally were better able to concentrate on details. Pauline felt her good management skills were due to the same cause: 'because I'm a woman I think I relate to people better'. Rachel also felt that women had a different interpersonal management style:

> They have less of a tendency to go through the review of the Monday night football game, and all that sort of thing, before they can get down to business, than men. But they don't feel they have to leave out all the humour and casual conversation. They are less likely to try and pry into details of private lives of people around them, but more likely to be concerned with trying to relieve any problems that might arise. Men are likely to be very interested in the details, and then very adamant about not lending a hand in them. (*Rachel*)

Women were also seen as having attributes which are not useful to them in their careers:

> We're more emotional, definitely. Rarely show anger, usually it's a different kind of emotional. I don't think we deal with conflicts very well, for the most part. We usually tend to internalize it . . . I think what ends up happening is that you get walked all over. And that's in the environment that I'm in. In research, I can't think of any difference. But in the manufacturing side I think women tend to have to learn to be tougher. (*Zena*)

Unfortunately these women engineers were also likely to perpetuate myths about female ways of thinking or the difficulty of having a female boss: for example, that they were more loyal but also more petty (Hazel), that they express themselves better (Suzanne), that they are more reticent about putting themselves forward (Alice). It is difficult to separate out myths people hold about gendered behaviour from behaviour that research suggests is different for men and women. However, it must be difficult for women who wish to have their gender disregarded in favour of a non-gendered image of a professional to be consistent when they themselves hold many stereotypical views of women. But the engineers in our sample are not unique. Feminist work on psychoanalysis (Mitchell, 1974; Maguire, in Ernst and Maguire, 1987) has shown how difficult it is for all women to counter the subconscious and sexist models of the world that we have all internalised.

Attitudes towards other women

Our engineers were in the main cautious about being identified as 'women's libbers', and did not wish to be seen to be claiming special consideration because of their sex. It seems to us that they were rightly taking advantage of some of the social changes brought about by the last twenty years of feminism, but few of them were self-identified as feminists. Some women felt alienated from women's groups or from the Women's Movement as they gained professional success:

> When I was in New York for a while I started to get involved in some women's groups. And I was very discouraged by them, disillusioned by

them. So when I came down here I haven't got involved in any. They go around on their soap boxes saying they're being discriminated against, and the hardships that they entail because they're women, and everything was because they were women . . . Maybe it's true, and to a certain extent it is true. We have to put up with certain prejudices, but you can't go round and keep on telling everyone that: you're not being fair to me because I'm a woman, because people resent that. And that's where I got discouraged. They were also older. They'd been through more than I have and they kept on looking at me like: you've got it lucky you're lucky because you're an engineer . . . you're an engineer and we paved the way for you. I felt like saying, 'it's not my fault I'm an engineer'. I worked hard to be it, so what are you giving me a hard time for? (*Alice*)

Alice describes feelings that Orbach and Eichenbaum (1987) would see as the product of envy directed at her; her success was probably threatening less successful women. A feeling of alienation combined with the individualist ethic of the professional kept many women away from WES and SWE. Both Meg and Rachel only got involved with SWE because their employer paid for them to go to a SWE conference. For Meg, her involvement was the beginning of a more wide-ranging interest in helping women:

I didn't know anything about SWE until I went to work for a particular company; they were a corporate member. They joined early on . . . and they had purchased a membership under which they could name five women, whose dues are paid. One year I got named as one of these five members. And I felt that if the company was going to pay for membership I should at least learn what the organisation was about. So I went to meetings and before I knew it I was an officer because they didn't have that many people who were interested. But then when I really learned what the organisation was about, this business of informing high school students about opportunities in engineering, and met some of the other women . . . it was a sort of awareness period.

They had a number of very good speakers, because the Society, at their convention, tends to have professional development topics – the kind of management things that women just can't get exposure to other places . . . So I listened to a number of those sessions, and then meeting other women, and being able to check off problems – just exchange ideas, and also find out that many of the things that you thought were hang-ups of yours are really far more general. It's a very good networking organisation to find your feet, find out how your salary compares to other women's salaries, and so on. (*Meg*)

Meg later became Director of Student Affairs, working with different student groups all over the country, and she loved it.

Although she eventually dropped out of an official position in SWE she continued working with student groups.

> Having been technically oriented, and not really into women's lib at all, in the sense that women are – you know, bra burning and everything – I had really only thought of the furtherance of technical women and not really much about the status of the secretary and so on. One of the women who gave a talk [at the last convention I was at] very much impressed upon me, as a member of her audience, that what happens to the secretary [matters], you just have to work in co-operation to elevate everybody with ability . . . As a result of that I did see and I helped – at work I helped secretaries put their résumés together to get higher jobs. And some of them were successful, and some of them weren't, but it was still a good thing to do . . .
> And I helped a lot of students find jobs, helped a lot of people change jobs. One of the things I think I'd like to devote time to is to try and help women who have difficulty getting their lives together. Sometimes just that last bit of encouragement that somebody from outside gives, or even maybe it's only not the last bit but the only bit of encouragement that they get. They see that they still have the resources within themselves to utilise and better their position. (*Meg*)

Many of the women described the support they got during their student days from being part of a group of women. For most, such belonging was a thing of the past. For those who managed through WES or SWE to recreate a supportive network there can be obvious rewards, as there were for Meg and Rachel. But, especially in Britain, the engineers seemed to prefer to get together only around particular issues, for example pressing for better maternity leave in the case of Veronica and her colleagues.

Ella was rare in describing a close friendship with a female colleague:

> we were more girly in the sense of having fun with the people that we work with – I don't know, having more giggle sessions – I don't know how to describe it really.
> It was a very female type relationship in that sense, and we used to work in an office that had a television and a pizza place across the street, and we used to go across and watch soap opera once a week – we were mutual confidantes on other levels than business. But since she left the company I haven't had the outlet to be girly, so that part of me's sort of become less girly in some way. (*Ella*)

Their relationship was encouraged by the local geography: the fact

that they could develop it watching a soap opera and eating together. In fact relationships with other women were as often difficult as they were helpful. Women can be very hard on each other in terms of the expectations they have of each other. Hazel expressed something many pioneering women must feel, that her female colleagues must not let the side down:

> I don't want to be conscious of being a woman because then it spoils everything. I can get angry with women who don't actually perform, because I think they're letting other women down. Like when they have days off to look after a child. You know if you come to work then you should come to work, making your arrangements around that. You see, I have my annual holiday but I try to keep a certain amount for that eventuality. I'm lucky because my husband knows that I'm the bread-winner really. He's self-employed. He has to accept that because of the nature of my job, that I can't just drop everything, he must do that . . . and I suppose in a funny sort of way I'm being unfair to other women that do drop everything because their husbands wouldn't. But I do feel that other women do let women down. I feel strongly about it because I consider that I don't let the company down being a woman. (*Hazel*)

Despite Hazel's first statement that she does not want to be conscious of being a woman, implicit in what she says is a consciousness of women's visibility in work. An unreliable male engineer would harm only his own interests, unless of course he was a member of a minority group, and then he would suffer the same problem. Hazel knows that every woman engineer, because she is so visible, represents *all* women engineers, and so she must worry about the reliability of other women because it will reflect on her.

Some of the women described keeping old friends from school and university as emotional support and confidantes. It could be hard to make new female friends once they were working as engineers. This is one reason why the issue of 'critical mass' is so important. Apart from anything else, their work demands often left them very little time to make new friends, especially if they had children. Alice is a single woman who feels that she worked so hard at university that she missed out on the socialising; now she has the time but she is made to feel odd because of her profession:

> It's always difficult to have a relationship, because you needed so much time to spend on education. I figured, oh, it will be easy when you get out of school to meet more people. When you're in the industry it's difficult, more difficult, to meet them. Because they start getting married when

you get out of school. And you never realize that. You figure, I didn't
have fun yet, I'm going to have fun. All these people had fun in school, so
they're settling down when you're just getting revved up.

Also I find – I don't know if it's because of me personally, or because of
what I do – that people get intimidated when you tell them you're an
engineer. If I go to your typical singles scene, or like when we go out for
drinks after work, and people start talking to us, they sort of look at you.
They say, 'You're an engineer?' And I've had people walk away from me
or stop talking to me because I was an engineer. And then I've had
people not believe me, or look at me funny because I was an engineer. So
yeah, it gets difficult.

When I've told that to other guys that were my friends, they say, 'Well
don't say you're an engineer, lie.' I said, 'I'm not going to lie about what I
am. If they can't deal with it to begin with, they're not going to be able to
deal with it after a relationship starts.' (*Alice*)

There is one important set of relationships with other women in
which our sample was involved; this was the relationship with those
women who fulfilled many of the female functions such as childcare
and housekeeping that our engineers were too busy to do themselves
– not a relationship of equals. We cannot know what kind of
employers of women our engineers were, but they were very aware of
their responsibilities in employing women. In Chapter 7 we
described the gratitude the women felt towards those others who
helped them with their childcare: for example, Lucy and Anne, who
described their childcarers as 'wonderful'; and Dora, who now
accepts responsibility for the housekeeper she has had for years, even
though she no longer needs her. We see that professional women are
dependent not only on colleagues and equals but, because of the way
domestic services are defined and organised in the UK and the USA,
on a body of non-professional women who enable them to work at all.

If it is true that women value and rely on strong female friendship
networks, then the price of entering engineering is the likely loss of
these. We saw in our sample women coming to grips with their
contradictory feelings about other women and putting energy and
thought into their small circle of female friends. Their willingness to
speak to groups such as school-girls could also be seen as an attempt
by them to establish contact with other women in a different way.

Relationships with men

We have shown how important men are, as early role models and

mentors, and often as providers of crucial information and support during the educational years of our sample. Most of our married UK sample were married to engineers. Despite what we say in Chapter 6 about the main problem for women engineers being their male colleagues, these same women have as their main support a male engineer.

Feminist work has, quite correctly, tried to establish the importance of female support networks in women's lives, and has often seemed to concentrate on the ways in which male-female relationships are unequal and oppressive. However, we found domestic situations of mutual support similar to those described by the Rapoports and perhaps even an improvement on them. Although we would not wish to deny that the political reality of inequality extends into private relationships, we found our engineers describing male partners who were struggling to reduce that inequality, even so far as bargaining away some avenues of career progress in order that their wives should pursue careers too.

All the women preferred to present themselves to us as heterosexual. We realise that a sample of thirty-seven would be statistically unlikely to be composed only of heterosexual women. However, we have illustrated how important it is for women in the engineering profession to retain a 'feminine' image to be accepted by their male peers. Therefore the women who talked to us about their partners told us only about male partners. This relationship was described by most of the women as being their most valuable relationship, and the one for which they were willing to make compromises in their career. If any of them had similarly close/ supportive relationships with women, they were not prepared to disclose them.

Identity

The engineers in our sample had a very strong sense of identity as individuals, rather than members of a category 'women'. So for many of them there was no particular pride to be gained from being a *woman* engineer, and most, like Marshall's managers (Marshall, 1984), repeatedly denied any suggestion that they might have been actively discriminated against or that their lives had in any important way been more difficult than their male colleagues. Also

like Marshall's managers, many played down their achievements by talking about their good fortune and how they had been in the right place at the right time. Yet they admitted that their education and career had been hard work.

We have discussed in Chapter 6 how the working practices of private industry foster the professional individualistic ethic, and how the economic pressures of the 1980s increased that pressure. It is not surprising that women, who have all their lives progressed on a career path in which their success has depended on them being able to function in an environment where there were few women equals, should not value belonging to any collective group labelled 'women'.

In terms of their professional identity they are 'new women': their attitude towards their work and their colleagues is radical and assertive; their private identity and choice of life-style is much more conservative. Most fulfilled traditional female roles in the way that middle-class women have always fulfilled them: by employing other women to carry out many of the jobs. They tried to achieve a balance in their professional and private lives to get the greatest amount of personal satisfaction as well as to reduce the guilt they felt. This is extremely difficult in the 1980s. The ideology of motherhood suggests that it is important, for example, that parents service all of the personal needs of children, so those jobs that professional and middle-class women once handed over to employees, such as washing clothes, preparing food and supervising children's time, are now imbued with importance in the emotional development of children, and in the emotional well-being of families. This puts a heavy burden of responsibility on women, and an inevitable sense of guilt, which is even felt by those who know it is not rational or productive guilt. It is ironic that the technological progress that they are all involved in professionally is not providing any solutions to their domestic responsibilities. These are still being fulfilled by their own labour outside work hours, and by other women.

10

Working for change

Having surveyed and analysed the work and lives of some professional women engineers, we return to our original question: *Should we be encouraging more women to become engineers?* The answer seems to be: *Yes, but with caution.* Our reservation is that engineering is likely to remain an uncomfortable environment for women for some years to come.

We should encourage women into engineering because, as we have seen, the work is challenging; it can offer women the opportunity to acquire skills, exploit their talents and fulfil their individual potential. The woman engineer reaps the professional rewards of high earnings and a materially comfortable life-style, but there is definitely a drawback in terms of the stress which maintaining both a professional identity and a private life engenders. This, combined with the all-pervasive male values of the engineering workplace, suggests that there is, at present, a high personal price for women to pay for success in this milieu.

Yet it is important for women to be able to pursue an engineering career and equally important for the profession to have women members to broaden its perspectives. Society pays a price for having such a crucial activity divorced from women and the perspectives and values that women bring – for example, concerns about caring, about nurturing people and relationships.

In this final chapter we look to the future. One could argue that the proportion of women in engineering has reached a plateau and that we shall not see greater numbers of women in the profession in the future; but an equally convincing case could be made that the steady increase in women engineers is bound to continue. American

researchers tend to take the first view (Rix, 1987); on the basis of views expressed to us during our own research, we tend to take the second. Despite industrial restructuring in both countries, there has been a general trend for more women to enter the workforce and, like our sample, we place great faith in the idea of critical mass. Once there is a visible corps of women in engineering, we believe that many more will follow; then, we hope, life will also become easier for those already there. We are constantly aware, therefore, of the acute need for increased practical support for women who wish to become engineers.

We raise questions about the role of educators, employers, the professional bodies, legislators and women themselves in offering support to women engineers. We look at the contributions they have already made and speculate on how they could be developed and improved. We then broaden our focus to take note of current feminist debates on the validity of this pragmatic approach and discuss the feasibility of changing engineering itself.

Support from educators

Educational initiatives which discriminate positively in favour of women students taking engineering courses can have many functions. The most obvious is to increase the numbers of women enrolled, but they also provide students with different combinations of academic, financial and personal support.

As we point out in Chapter 5, most of our sample, like most professional engineers, obtained their qualifications by taking degree courses in universities. Only Frances benefited from a special award oriented towards women students; she had been offered a scholarship to encourage her, as a woman student, to enter the traditionally male preserve of chemical engineering. Such a scholarship was probably available as a result of Title IX of the Education Amendments of 1972, the US federal law prohibiting sex discrimination in federally funded education programmes. This spawned many excellent schemes in American universities and colleges which were specifically designed to improve opportunities for women in predominantly male fields; they aimed to attract women and to offer them support during their studies. Unfortunately, the Reagan administration repeatedly cut the federal budget

which supported these schemes. Most of them have now ended, but those that survive on a combination of university funding and industrial sponsorship are impressive.

Model schemes

Perhaps the most comprehensive undergraduate recruitment and support programme for women in engineering takes place in the School of Engineering at Purdue University in West Lafayette, Indiana (Daniels, 1982, 1987). Recruitment is directed towards increasing the pool of girls who consider engineering as an appropriate career. It uses a variety of media: a poster aimed at 6–12 year old girls, a tape-slide presentation for girls at high school, a videotape for school-teachers and counsellors, career days for girls and their parents held on the university campus, an exhibition and reception held at the annual state conference of counsellors, and industry-sponsored information forums on women in engineering at Purdue, held regionally, to which high school girls, their parents, teachers and counsellors are all invited.

Support mechanisms for women engineering students who are enrolled at Purdue are equally diverse. They include individual counselling from the co-ordinator of the women in engineering programmes, an engineering women students' newsletter, industry-sponsored awards and scholarships, and a Women in Engineering seminar. The latter is an optional course which aims to equip students with information about the position of women in engineering by providing contact with professional women engineers, most of whom are Purdue graduates. It also sets out to help them identify their own potential in relation to career options, to promote skills which will enable them to meet the demands of such a career – particularly assertiveness – and to demonstrate the ways that different women engineers cope with the combination of a demanding career and family commitments. The seminars consist of two presentations on a weekly theme, followed by questions and discussions. Topics covered include the different branches of engineering, selecting a graduate degree, the relevance of business studies, and dual-career couples. Students may choose to register for credit, which requires the submission of a project for assessment at the end of their first semester, or to attend the seminar for

interest only. For the women students, this seminar creates an understanding of their own special strengths and needs; it is open to men, but only a handful take it.

Together, these support activities foster a solidarity among the students and establish a women's network which is nurtured and sustained by the very energetic student chapter of SWE.

One scheme which offers a similar level of student support in Britain is the Women in Technology (WIT) Project at the Open University. With funding from the Training Agency (formerly the Manpower Services Commission and then the Training Commission) it provides financial support, a confidence-raising preparatory weekend, and special woman-oriented counselling for mature women who wish to begin their studies in technology and engineering or to update their qualifications (Swarbrick, 1986). It, too, represents a remarkable feminist model of learner support, but we know of nothing similar for women engineering undergraduates at conventional British universities, although a handful have more limited programmes, and there are new (1989) initiatives for postgraduate courses for women engineers at Bradford University and Cranfield Institute of Technology.

A few university departments of engineering, however, have aimed special publicity drives towards the recruitment of women students, and the Engineering Industry Training Board's INSIGHT programme offers female A level students a one-week course at a university to find out about careers in engineering. A follow-up study has demonstrated the effectiveness of this initiative in persuading girls to enter the profession (EITB, 1987).

Technical vocational training schemes directed specifically at women exist in both the USA and the UK, and often provide a bridge to future study as well as competence in technical skills and improved employment prospects. Examples are the courses in computing and electronics at the Women's Technical Training Institute in Boston, Massachusetts, and the East Leeds Women's Workshop in Leeds, West Yorkshire. Each scheme has a different target group, since they are usually set up to meet a specific set of perceived local needs at a particular point in time. They seek to attract women with various backgrounds and accept lower levels of educational attainment than higher education courses. They are often explicit in recognising the advantage for women in learning in a predominantly female environment. Students work co-operatively with other women students, and women instructors

provide them with positive role models. Once their self-confidence is established, they may well be spurred on to enrol for more advanced courses. For small numbers of students this is now an established route to a degree and a career as a professional engineer. It is a model that is particularly appropriate for women who have been unemployed for a long period and seek retraining, those who had no thought of a career when they left school, or those who chose traditional women's work at that time and later find themselves ready to try their hand at non-traditional skills.

Single-sex groups

All these models make use of single-sex groups at some point: the Women in Engineering seminar at Purdue, the preparatory week-end for the Open University WIT Project, and most classes in technical vocational training courses for women. Educational research shows that girls at school do better in science and mathematics in single-sex groups (Kelly, 1987). Many teachers in schools now have experience of running single-sex groups in these problematic subjects. It is also becoming clear that girls gain less computing experience than boys at co-educational schools and can benefit from girl-only, out-of-school computing projects (Armstrong *et al.*, 1985; Culley, 1986; Nicholson and Sullivan, 1987).

Single-sex education is a controversial issue even among feminists. While we do not wish to suggest single-sex education as a norm, we feel that the success of these models demonstrates that women can and do benefit enormously from the gain in self-confidence that can be made even in short-term single-sex groups, particularly at a formative stage in their studies in a non-traditional field. Fortified in this way, they are then in a stronger position to cope with being in a difficult minority position at a later stage in their educational careers.

Support from employers

We have seen in Chapter 8 that the engineers, while firmly committed to the content of their work and to an engineering career, are often hampered in their career development by employers who do not do enough to facilitate it. Many companies are

far from ideal in formulating and disseminating their staff develop-
ment policies. What we are interested in here are examples of what
might be considered to be good practice.

Veronica works for a large British partnership of consulting
engineers where she and another woman colleague have been
involved in developing a company policy on maternity leave. She
suggested that the company has an enlightened attitude towards all
its employees, recognising that they are its greatest resource.

They are, for example, concerned to provide training and
development for mid-career engineers as well as for newly recruited
graduates. The path for career progression is made clear to
everyone, and staff are encouraged to fulfil the requirements for
their next promotion in either a technical or a managerial direction.
While the younger groups are looked after reasonably well in most
companies, it is rare at present to find the older group as a
deliberate focus of attention. In Britain, companies are being
forced to shift this emphasis for demographic reasons: the pool of
qualified school-leavers is shrinking, making it more important to
nurture and retain mid-career employees at all levels. The shift
should benefit women wishing to return to work after a career
break.

Women engineers in this company are said to be highly regarded
and, because the company wishes to retain the now highly skilled
women graduates recruited in the last ten years, senior manage-
ment has been amenable to the introduction of a company-wide
maternity policy with extensive provisions. This enables women
engineers who wish to begin having children to do so without the
fear that such a decision will damage their careers. A woman may
take maternity leave for up to three years, during which training
programmes are available to ensure that she will keep up to date in
her field and feel confident about making a valuable contribution to
the company when she returns. She may also opt to return to work
on a part-time basis should she so wish.

Before the introduction of this policy, pregnant engineers in the
company were able to negotiate liberal leave, but this had to be
done on an individual 'grace and favour' basis, similar to that
described by some of the American engineers – an unsatisfactory
and uncertain procedure. Now all women employees know exactly
what leave they would be entitled to. However, the company
chooses to project a non-bureaucratic and non-hierarchical image,
and within this culture, most important matters such as leave,

training and salary are decided in personal consultation with an immediate superior. This has both advantages and disadvantages to the employee. On the one hand it generates feelings of openness and caring towards individuals, while on the other it prevents individuals from knowing whether they are being dealt with fairly *vis-á-vis* their colleagues – are their peers receiving similar advice and treatment?

The issue of establishing a workplace crèche is one which was raised by senior management in this company. Several of our engineers felt that this was an essential on-site facility. Others would not choose to use a crèche, preferring pre-school children to be cared for at home by a nanny. Engineers are, of course, in a privileged position in earning enough to pay a private nanny. Some of those who did not want a crèche for their own children were able to appreciate both that other engineers might opt for socialised childcare and that an on-site crèche might provide a solution to the pre-school childcare problems of lower paid technical, secretarial and clerical staff.

An on-site crèche does not, of course, offer help to the working parents of school-age children, who may need care in the early morning, late afternoon and during school holidays. 'Out of school' care has always been an issue of national educational and childcare provision, rather than an employer-provided facility.

As well as developing company policies on career progression, training, maternity leave and childcare, it seems important for the personal development of women engineers that employers should encourage them in less formal activities too. Here we have in mind their participation in programmes such as Opening Windows on Engineering, where practising engineers go to talk to secondary school pupils about what engineering is, and their activity in professional societies and community groups. Three of the US engineers in our sample were first introduced to SWE by their companies, who had taken out corporate membership and nominated them as the engineers to participate; they each said that they might otherwise have rejected the idea of joining a society in which all three are now very active. In a public setting, confident, competent engineers must bring credit to their employers as well as to themselves. This should be ample compensation for the flexibility entrusted to the employee, who thereby has the opportunity to enhance her professional status.

Finally, good practice for an engineering employer might include sponsoring education programmes and research projects on women in engineering. In the USA, corporations of whatever size have both tax and image incentives to provide sponsorship; they feel the need to develop a philanthropic public face and do so willingly in return for public acknowledgement of their donations at appropriate junctures. One consequence of the variety of funding sources is the quantity of small projects that are spawned, from prizes or scholarships for women engineering students to conferences where current research on the position of women in engineering can be discussed.

One could argue that such sponsorship places severe political limits on the kinds of initiatives for which funding is sought. However, *some* activity seems preferable to none at all, and since funds from 'independent' sources are rarely obtainable, we feel that companies should be encouraged to give in this way.

Support from professional bodies

We have already described the British professional engineering institutions as heavily male-dominated and male-oriented. The same is true of both British and American specialist professional societies. Some of our sample talked of their activity at a local level, in the Gas Association or the Institution of Production Engineers, for example, but no one was active at a national level. A first step towards encouraging the participation of women in their programmes would be to ensure that women are nominated for, and elected to, national office and charged with this brief. Hopefully, these officers would then research and monitor the needs of women members and seek to extend their involvement. We feel that all these bodies need to place women engineers high on their agenda for future development.

In Britain, the Engineering Council is obliged, among other things, to: 'take and encourage action for securing the supply and best use of engineers'. The 1984 WISE national publicity campaign, of which the Council was co-sponsor, followed from this obligation. The campaign continues with a lower profile, but lacks funds for major new initiatives. In this context, the Council monitors annually the proportion of women entering engineering degree

programmes. At present, since there has been a small but steady increase over the last five years, it simply monitors these figures and ensures that they are widely circulated. Should the situation change for the worse, we hope that the Council would develop new initiatives, backed by adequate funding, to stimulate the recruitment of women into engineering.

The retention of women engineers is a problem which the Engineering Council began to address in 1984 by forming a working party on the subject. In 1985 it published *Career Breaks for Women*, an excellent document which suggests that companies should develop a positive approach towards career breaks, and sets out guidelines for good practice for employers and other concerned groups. It is particularly helpful in describing some schemes which have been successfully implemented in other fields such as banking, medicine and dentistry. The publication has attracted considerable interest. It was followed by a career breaks videoptape, made with financial support from the Manpower Service Commission for use at conferences and seminars. The Engineering Council is the most influential body in engineering profession in Britain, and it is in a strong position to produce overviews of issues which affect women engineers. We hope that it will continue to devote a significant portion of its attention to their interests.

Support from legislation

There is always room for support for a particular group through the development, enactment and subsequent enforcement of appropriate legislation. It might, for example, be desirable to have equal opportunities legislation in Britain instead of laws which are limited to anti-discrimination (see Chapter 2); this would require a change in legislative philosophy. However, we are acutely aware that legislation is political, and that neither the USA nor the UK government at present (early 1989) is strong in its support of women as independent individuals with equal rights in every sphere.

Nevertheless, British and American women engineers could benefit substantially from protective legislation on maternity leave, on part-time working, and on paternity leave for their partners. Some of the flexible patterns of employment conditions developed in Scandinavia might provide good models here. Equitable changes in tax legislation could also be of benefit. In Britain for example,

women single parents are unable to claim tax relief on childcare expenses, whereas men in the same position are entitled to a tax-free allowance for a housekeeper. Similarly, Jennifer, who is self-employed, pointed out that she is able to claim tax relief for a secretary, but not for a nanny. Her solution is to use the official route of employing a secretary whilst ensuring that the one she selects is able and willing to undertake the childcare.

The British Equal Opportunites Commission (EOC) could have a more active, enhanced role in cases of alleged discrimination, more in line with the American EEOC model. Meanwhile it is obviously vital that the EOC and the EEOC continue their work in monitoring equal pay and anti-discrimination practices as they currently exist, and in disseminating regular information in these areas. Support for their role should be strengthened, and any attempt to undermine them should be strongly resisted.

Because of the sex inequity in access to jobs and the consequent earnings gap, the debate on equal pay in both contries is shifting to one on comparable worth. The emphasis is now on equal pay for work of equal value, so that compensation is commensurate with the skills and responsibilities of the job rather than linked to the sex of the person doing it. Closing the earnings gap would require far more than legislation. At present the problem is the 'ghettoisation' of women's work: in general, what women do is seen to have lower status and less value than what men do. Revaluation could be achieved by a total restructuring of pay scales for women's and men's work.

Historically the effect of the entry of women into what were previously male areas of work – clerical work is the most obvious example – has been paralleled by a drop in the status of that work and by a drop in earnings. Engineering organisations and unions have, in the past, been active in excluding women on the grounds that they would depress overall earnings. It is hoped that the death of the notion of the family wage, combined with the effects of equal pay legislation, will ensure that history does not repeat itself with this particular profession.

Support from women engineers themselves

Mutual self-help is a strategy in which groups of women who share similar values are skilled. As an addition to support from other

sources, it is one which we would firmly recommend to women engineers, many of whom already practise it in some form.

Positive role models

The use, conscious or otherwise, of women engineers as positive role models helps to encourage other women into the field. They see what can be achieved by women, and gain in self-confidence and awareness of their own potential. Thus, Pearl speaks to groups of high school girls about being a highway engineer in the hope that they might see her as a successful woman with an interesting career and identify sufficiently with her to opt for an engineering degree themselves; Suzanne, an established lecturer, had recently hosted a lunch for the women undergraduates in her department to discuss with them the options available at graduate school; Purdue graduate women engineers return to talk to the first-year students taking the Women In Engineering seminar. Many such examples point to the successful use of positive role models, and we suggest in Chapter 9 that this work gives the role model herself a sense of support. Women engineers should therefore learn of their own potential as a resource and be aware of the part they can play in supporting younger women.

Networking

Keeping in touch is another effective self-help strategy. Networking among people with shared interests has developed rapidly over the last twenty years. Many women learnt to do it in the Women's Movement and then applied it to their own professions, more recently with the added help of personal computers and electronic networking and conferencing facilities. Thus there are groups of women architects and women psychotherapists as well as women engineers who keep themselves in touch with each other via a network, through regular group meetings, a newsletter and address list, or even a computerised bulletin board.

Networking not only provides mutual support to participants; it can also provide career development by alerting members to vacancies, much as the old school tie and club networks have always

done for professional men. Women engineers possibly have the greatest need, in this respect, to enhance their networking within the professional societies, so that they are aware of, and apply for, vacant senior positions in their own specialised fields. The USA seems to be especially full of active and well-established nationwide networks in which engineers can participate at a local or national level. The Association of Women In Science and the American Association of University Women are but two examples.

The Society of Women Engineers (SWE) in the USA and the Women's Engineering Society (WES) in the UK are the special networking organisations for women engineers. We experienced the effectiveness of their activities in trying to find our sample. As well as their national journals, they circulate newsletters among the members of local branches or 'chapters' and through campus-based student groups. At Purdue, SWE student members contribute a telephone network to the recruitment effort for women in engineering. They organise a 'phon-a-thon', contacting every young woman who has been offered an engineering place, with the aim of increasing the acceptance rate. They are not subjected to a hard sell, but given an opportunity to ask questions about any aspect of life at Purdue. The programme is so successful that new students remember the call and willingly volunteer to become a caller the following year.

Although well-established, both organisations take their role and responsibility in supporting women very seriously and are constantly reviewing their priorities and the strategies they use. In 1986, for example, WES held a weekend 'think tank' meeting to consider future developments of the Society which focused on career development, student groups, schools liaison, internal administration and communications, and public relations and the media. The aim was to generate ideas for an expanding Society which could have a higher profile of activity in the careers of its members.

A choice of agenda?

We are very conscious of the fact that all the support strategies for women engineers outlined so far basically underpin the engineering profession as it exists at present. They serve, principally, to enable

women to knock boldly on the front door instead of creeping in almost unnoticed through the back entrance. Such strategies are essential for women in engineering to-day and tomorrow to ensure that they get a constantly improving deal within the profession. But what of their long-term prospects?

Women in different countries take different approaches to the problem of encouraging women into engineering. At one end of the spectrum of opinion is the belief that any kind of intervention programme which encourages women into engineering must be beneficial. Evaluation is in terms of numerical increases in the proportion of women undergraduates or graduates, and of the greater material benefits for women which come with the career – high pay brings expensive houses and cars. Most US programmes, for example, place emphasis on conformity with existing norms of the profession, how to 'dress for success' for example. At the other end of the spectrum is the belief that women engineers have a difficult time within the profession and that they should not be encouraged into it until the profession itself is changed. This more radical analysis seeks an end to male dominance and works towards a model of socially responsible engineering in which women are able to make conscious choices to work on humane projects such as district heating, and not to work on projects such as nuclear weapons design.

We find ourselves sympathetic towards this latter position because, as we describe in Chapter 9, we were disturbed by the difficulty many of the engineers in our sample have in looking beyond the confines of their own work. They find it hard to use analytical skills to situate it within the context of their views on technological progress and social change. Although the work may be interesting and the material rewards plentiful, we see, at the end of our study, that the quality of life for women engineers, in terms of the various pressures under which they live and work, is not entirely desirable. Engineering practice functions within the boundaries of a profession which, by taking a blinkered view, often blocks out consideration of its consequences.

Feminist engineering

These doubts raise the question of whether there can be a feminist

engineering, paralleling the visions of a feminist science which have been so energetically discussed in recent years. Feminist critiques of science have been developing for ten years or more. Critiques of technology have been current for perhaps half that period, but these ideas on a feminist view of engineering are only just emerging.

Evelyn Fox Keller, in her writing about Barbara McClintock, the geneticist and Nobel laureate, describes the root of the difference between McClintock's methodology and that of her colleagues as lying in the naming of nature.

> Underlying every discussion of science as well as every scientific discussion, there exists a larger assumption about the nature of the universe in which that discussion takes place. The power of this unseen ground is to be found not in its influence on any particular argument in science but in its framing of the very terms of the argument – in its definition of the tacit aims and goals of science . . .
>
> We have to remind ourselves that, although scientists share a common ambition for knowledge, it does not follow that what counts as knowledge is commonly agreed upon. The history of science reveals a wide diversity of questions asked, explanations sought and methodologies employed in this common quest for knowledge of the natural world; this diversity is in turn reflected in the kinds of knowledge acquired, and indeed in what counts as knowledge. To a large degree, both the kinds of questions one asks and the explanations that one finds satisfying depend on one's *a priori* relation to the objects of study. In particular I am suggesting that questions asked about objects with which one feels kinship are likely to differ from questions asked about objects one sees as unalterably alien. (Keller, 1985, p. 167)

In this quotation, if we replace 'science' with 'engineering', and 'scientist' with 'engineer', we glimpse the beginnings of a feminist model of engineering. First it requires the re-examination of the fundamental assumptions on which engineering has been built, and second it requires an acknowledgement of non-objectivity on the part of the engineer.

Anette Kolmos (1987) illustrates the first requirement. She contrasts the traditional male ideology or stereotype of relevant technical knowledge with traditional female values which are currently defined by society as non-relevant technical knowledge in the context of present-day engineering. Table 10.1 lists the characteristics of each type of knowledge under the heading of 'ideology'; it also shows Kolmos's strategies for building a bridge between a traditional technical engineering and a new complete technological

engineering, which she characterises under the heading 'vision'. The innovative engineering curriculum adopted by the University of Aalborg in Denmark, where students work on interdisciplinary projects for the whole of their course, is an attempt to educate engineers towards that vision.

Table 10.1 Towards the development of future knowledge in engineering

1. Ideology	
Relevant technical knowledge	*Non-relevant technical knowledge*
Social masculinity	Social feminity
Dominates nature	Is a part of nature
Linear	Iterative/spiral
Techno-economic rationality	Caring rationality
Non-dependent recognition	Dependent recognition
Objective	Subjective
Hierarchical	Non-hierarchical
Logical	Emotional

2. Strategy
Un-think traditional ways of thinking
Re-think with all senses
Develop new ideas
Take courage to speak and act upon them

3. Vision
Complete Technological knowledge
Integrated and transcendent
Social masculinity and social femininity
Respect of nature as basic existence
Dynamic
A whole rationality
Holistic recognition
Respect and acceptance
Equality

Source: based on Kolmos, 1987

At the Open University in Britain a similar approach to engineering education has been developed for first-year students in the

Technology Faculty. The traditional introduction to engineering science has been replaced with a foundation course in technological decision-making. The integrative themes are systems, design, and modelling, and the emphasis is on distinguishing between facts, values, and beliefs in complex technological settings. Like Kolmos, we have argued that this course design, combined with the choice of issues discussed, makes a non-traditional field unusually relevant and appealing to women.

This requirement of relevance and non-objectivity, the acknowledgement of the need to recognise values in engineering, is also illustrated by Ellen van Oost and Saskia Everts (van Oost and Everts, 1987). Their research on the interests of female engineering students at the University of Twente in the Netherlands shows that 'usefulness to society' is an important criterion for them in prioritising the activities encompassed by their studies. This is unsurprising when viewed against the background of Carol Gilligan's work on the different development of moral attitudes in women and men which arise, she says,

> in a social context where factors of social status and power combine with reproductive biology to shape the experience of males and females and the relations between the sexes. (Gilligan, 1982), p. 2)

Van Oost and Everts also put forward interdisciplinary project-based work as meeting the specific interests of women and encouraging them to participate in engineering education.

We feel sure that in working towards a feminist engineering, new initiatives in engineering education are extremely important in providing all engineers with the tools to see beyond the work in which they are engaged. The skills with which engineers are equipped must enable them to understand engineering problems holistically and to handle them in a socially relevant manner. This much has already been recognised by the British Engineering Council, who emphasise the need for a systems approach in education and training (Further Education Unit and The Engineering Council, 1988). Our own experience of teaching the systems approach suggests that systems thinking, which is both holistic and non-objective, could contribute considerably to a feminist model of engineering education.

Women from Third World countries make it clear that their most

urgent concerns are not necessarily to increase the proportion of women engineers but to ensure that engineering deals with the problems which women are able to define from their own experience. They seek appropriate technological solutions to the needs of women in their countries: simple, durable pumps to provide clean water and irrigation, or lightweight drying frames for maize and other crops; appropriate technological training to accompany new projects, such as the establishment of horticultural co-operatives by rural women in the Philippines. At present such demands are often dismissed as trivial by those engineers who prefer to concentrate on large-scale, prestigious projects like power stations and telecommunications networks, which bring them status in developed countries (though this is obviously not true of all engineers). The feminist model of engineering, with its requirement of non-objectivity, would cope readily with small-scale, women-oriented technologies.

Challenges

We began this book, and our study of British and American women engineers, with some unanswered questions in mind. The one that is most comprehensive and has most significance for our own future work is: To what extent is the increased participation of women in engineering desirable?

In the first part of this chapter we showed that bodies currently concerned with different aspects of the engineering profession *can* make considerable contributions to improving conditions for women engineers. In the second part we threw out some wider challenges.

We believe that our research demonstrates that engineering provides great satisfaction for women. We also believe that women have themselves begun to have an impact on the profession by, for example, proposing new policies on maternity leave and forcing their male colleagues to re-examine their sexism. However, we see the route to the increased participation of women as an issue of empowerment. It is not enough to rely on paternalistic measures of improvement from established bodies. Women engineers must take control of the situation in which they find themselves by consciousness raising, networking, or any other means available.

This seems to us to raise the question of what women who are not engineers can do to reduce the isolation of those who are. First, we must offer to support them individually, despite the fact that some feminists would regard them as having 'sold out' to a male professional establishment in return for material rewards. It seems hard to castigate women who seek interesting, socially useful, well-paid professional work which offers them and their families economic security. Second, we must support national policies which will benefit women and press for such policies to be well formulated.

Finally, all women, like all citizens, have a social and personal responsibility to inform themselves about science and technology. We must not avoid engineering issues because they seem too complex. Change is too important to leave to male 'experts'; it should be effected through the full participation of all social groups.

Appendix 1

Biographies

The following brief biographies contain skeletal background information about the interviewees. For those readers who are interested in following the comments of particular individuals in the sample, the level of detail provided should be adequate for constructing a profile.

Engineering in the UK and the USA still remains a primarily white profession. In the USA there is as much, if not more, concern over the participation of people from ethnic minorities as there is over women. Our sample does contain some women of colour. Of the UK sample, one is Afro-Caribbean and one is of Chinese origin; both were born outside the UK. Two of the US sample are of Afro-Caribbean origin; one was born outside the USA, the other is a black American. We do not identify these women here, but refer to issues of race and colour in the book when the engineers themselves see them as significant.

Biographies of UK engineers

Angela is a 33 year old civil and structural engineer working for a large partnership of consulting engineers. At the time of the interview she was on maternity leave. She is married to a mechanical engineer and has one other pre-school child.

Anna is a 28 year old metallurgist. At the time of the interview she had just been made redundant from a large firm of engineering consultants for the oil industry. She is single and lives with her boyfriend. They have no children.

Audrey is an electrical engineer working for a division of a large multinational electronics company. She is 37 and married to an engineer. They have two school-age children.

Claire is a 26 year old control engineer in the instrumentation industry. She is single and lives alone.

Doris is a public health engineer. She works in sewage treatment, in a senior position at a regional level. She is in her late forties and lives alone.

Eileen is a 32 year old civil and public health engineer. She works as a group manager for a regional water authority. She is single and lives alone.

Hazel is a 41 year old water quality engineer. She works in a water quality laboratory. She is married and has a 6 year old son.

Jane is a 26 year old metallurgist who works in research for the nuclear power industry. She is married to a minister of religion. They have no children.

Jennifer is a self-employed civil and structural engineer. At the time of the interview she had one pre-school child and was pregnant. She is married to an engineer.

Joyce is a 28 year old mechanical engineer. She works as a project engineer on safety aspects in the nuclear power industry. She is married to an engineer. They have no children.

Lin is a 36 year old electronics engineer. At the time of the interview she was on maternity leave from her job as senior engineer with a multinational electronics company, awaiting her first child. She is married to an engineer.

Lucy is a 42 year old gas engineer. She was originally qualified as a mathematician, she now works on regional planning in the gas industry. She is married to a teacher and they have two children in their late teens.

Margaret is a 33 year old civil engineer responsible for building projects for the gas industry. She is married to an engineer and they have a son of 2.

Nicola is a 27 year old metallurgist. She works as programme manager for a small telecommunications company. She is married to an engineer. They have no children.

Rebecca is a 36 year old aerodynamacist. She works for a private research establishment. She is married with no children.

Sybil is 35 years old, a technician grade engineer qualified in mechanical and production engineering. She works as a project engineer with a multinational electronics company. She is married to an engineer. They have no children.

Tanya is a 30 year old civil engineer working for a large chemical company. She is married with no children.

Valerie is a civil and public health engineer. She is 34, married to an engineer and they have two pre-school children. At the time of writing she was not in employment and had travelled to the USA with her husband for his job.

Veronica is a 32 year old civil and structural engineer. She works for a large partnership of consulting engineers. At the time of the interview she was on maternity leave. She is married to a banker, they have two pre-school children.

Victoria is a 31 year old chartered measurement and control technologist working as an Engineering Section Head in a multinational pharmaceutical company. She is married to an engineer. They have no children.

Wendy is a 30 year old transport engineer. She works for a large local government transport authority. She is single and lives alone.

Biographies of US engineers

Abigail is 38 years old. She trained first as a chemical engineer and then took two masters degrees, one in civil engineering and one in public administration. She works as a senior administrator on environmental policy and regulation in the civil service. She is married with a daughter aged 14 and two sons aged 12 and 8.

Alice is 25 years old. She is an electrical engineer working for a telecommunications company evaluating the performance of switching networks. She is single without children.

Anne is 45 years old. She is trained as a chemical engineer with a PhD in control systems. She is now a senior administrator in the engineering department of a small inner-city college.

Dora is 65 years old. She trained as a physicist and spent most of her working life in acoustic engineering research. She is now in active retirement. She is married with two sons aged 21 and 22.

Ella is 27 years old. Before qualifying as a civil engineer she gained a degree in international studies. She works as a geotechnical engineer in a small consultancy where, as a senior project manager, she is third in the management line. She is married without children.

Elaine is 22 years old. She works as a mechanical engineer on vibrations in the research and development department of a machine tool company. She is married without children.

Frances is 28 years old. She is a water resources engineer working for an

agency which has responsibility for research on a large river basin. She is separated without children.

Julia is 28 years old. She is an electrical engineer working on signal processing systems in a company manufacturing electronic equipment. She is married with a 14 month old son.

Lois is 42 years old. She has a liberal arts degree followed by a masters in broadcasting communication and a PhD in education. Although she is not strictly an engineer, she works in a wholly technical environment as a senior manager in a satellite communications company. She is single without children.

Meg is 61 years old. She has degrees in mathematics and chemistry. She is an aerospace engineer working on rocket propulsion systems in the spacecraft division of a large corporation. She is married with three children aged 29, 25 and 21.

Noreen is 28 years old. She is an electrical engineer working for a power company with responsibility for locating power lines. She is married with two sons aged 5 and 6.

Pauline is 50 years old. She works as a nuclear engineer managing a radioactive waste disposal research programme. She is married with six children aged between 23 and 34.

Pearl is 39 years old. She is a highway engineer working for a government department on the development of forest highways. She is single without children.

Rachel is 62 years old. She retired from her work as an electrical engineer in the defence industry to form her own consultancy in electrical and electronic systems analysis and development. She is single without children.

Suzanne is 33 years old. She is a lecturer in civil engineering at a large state university. Her research is in geotechnical engineering. She is married with a 3 year old son and was four months pregnant at the time of her interview.

Zena is 33 years old. She trained as a chemical engineer and now works as a process engineer in a plant which manufactures agricultural chemicals for a multinational company. She is married without children.

Appendix 2

Research method

Process: working together

Our reading of material already published influenced our decisions about what we wanted to study and how we wanted to write up our work. The early writings of the Women's Liberation Movement, which floated the notion that 'the personal is political', have informed both the topics of feminist research as well as the methods. We feel that one of the great successes of feminist scholarship has been to develop methods of investigating women's lives and experience in such a way as not to objectify the women being researched. They allow the women's own voices and understandings to speak through the work, and so to develop an analysis of subjects' lives which does justice to their own experience (Stanley and Wise, 1983). British researchers who influenced us strongly were Ann Oakley on women and maternity, and Angela Coyle on women textile workers who were made redundant. We wanted to use their innovative examples to produce a book using extensive, open-ended interview material.

We found ourselves discussing a joint project at the time when one of us was preparing to take a year's sabbatical leave in Washington DC, USA. Ruth's purpose was primarily to investigate initiatives to increase the proportion of women studying engineering and technology in higher education there, in order to develop a wider range of initiatives in the Open University. We were aware that equal rights legislation in the USA had made it possible for educational institutions and workplaces to put in place positive discriminatory practices which would be at least frowned upon, if not illegal, in the UK. We wanted to know what effect this had had on engineering in particular. We wanted to compare the lives of professional engineers on both sides of the Atlantic, to see whether there were structural opportunities that women were differentially able to benefit from, and whether there was any difference in the kind of social support from friends, family and colleagues that women could draw on.

We are as much committed to representing our interviewees in a way that does justice to their lives and ideas, as we are in pursuing our analysis

(Kirkup, 1986). This has occasionally led to some heart-searching, especially over how to deal with instances when the two positions contradict each other; for example the engineers often said they had experienced no direct sexual discrimination, but went on to describe incidents which, to us, appeared to be just that. In some cases, too, we felt that the terms and conditions of employment were not favourable for women, while the women themselves were telling us how good they felt their employment to be. We have tried to air these contradictions and engage in a dialogue with the interview material so that we can do justice both to the engineers and to ourselves.

Technique: sampling and interviewing

We decided to restrict ourselves to women who were independently classified as 'professional engineers'. During 1985/6 Ruth interviewed sixteen women engineers in the USA, and at the same time Gill interviewed twenty-one engineers in the UK. Walshok and Cockburn had researched blue-collar women workers, and we felt that more critical work needed to be done on professionals.

We also felt that it was important to have a clearly defined and comparable population when doing an international comparison. In the UK 'professional engineer' meant chartered by an engineering institution (although we have retained in our sample some women who have got the lower-status title of technician engineer, but because of their level of work or senior position were treated as chartered). In the USA engineers are not nationally recognised in the same way; instead each state registers engineers to practise in that state. Registration is less central in obtaining employment and less crucial in terms of career development, so many engineers do not pursue it. We therefore accepted the self-definition of our American interviewees.

In discussing the project with American women, Ruth very quickly hit an interesting communication problem which turned out to be one of semantics. Since our work is in a Faculty of Technology, which offers courses in engineering, in conversation she was using the words 'technology' and 'engineering' interchangeably, a common British practice. For Americans, however, 'technology' and 'engineering' are quite distinct. 'Technology' has a more practical or vocational connotation, whereas 'engineering' is theoretical and of higher professional status. It became important for her to explain that our interest was in engineering as opposed to technology graduates, and that her own professional base was in the American equivalent of a school of engineering.

We used different methods of drawing the sample. The first half dozen or so UK engineers were drawn from a sample provided by the Women's Engineering Society (WES). WES was very interested in the project, and in order to retain the confidentiality of its membership registers, the Secretary passed on a circular letter from us to about a dozen members, leaving them

to decide whether they wanted to contact us. The response was good. After interviewing this first small sample and finding the interview schedule worked well, generating interesting material, Gill sent letters to most of the main professional engineering institutions. She felt that although a letter in the WES newsletter was likely to provide us with as many potential interviewees as we could cope with, it would give us a particular kind of engineer, one more likely to be conscious of her gender and keen to effect change in the profession. Many of the institutions wrote back to us, interested in and supportive of the project. They put copies of our letter in their newsletters, encouraging their interested women members to contact us. However, this still makes the sample self-selecting and probably more interested in issues of gender than non-respondents. At least one institution Gill contacted had no female members, and some did not know how many they had because no record of gender was kept. Roughly fifty responses were elicited, and from these the UK sample was drawn.

Initially any UK respondent who was able to give up the minimum hour necessary to be interviewed, over the phone or in person, was interviewed. As the sample grew we attempted to find engineers from different fields and in different age groups. However, in the final sample of UK engineers certain branches of engineering are not represented, and the sample is biased towards women at the early stages of their careers, in their late twenties and early thirties.

The first US engineers were contacted through a brief plea for volunteers placed in one issue of the newsletter of the Baltimore-Washington Chapter of the Society of Women Engineers (SWE). The initial respondents were all engineers in their twenties who were shocked to find that the profession could still be treating women differently. They were clearly self-selecting in seeking a way of expressing their outrage to an interested outsider.

One of the older engineers in the sample was a personal contact, a friend of a colleague in Britain. She too was active in SWE both in her own locality and nationally, and proffered contacts representing all branches of engineering nationwide. In practice, it was only feasible to interview those who were located reasonably near Washington, and those whom Ruth was lucky enough to catch as they attended conferences in the area.

In researching affirmative action programmes for women in engineering, Ruth had already acquired a sizeable network of contacts. These enabled her to make personal requests for the names of colleagues and acquaintances of the women in her network who would fill in the gaps in the age or specialism range of the sample. A networking strategy was far more successful than her few approaches to the human resources (personnel) departments of corporations that she thought would be likely to employ women engineers whom she could interview. All such approaches were met with polite interest, and little apparent suspicion or hostility. They always elicited apparently friendly promises of names, but somehow these names never materialised.

The US sample does include engineers of all ages drawn from most branches of engineering. It is not (and was never intended to be)

geographically representative of the USA, but our impressions are that American professionals are sufficiently mobile for location to have little bearing on the questions we were examining.

The interviews took place either in person with the engineer at her or our homes or in an office at her work. We worked from the same broad interview schedule to prompt the direction of the narrative rather than trying to elicit answers to precise questions. Many of the UK interviews were done over the telephone, but only one of the US sample. Ruth's preference was for face-to-face interviews; she felt that, as a foreigner in a strange culture, she should at least present her credentials and the case for such a personal interview in person. Thus the time and travel costs incurred necessarily limited the size of the US sample.

All except three of the interviews were tape-recorded. They were then transcribed verbatim; the excerpts presented in this book are taken directly from the transcripts, with only the minimum editing to clarify meaning. We have changed all proper names in order to preserve, as far as possible, the anonymity of our interviewees. In some cases we have had to remove references to the particular job or position held by the engineer, because, being perhaps the only woman holding such a position, reference to it would render her immediately identifiable.

Bibliography

Akimbode, I. Adefolu (1987) *Factors Affecting the Achievement of Women and Girls in Scientific Endeavour*, paper contributed to the Fourth International Conference on Girls and Science and Technology, University of Michigan, July.

Alic, Margaret (1986) *Hypatia's Heritage: A History of Women In Science from Antiquity to the Late Nineteenth Century*, The Women's Press, London.

American Association of University Women (1984) *Fact Pack No 2: The Working Family*, American Association of University Women, Washington DC.

Armstrong, P., LeBold, W. K. and Ward, S. (1985) *Profile of the 1985 Beginning Engineering Freshmen*, mimeo, Purdue University, West Lafayette, Indiana.

Baines, Alison (1988) *Success and Satisfaction*, Paladin, London.

Beechey, Veronica (1987) *Unequal Work*, Verso, London.

Bleier, Ruth (ed.) (1986) *Feminist Approaches to Science*, Pergamon Press, Oxford.

Bogart, Karen (1984) *Toward Equity: An Action Manual For Women In Academe*, Project on the Status and Education of Women, Washington DC.

Bowles, Gloria and Klein, Renate Duelli (eds) (1983) *Theories of Women's Studies*, Routledge & Kegan Paul, London.

Brecher, Deborah L. (1985) *The Women's Computer Literacy Handbook*, New American Library, New York.

Brownlee, W. Elliott and Brownlee, Mary M. (1976) *Women in the American Economy: A Documentary History 1675–1929*, Yale University Press, New Haven, CT.

Bruce, Margaret and Kirkup, Gill (1985) 'Post-experience Courses in Technology for Women: Aims and Processes', *Adult Education*, Vol. 58, No. 1, June.

Byrne, Eileen M. (1973) *Women and Education*, Tavistock, London.

Carr-Saunders, A. M. and Wilson, P. A. (1933) *The Professions*, Oxford University Press, Oxford.

Carter, Ruth (1987) *WISE Women at the Open University*, paper contributed to the Fourth International Conference on Girls and Science and Technology, University of Michigan, July.

Carter, Ruth (1987) Women Into Engineering: Perspectives on Positive Discrimination from the USA', *International Journal of Science Education*, Vol. 9, No. 3.

Carter, Ruth and Kirkup, Gill (1987) *Being Professional Women Engineers: The Public and The Private*, paper presented to Science Technology and Society, the Annual Conference of the British Sociological Association, University of Leeds, April.

Carter, Ruth and Kirkup, Gill (1987) *The Working Lives of Women Engineers*, paper contributed to the Fourth International Conference on Girls and Science and Technology, University of Michigan, July.

Carter, Ruth, Martin, John, Mayblin, Bill and Munday, Michael (1984) *Systems, Management and Change: A Graphic Guide*, Harper and Row, London.

Central Statistical Offices (1987) *Social Trends, No. 17*, HMSO, London.

Coalition of Women on the Budget (1983 and 1984) *Inequality of Sacrifice: The Impact of the Reagan Budget on Women*, National Women's Law Center, Washington DC.

Cockburn, Cynthia (1983) *Brothers*, Pluto Press, London.

Cockburn, Cynthia (1984) *Women and Technology: Opportunity Is Not Enough*, paper presented to the Annual Conference of the British Sociological Association.

Cockburn, Cynthia (1985) *Machinery of Dominance: Women, Men and Technical Know-How*, Pluto Press, London.

Cole, Jonathan R. (1979) *Fair Science: Women In The Scientific Community*, The Free Press, New York.

Coyle, Angela (1984) *Redundant Women*, The Women's Press, London.

Culley, Lorraine (1986) *Gender Differences and Computing in Secondary Schools*, Loughborough University of Technology, Loughborough.

Daniels, Jane Z. (1982) 'Women In Engineering Programs: A Holistic Approach', *Engineering Education*, Vol. 72, No. 7, pp. 738–41.

Daniels, Jane Z. (1987) *A Multifaceted Approach to the Recruitment of Women Into Engineering*, paper contributed to the Fourth International Conference on Girls and Science and Technology, University of Michigan, July.

Davis, Barbara Gross and Humphreys, Sheila (1983) *Evaluation Counts: A Guide To Evaluating Math & Science Programs for Women*, National Science Foundation, Washington DC.

Drake, Barbara (1984) *Women In Trade Unions*, Virago, London.

Dex, S. and Shaw, L. B. (1986) *British and American Women At Work: Do Equal Opportunities Policies Matter?*, Macmillan, London.

Dowrick, Stephanie and Grundberg, Sybil (eds) (1980) *Why Children?*, The Women's Press, London.

Emmerson, George S. (1973) *Engineering Education: A Social History*, David & Charles, Newton Abbot.

Engineering Council (1985) *Career Breaks for Women Chartered and Technician Engineers*, Engineering Council, London.

Engineering Council (1986) *Annual Report and Accounts for 1986*, Engineering Council, London.

Engineering Council (1987) *Science and Engineering Degree Courses: Women Entrants 1982/3 to 1986/7*, Engineering Council, London.

Engineering Industry Training Board (1984) *Women in Engineering*, Occasional Paper No 11, EITB, Watford.

Engineering Industry Training Board (1986) *Annual Report 1985–86*, EITB, Watford.

Engineering Industry Training Board (1987) *Insight: Encouraging Girls To Become Professional Engineers*, RC 18, EITB, Watford.

Equal Opportunities Commission and the Engineering Council (1984) *What Is WISE Year All About?* EOC, Manchester.

Equal Opportunities Commission (1988) *Women and Men in Britain 1987*, HMSO, London.

Faulkner, Wendy and Arnold, Erik (eds) (1985) *Smothered by Invention: Technology in Women's Lives*, Pluto Press, London.

Finniston, M. (Chair) (1980) Committee of Enquiry into the Engineering Profession, *Engineering Our Future*, Department of Industry, Cmnd 7794, London.

Florman, Samuel C. (1978) 'Engineering and the Female Mind', *Harpers*, February, pp. 57–63.

Fraser, Ronald (ed.) (1968) *Work: Twenty Personal Accounts*, Penguin, Harmondsworth.

Further Education Unit and the Engineering Council (1988) *The Key Technologies: Some Implications for Education and Training*, Occasional Paper, FEU and Engineering Council, London, February.

Gamarnikow, Eva, Morgan, David H. J., Purvis, June and Taylorson, Daphne (eds) (1983) *The Public and the Private*, Heinemann, London.

Gardner, R. E. (1976) 'Women in Engineering: The Impact of Attitudinal Differences on Educational Institutions', *Engineering Education*, Vol. 67, No. 3, pp. 233–40.

Gilligan, Carol (1982) *In a Different Voice: Psychological Theory and Women's Development*, Harvard University Press, Cambridge, MA.

Gornick, Vivian (1983) *Women in Science: Portraits from a World in Transition*, Simon & Schuster, New York.

Gower, Dan and Legge, Karen (1978) 'Hidden and Open Contracts in Marriage', in R. and R. Rapoport (eds) *Working Couples*, Routledge & Kegan Paul, London.

Green, Francis and Potepan, Michael (1987) *Vacation Time in the United States and Europe*, mimeo, EMRU Labour Economics Study Group, Hull University.

Griffin, Susan (1978) *Women and Nature – The Roaring Inside Her*, Harper & Row, London.

Hall, Roberta M. (1982) *The Classroom Climate: A Chilly One For Women*, Project on the Status and Education of Women, Washington DC.

Harding, Jan (ed.) (1986) *Perspectives on Gender and Science*, The Falmer Press, Lewes.

Harding, Sandra (1986) *The Science Question in Feminism*, Open University Press, Milton Keynes.

Hearn, Jeff and Parkin, Wendy (1987) *Sex At Work: The Power and Paradox of Organisation Sexuality*, Wheatsheaf, Brighton.

Imray, Linda and Middleton, Audrey (1983) 'Public and Private: Marking the Boundaries', in Eva Gamarnikow *et al.* (eds) *The Public and the Private* Heinemann, London.

Kahle, Jane Butler (ed.) (1985) *Women in Science: A Report from the Field*, The Falmer Press, Lewes.

Kamerman, Sheila B. and Kingston, Paul W. (1982) 'Employer Responses to the Family Responsibility of Employees', in *Families That Work*, National Research Council, Washington DC.

Kanter, Rosabeth Moss (1977) *Men and Women of the Corporation*, Basic Books, New York.

Keller, Evelyn Fox (1983) *A Feeling for the Organism: The Life and Work of Barbara McClintock*, Freeman, New York.

Keller, Evelyn Fox (1985) *Reflections on Gender and Science*, Yale University Press, New Haven, Ct.

Kelly, Alison (ed.) (1981) *The Missing Half: Girls and Science Education*, Manchester University Press, Manchester.

Kelly, Alison (1985) 'The Construction of Masculine Science', *British Journal of Sociology of Education*, Vol. 6, No. 2, pp. 133–46.

Kelly, Alison (ed.) (1987) *Science for Girls?*, Open University Press, Milton Keynes.

Kirkup, Gill (1980) *The Identification and Interpretation of Student Success and Failure at a Polytechnic*, unpublished MPhil thesis CNAA.

Kirkup, Gill (1986) *CAREERWISE: A Fresh Start in Technology – Women Tell Their Stories*, The Open University, Milton Keynes.

Kirkup, Gill (1986) 'The Feminist Evaluator', in Ernest R. House (ed.) *New Directions in Educational Evaluation*, The Falmer Press, Lewes.

Kolmos, Anette (1987) *Gender and Knowledge in Engineering Education*, paper contributed to the Fourth International Conference on Girls and Science and Technology, University of Michigan, July.

Kozak, Marion (1976) *Women Munition Workers During the First World War With Special Reference to Engineering*, unpublished PhD thesis, University of Hull.

Leeds TUCRIC (1983) *Sexual Harassment At Work*, Leeds TUCRIC.

Lenz, Elinor and Myerhoff, Barbara (1985) *The Feminization of America*, Tarcher, Los Angeles, CA.

Maguire, Marie (1987) 'Casting the Evil Eye – Women and Envy', in Sheila Ernst and Marie Maguire (eds) *Living With the Sphinx: Papers from the Women's Therapy Centre*, The Women's Press, London.

Marshall, Judi (1984) *Women Managers: Travellers in a Male World*, John Wiley, Chichester.

Masini, Eleonora Barbieri (1987) 'Women As Builders Of The Future', *Futures*, August.

McNeil, Maureen (ed.) (1987) *Gender and Expertise*, Free Association Books, London.

Miller, Gordon N. (1970) *Success, Failure and Wastage in Higher Education*, Harrap, London.

184 *Bibliography*

Mitchell, Juliet (1974) *Psychoanalysis and Feminism*, Penguin, Harmondsworth.

Moon, J. (1981) *Sixteen Years On: A Perspective on Industrial Training From the Viewpoint of the EITB*, paper presented to the Annual General Meeting of the Association of Colleges for Further and Higher Education, ACFHE, Sheffield City Polytechnic, Sheffield, February.

National Science Foundation (1986) *Women and Minorities in Science and Engineering*, National Science Foundation, Washington DC.

Newton, Peggy (1987) 'Who Becomes An Engineer? Social Psychological Antecedents of a Non-traditional Career Choice', in Anne Spencer and David Podmore (eds) *In A Man's World*, Tavistock, London.

Nicholson, Heather Johnston and Sullivan, Ellen Wahl (1987) *Operation SMART: From Research to Programme and Back*, paper contributed to the Fourth International Conference on Girls and Science and Technology, University of Michigan, July.

Oakley, Ann (1974) *The Sociology of Housework*, Martin Robertson, Oxford.

Oakley, Ann (1981) *From Here To Maternity*, Penguin, Harmondsworth.

Oakley, Ann (1981) 'Interviewing Women: A Contradiction in Terms' in Helen Roberts (ed.) *Doing Feminist Research*, Routledge & Kegan Paul, London.

van Oost, Ellen C. J. and Everts, Saskia I. (1987) *Women's Interests in Engineering*, paper contributed to the Fourth International Conference on Girls and Science and Technology, University of Michigan, July.

Open University (1980) T101 *Living With Technology: A Foundation Course*, The Open University, Milton Keynes.

Orbach, Susie and Eichenbaum, Luise (1984) *What Do Women Want?*, Fontana, London.

Orbach, Susie and Eichenbaum, Luise (1987) *Bitter Sweet*, Century Hutchinson, London.

Ott, Mary Diederich and Reese, N. A. (eds) (1975) *Women In Engineering . . . Beyond Recruitment*, Cornell University Press, Ithaca, NY.

Ott, Mary Diederich (1977) 'Men and Women of the Class of '79', *Engineering Education*, vol. 67, No. 3, pp. 226–32.

Pages, Paulina D. (1987) *Rural Women in Ornamental and Medicinal Plants*, paper contributed to the Fourth International Conference on Girls and Science and Technology, University of Michigan, July.

Phillips, Anne (1983) *Hidden Hands: Women and Economic Policies*, Pluto Press, London.

Rapoport, Rhona and Rapoport, Robert N. (1976) *Dual-Career Families Re-examined: New Integration of Work and Family*, Martin Robertson, London.

Rapoport, Rhona and Rapoport, Robert N. (1978) *Working Couples*, Routledge and Kegan Paul, London.

Richmond-Abbot, Marie (1979) *The American Woman: Her Past, Her Present and Her Future*, Holt Rinehart & Winston, New York.

Rix, Sara E. (ed.) (1987) *The American Woman 1987–88: A Report In Depth*, W. W. Norton, New York.

Robin, S. S. (1969) 'The Female in Engineering', in R. Perrucci and J. E. Gerstl (eds), *The Engineer and the Social System*, Wiley, New York.

Rossiter, Margaret W. (1982) *Women Scientists In America: Struggles and Strategies to 1940*, Johns Hopkins University Press, Baltimore.

Rothschild, Joan (ed.) (1982) *Women, Technology and Innovation*, Pergamon Press, New York.

Rothschild, Joan (ed.) (1983) *Machina Ex Dea: Feminist Perspectives on Technology*, Pergamon Press, New York.

Rueschemeyer, Marilyn (1981) *Professional Work and Marriage: An East-West Comparison*, Macmillan, London.

Society of Women Engineers (1984) *A Profile of the Woman Engineer*, SWE, New York.

Solomonides, Tony and Levidow, Les (1985) *Compulsive Technology: Computers as Culture*, Free Association Books, London.

Spencer, Anne and Podmore, David (1987) *In a Man's World: Essays on Women in Male-Dominated Professions*, Tavistock, London.

Spender, Dale (1981) *Man Made Language*, Routledge & Kegan Paul, London.

Stanworth, Michelle (1983) *Gender and Schooling: A Study of Sexual Divisions in the Classroom*, Hutchinson, London.

Stanley, Liz and Wise, Sue (1983) *Breaking Out: Feminist Consciousness and Feminist Research*, Routledge and Kegan Paul, London.

Stoney, Sheila M. and Reid, Margaret I. (1981) *Balancing the Equation: A Study of Women and Science and Technology within Further Education*, Further Education Curriculum Development and Review Group, Middlesex.

Swarbrick, Ailsa (1986) 'Women in Technology: A Feminist Model of Learner Support in the Open University', *International Council For Distance Education Bulletin*, Vol. 12, pp. 62–6.

Terkel, Studs (1975) *Working*, Penguin, Harmondsworth.

Tobias, Sheila (1980) *Overcoming Math Anxiety*, Houghton Mifflin, Boston, MA.

Turkle, Sherry (1984) *The Second Self: Computers and the Human Spirit*, Granada, London.

United States Department of Labor, Women's Bureau (1985) *UN Decade for Women 1976–1985: Employment in the United States*, US Department of Labor, Washington DC.

Walby, Sylvia (1986) *Patriarchy at Work*, Polity Press, Cambridge.

Walshok, Mary Lindenstein (1981) *Blue Collar Women: Pioneers on the Male Frontier*, Anchor Books, New York.

Walton, Kevin (1987) *What is Engineering?* Edward Arnold, London.

Weingarten, Kathy (1978) 'Interdependence', In R. and R. Rapoport (eds) *Working Couples*, Routledge & Kegan Paul, London.

Weinreich-Haste, Helen and Newton, Peggy (1983) 'A Profile of the Intending Woman Engineer', *EOC Research Bulletin*, No. 7, Summer.

Wolpe, Anne-Marie (1971) *Factors Affecting the Choice of Engineering as a Profession Among Women*, unpublished MA dissertation, University of Bradford.

Young, Michael and Willmott, Paul (1973) *The Symmetrical Family*, Routledge & Kegan Paul, London.

Zimmerman, Jan (ed.) (1983) *The Technological Woman: Interfacing With Tomorrow*, Praeger, New York.

Zimmerman, Jan (1986) *Once Upon The Future*, Pandora Press, London.

Index of references to engineers

UK Engineers

Angela 37, 73, 89, 90, 102
Anna 46, 137, 145
Audrey 46, 57, 60, 62, 64, 70,
 73, 86, 94, 95, 102, 112, 130,
 142
Claire 29, 31, 43, 46, 52, 53, 62,
 63, 69, 82, 83, 84, 89, 98, 130
Doris 80, 112, 129, 141
Eileen 39, 43, 54, 70, 72, 77,
 126, 131, 133, 141
Hazel 56, 68, 69, 102, 106, 113,
 130, 133, 147, 150
Jane 26, 27, 34, 44, 59, 60, 68,
 71, 105, 113, 130, 134
Jennifer 36, 53, 62, 64, 102, 108,
 138, 142, 163
Joyce 53, 69, 78, 81, 95, 111,
 135, 144, 145
Lin 48, 56, 57, 91, 126
Lucy 34, 79, 93, 104, 138, 151
Margaret 44, 45, 53, 55, 63, 81,
 93, 94, 101, 103, 104, 105,
 106, 137
Nicola 60, 97, 107, 114, 115,
 135, 136, 143, 144
Rebecca 42, 46, 87, 128, 144
Sybil 53, 55, 65, 66, 73, 83, 112,
 118, 136, 144
Tanya 22, 40, 46, 47, 55, 59, 60,
 61, 78, 82
Valerie 46
Veronica 24, 25, 26, 32, 42, 62,
 89, 90, 92, 112, 131, 149, 159

Victoria 26, 31, 42, 54, 72, 86,
 107, 108, 110, 112, 127, 132,
 135
Wendy 61, 78, 96, 112, 131

US Engineers

Abigail 30, 31, 32, 37, 78, 80,
 86, 98, 113, 119, 138
Alice 46, 52, 65, 67, 71, 80, 92,
 93, 94, 129, 132, 146, 147,
 148, 150, 151
Anne 31, 32, 41, 67, 97, 98, 103,
 108, 110, 112, 114, 116, 117,
 133, 142, 143, 151
Dora 32, 33, 42, 66, 109, 111,
 118, 122, 125, 151
Ella 31, 48, 56, 57, 58, 62, 113,
 114, 126, 134, 144, 149
Elaine 38, 44, 57, 144
Frances 24, 25, 26, 37, 38, 57,
 129, 131, 141, 155
Julia 32, 33, 48, 56, 71, 74, 91,
 112, 129
Lois 17, 18, 27, 28, 29, 56, 85,
 98, 118, 133
Meg 30, 88, 102, 107, 114, 116,
 118, 122, 124, 125, 148, 149
Noreen 16, 43, 57, 70, 74, 79,
 85, 126, 127, 133, 134
Pauline 16, 22, 48, 56, 58, 71,
 79, 84, 104, 110, 117, 118,
 128, 132, 138, 143, 146

Pearl 16, 40, 55, 66, 85, 93, 98, 112, 127, 128, 138, 164

Rachel 66, 84, 92, 94, 97, 122, 123, 124, 125, 145, 146, 148, 149

Suzanne 40, 62, 64, 65, 78, 107, 116, 129, 147, 164

Zena 26, 29, 30, 38, 39, 58, 64, 71, 80, 81, 105, 106, 126, 138, 143, 147

Index of authors and subjects

age 67–70
A-level 43, 45, 47, 53, 68
Amalgamated Society of
 Engineers (ASE) 9
ambition 6, 97, 132–6, 138–9
 adolescent 36, 38, 39, 40, 44
anti-discrimination 14–15, 155,
 162, 163
appearance 79–82
apprenticeship 14, 45, 53, 62, 73
Association of Consulting
 Engineers 90

bachelor's degree 50, 123, 155
Baines, Alison 99
balancing demands 6
black, being 68, 78, 80, 119
boundaries between home and
 work 86–9, 98
British Association of Young
 Scientists 46
brothers 41–2
business travel 30–1, 91–3

career break 56, 64, 159, 162
career change 113, 137–8
career choice 2
 influences 5, 6; at home 36–
 43, 55; at school 43–5, 52
 non-traditional 36
career decisions 92, 115
career progression 29, 122, 126–
 7, 158–60
careers advice 123, 127
 from teachers 43–5, 52–4
 outside school 45–7, 70

car maintenance 109–11
chartered engineer 10, 58, 64,
 130
Chernobyl nuclear accident 141,
 145
children and childcare 5, 24, 32,
 89–91, 100, 101–4, 118, 120–
 1, 159, 160
Civil Rights Act 1964 (Title
 VII) 14
civil rights movement 132
class 2, 67–70, 106
class action suits 14
Cockburn, Cynthia 4
college preparatory
 programme 43
colleagues 6
 female 90–1, 96–8, 119, 149–
 50
 male 82–4, 89, 99, 139, 152
 social interaction with 84, 94,
 140
 wives of 83, 92
commitment 6, 36, 87, 88, 101,
 122–39, 140
comparable worth 163
company crèche 135, 160
competency 84–6
competition 5, 118
 with men 84–6
conditions of employment 5, 8,
 14, 15–20, 132, 162
confidence 44, 61, 86
conspicuousness 66, 67, 69, 71,
 78, 150
coping strategies 30, 35, 82, 88

core curriculum 74
critical mass 70–2, 99, 150, 155

daily life 5
typical working day 23–9
domestic roles 5, 100–17, 153
domestic work 104–9
paid employee for 108–9;
responsibility to 151
sexual division of labour
in 104–8, 121
double day 99, 120
drafting/draughting (*see also*
technical drawing) 44
dress 79–80
dual-career couples/families 33,
100, 120, 133

educational experiences 5, 50–
75, 153
Eichenbaum, Luise 118, 148
employers 5, 130, 132, 148, 151,
158–61
Employment Protection Act
1975 18
empowerment 170
encouraging women to become
engineers 1, 6, 154, 166
engineering
British industry 142, 145, 146
consultancy 90
employment of women 5, 9,
11–13
in the Third World 169–70
process and content 21, 34,
62, 166–70
underrepresentation of girls and
women 2
Engineering Council 10, 11,
161–2, 169
engineering education 142–3,
168–9
courses 45, 54, 155, 161–2,
169
first-year experience 58–61
interdisciplinary projects 168–
9
male environment 61, 65–7, 74

mature students 3, 56, 57, 58,
69, 157
recruitment and support of
women students 70–2,
156–8
undergraduate enrolment 50–1
Engineering Industry Training
Board INSIGHT
programme 157
engineering institutions 9, 12,
161
engineering profession 1, 8–11,
165–6
gendering of 2, 99
changing proportion of women
in 154
development 8–9
mature entrants 48
structure 10
women's exclusion 9, 163
women's organisations 10,
136–7
environmental issues 141, 143
envy 97, 118, 148
Equal Employment Opportunity
Commission (EEOC) 14,
163
equal opportunities 2
legislation 7, 8, 13–15, 162–3
Equal Opportunities Commission
(EOC) 14, 163
equal pay 13–14, 163

family responsibilities 32, 69,
100, 140, 145
fathers 37–9, 40, 42, 43, 55, 64
Fawcett Society 10
female, being 6, 139, 146–7, 150
feminine 1, 88, 145
feminist analysis
of science 4, 167
of technology 3–5
feminist campaigns around
technological issues 141
feminist engineering ·166–70
feminists 140, 147, 158
financing study 56, 57–8, 62–3
flexitime 16

Florman, Samuel C. 69
friends/friendship
 boyfriends 42, 43, 72–4
 girlfriends 70–2
 women friends 70–2, 118–19,
 121, 149–50, 151

gender 1, 3, 98, 99, 147
 as an issue for male
 colleagues 82–4
gender stereotyping 3
 occupational 2, 21
girls' schools 53, 54, 59, 61, 70
Gower, Dan 114
graduate trainee 129
grandmothers 43, 58
grandparents 102, 120
guilt 5, 99, 100, 104, 108, 115,
 117, 120, 121, 139, 153

Hearn, Jeff 84, 95
health care and sickness
 benefits 17
Higher National Diploma
 (HND) 47
holism 169
hours of work 15–16, 87
household repairs 109–11
housework *see* domestic work
husbands *see* partners

identity
 individual 152–3
 professional 131–2, 154
ideology
 of housework 106
 of motherhood 153
ill-health 32, 33, 41, 61
 of children 103
 of others 106
Imray, Linda 77, 93
instructional factories 9
intervention programmes 2, 70,
 72, 166

job applications 64
job creation 143
job descriptions 22

job interviews 64, 67, 83, 126
job titles 22, 124
jokes 82, 92, 93–6

Kanter, Rosabeth Moss 81, 83,
 97
Keller, Evelyn Fox 167
Kolmos, Anette 167–8

laboratory work 60, 66
leaving home 55, 61
Legge, Karen 114
legislation 5, 7, 8, 13–15, 18–19,
 155, 162–3
leisure activities 24, 28–9, 88,
 112, 117
lunchtime 25, 84, 88, 112

Maguire, Marie 97
male classroom 65–7
male sexual fantasies 92
male sexual narrative 84
management style 124, 146
managerial role 26, 29, 83, 123–
 5, 138
 moving into a 125–9
manual labour 83
Manpower Services Commission
 (renamed first the Training
 Commission, then the
 Training Agency) 64, 157,
 162
Marshall, Judi 127, 152–3
masculine/masculinity 1, 4, 53,
 76, 99, 140
master's degree 63, 64, 129
maternity leave and benefits 18–
 19, 89, 90, 159, 162, 170
McClintock, Barbara 167
Middleton, Audrey 77, 93
mothers 37, 40–1, 42, 43, 55, 73

National Health Service
 (NHS) 17
National Insurance
 contributions 17
National Organisation of
 Women 10

National Science Foundation,
 monitoring function 12
new technology 21, 111, 129,
 130–1
Newton, Peggy 37
non-objectivity 167, 169–70
nuclear power industry 144–5

Oakley, Ann 120
Office of Federal Contract
 Compliance 15
O-Level 68
Opening Windows on Engineering
 programme 160
Open University Women in
 Technology (WIT)
 Project 157, 158
Orbach, Susie 118, 148
Ordinary National Diploma
 (OND) 46, 48

parents 55, 61
Parkin, Wendy 84, 95
partners (and husbands) 5, 33–4,
 64, 65, 73–4, 89, 92, 102, 105,
 113–17, 121, 138, 152, 162
part-time work 8, 88–9, 90, 100,
 135, 159, 162
paternity leave 19, 162
patriarchy 3
pattern breaking 48–9
personal reputation 78
personal values 6, 85, 140–53
PhD 48, 64, 105, 130
physical attributes 81, 110
pin-ups 78, 96
positive discrimination 78, 155
positive role models 43, 157, 164
postgraduate study 63–4
power 76, 95, 99
pregnancy 89–91
 planning 120, 134–6
prejudice 86
pressure
 ageist 69
 at work 31, 33, 87, 113
 racist 69

to succeed 67
 towards marriage 73
private companies 31, 87, 125
private domain/sphere/world 76,
 84, 100
private health insurance 17
private lives/roles 76, 88, 98,
 100–21, 154
professional image 79–82, 152
professional recognition and
 registration 10–11, 58, 123
professional roles 34
professional societies 136–7, 160,
 161, 165
project management 127
promotion 14, 83, 123–4, 126–8,
 137, 145
public domain/sphere/world 76,
 82, 84
public lives 76–99
public sector 31
Purdue University, Indiana 156–
 8, 164, 165

race 2, 6, 67–70, 78, 80, 119
Rapoport, Rhona and
 Robert 100, 104, 113, 152
Reagan administration 155–6
relationships 5
 personal 34, 87
 professional 34
 with men 151–2
 with partners 33–4, 113–17
 working 19, 83; on site 82
responsibility 87, 89, 99, 100,
 102, 107
retirement 109, 113, 125
retraining 14, 158
roles 116, 117, 120
 as housekeeper 100
 as mentor 128, 152
 as mother 87, 98, 100
 as partner 87
Rueschemeyer, Marilyn 121

salary 15, 127
sandwich courses 62, 63

scholarships or prizes 56, 155, 161
secondary schooling 52–4
secretaries 83, 98, 135
sex 2, 6
sexual discrimination 6, 75, 78, 84, 86, 123, 138, 148
sexual harassment 67, 93–6
sexual objectification 78
significant others 42–3
single-parent households 8
single-sex colleges/ dormitories 66, 71, 73
single-sex education 51–2, 53–4, 158
single-sex groups 158
single-sex schools 6, 43, 50, 53, 72, 73, 74
sisters 43, 61
Snow, C. P. 112
Society of Women Engineers (SWE) (*see also* Women's Engineering Society) 10, 46, 71, 94, 136–7, 148–9, 157, 160, 165
space-shuttle explosion 141, 142
Spender, Dale 76
sponsorship 57, 61–3, 129, 155, 161
stress 5, 101, 112–13, 154
student grants 56, 57
student loans 56, 58
supervisory role 26, 83, 90, 123
support
from educators 155–8
from employers 158–61
from family and friends 6, 117–19
from legislation 162–3
from partners 113–17, 121
from professional bodies 161–2
from women engineers 163–5
networks 119, 149, 152, 164, 170
parental 55, 61
systems approach in education and training 169

teacher training 47
technical drawing (*see also* drafting/draughting) 44, 52, 59
technical subjects, accessibility 56
technical vocational training schemes 157
technological progress 141, 146, 153
attitudes to 141–6, 166
technology 3–5
and defence and economic policies 3–4, 144, 145–6
and masculinity 4
and personal values 140–53
and society 6
effects of 142
feminist analysis of 4
safety of 143, 146
trades unions 5, 9, 95
membership of 131–2
training 2, 9, 14, 129–31, 137, 138, 159–60, 169, 170
turning point 41, 48–9

unemployment 8

vacation, paid 16–17, 18
values 6, 140, 154

Walshok, Mary Lindenstein 48
war
Falklands War 144
Great War 1914–18 9
World War II 40
Weingarten, Kathy 114
welfare provision 5
Willmott, Paul 104
woman-centred learning 4, 157
women and technology 3–5
Women into Science and Engineering Year 1984 2, 161
women managers 127, 152–3
women professionals 4
women writers 76

women's colleges/dormitories 60,
 71, 72
women's employment 8
 in engineering 11–13
 direct and indirect
 discrimination 14
Women's Engineering Society
 (WES) (*see also* Society of
 Women Engineers) 10, 46,
 101, 112, 136–7, 148–9, 165
women's liberation
 movement 77, 97, 119, 132,
 147, 164
women's oppression 3
work 6
 delegating 26, 82, 107–8
 enjoyment of 29, 122

flexibility of 33, 87, 103, 160
gendering of 77–9
pressures 31, 33, 87
reflective 29–30
taking work home 28, 30, 31–
 3, 87
texture of 22–9
unpaid 32
variety of 29
wartime 9
working
 environment 6, 75, 154
 from home 90
 style 81
 to finance study 57

Young, Michael 104